ELIZABETHTOWN COMMUNITY COLLEGE
MEDIA CENTER

THE PAINTINGS OF

BRUEGEL

BY F. GROSSMANN

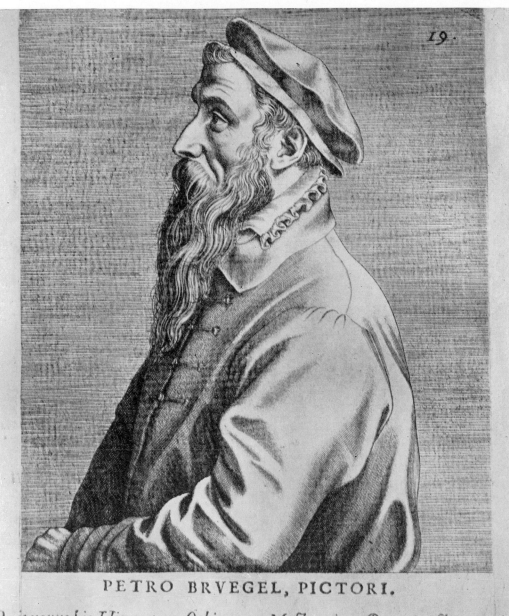

PORTRAIT OF BRUEGEL

Engraving from Dominicus Lampsonius,

Pictorum aliquot celebrium Germaniae inferioris effigies,

Antwerp, 1572

BRUEGEL

THE PAINTINGS

COMPLETE EDITION

BY F·GROSSMANN

LONDON · PHAIDON PRESS

ALL RIGHTS RESERVED BY PHAIDON PRESS LTD

5 CROMWELL PLACE, LONDON SW7

FIRST PUBLISHED 1955

SECOND EDITION · REVISED · 1966

MADE IN GREAT BRITAIN

DESIGNED BY L. GOLDSCHEIDER, LONDON

COLOUR PLATES PRINTED BY HENRY STONE AND SON LTD, BANBURY, OXON

TEXT AND MONOCHROME PLATES PRINTED BY HUNT BARNARD AND CO LTD, AYLESBURY, BUCKS

PREFACE

IN recent times the work of only few Flemish artists has received as much attention and has been the object of as much intensive study and scrutiny as that of Pieter Bruegel the Elder. Several different methods of approach, provoked by the peculiar character of this work, have been tried and various aspects of Bruegel's art have been explored. We have become aware of more and more problems, though it has not always proved possible to find unequivocal solutions. It is a measure of this like any other great artist's stature that many more questions still remain to be asked. For this reason I gladly accepted the late Dr. B. Horovitz's suggestion to write yet another book on Bruegel. Actually only a short while ago practically all documentary material on the master's work I had collected over a number of years and placed at the late Dr. Gustav Glück's disposal, was published in the catalogue raisonné of Glück's book on the paintings of Bruegel, first in the 1951 German edition, and again, with some additions, in the English edition (1952), but of course I did not have the opportunity there of presenting a coherent view of Bruegel's art as it appeared to me, nor of expressing my own opinion as to the authenticity, or otherwise, of a number of disputed paintings. In addition since 1952 some further documentary material and several more works of the master have come to my notice. The new catalogue raisonné of the extant authentic oeuvre will therefore contain some paintings which could not be known to Glück, on the other hand it will not include all paintings accepted by him. However, while the raison d'être of the new catalogue is its difference from the earlier ones, it will remain greatly indebted to the most careful and circumspect work of Glück and the pioneer catalogue of Hulin de Loo.

The catalogue is reserved for the second volume of this book. In the present volume an attempt is made to sum up what we know, or can deduce from various sources, about the artist's life, and to survey the varying interpretations of his work from his day to ours and thus to point out in nuce the problems that confront the modern student of Bruegel. The plates included in this volume present all authentic surviving paintings

by the master known to me. Interpretative notes, based on the catalogue and the examination of the work in the second volume, are added in order to enable the reader to use the first volume independently.

The catalogue raisonné will deal with the extant as well as the lost paintings known from copies and other sources. Since a very considerable part of Bruegel's output survives only in copies and since these lost works also provided an inspiration for other artists, it is perhaps more urgent here than anywhere else to reconstruct and illustrate the lost oeuvre. A further section of the catalogue is devoted to the paintings accepted by some scholars as authentic, which, however, in my view are the works of other artists among whom Jan Brueghel the Elder deserves special attention. The catalogue is supplemented by the reprint in extenso of all early documents.

PREFACE TO THE SECOND EDITION

In this new edition the text has remained essentially unaltered though, due to continued study and the results of recent research, as well as to the emergence of new drawings, some additions have been made. These will be found mainly in the chapter on Bruegel and the Critics and in the notes on the plates where discoveries of documents and those new interpretations which seem to me worthy of consideration have been duly noted. No new undoubted paintings have come to light since the first publication of this book. There are, however, some two or three paintings which are in need of further study before they can be definitely added to or withdrawn from the oeuvre of Bruegel. They are not included here while they are still sub judice and have been reserved for discussion in the catalogue raisonné, where this can be done at greater length. Only two pictures have found new homes: the Tower of Babel (Plate 51), which has been purchased by the Museum Boymans-van Beuningen, Rotterdam, from the van Beuningen Collection, Vierhouten, and the Landscape with the Parable of the Sower (Plate 5), formerly on loan to the National Gallery of Art, Washington, from the Stuyck del Bruyère Collection, Antwerp, which has been acquired by the Timken Art Gallery, San Diego.

Manchester, May 1965

INTRODUCTION

The Life of Bruegel

IN 1604 Carel van Mander's *Schilder-Boeck* was published. It includes the earliest biography of Pieter Bruegel the Elder, and this remains a most important source for the artist's life. This is what van Mander has to say:

IN a wonderful manner Nature found and seized the man who in his turn was destined to seize her magnificently, when in an obscure village in Brabant she chose from among the peasants, as the delineator of peasants, the witty and gifted Pieter Breughel, and made of him a painter to the lasting glory of our Netherlands. He was born not far from Breda in a village named Breughel, a name he took for himself and handed on to his descendants. He learnt his craft from Pieter Koeck van Aelst, whose daughter he later married. When he lived with Koeck she was a little girl whom he often carried about in his arms. On leaving Koeck he went to work with Jeroon Kock, and then he travelled to France and thence to Italy. He did much work in the manner of Jeroon van den Bosch and produced many spookish scenes and drolleries, and for this reason many called him Pieter the Droll. There are few works by his hand which the observer can contemplate solemnly and with a straight face. However stiff, morose or surly he may be, he cannot help chuckling or at any rate smiling. On his journeys Breughel did many views from nature so that it was said of him, when he travelled through the Alps, that he had swallowed all the mountains and rocks and spat them out again, after his return, on to his canvases and panels, so closely was he able to follow nature here and in her other works. He settled down in Antwerp and there entered the painters' guild in the year of our Lord 1551. He did a great deal of work for a merchant, Hans Franckert, a noble and upright man, who found pleasure in Breughel's company and met him every day. With this Franckert, Breughel often went out into the country to see the peasants at their fairs and weddings. Disguised as peasants they brought gifts like the other guests, claiming relationship or kinship with the bride or groom. Here Breughel delighted in observing the droll behaviour of the peasants, how they ate, drank, danced, capered or made love, all of which he was well able to reproduce cleverly and pleasantly in water colour or oils, being equally skilled in both processes. He represented the peasants, men and women, of the Campine[1] and elsewhere naturally, as they really were, betraying their boorishness in the way they walked, danced, stood still or moved. He was amazingly skilful in his compositions and drew neatly and beautifully with the pen, producing many small views after nature. As long as he lived in Antwerp, he kept house with a servant girl. He would have married her but for the fact that, having a marked distaste for the truth, she was in the habit of lying, a thing he greatly disliked. He made an agreement or contract with

1 The country east of Antwerp.

her to the effect that he would procure a stick and cut a notch in it for every lie she told, for which purpose he deliberately chose a fairly long one. Should the stick become covered in notches in the course of time, the marriage would be off and there would be no further question of it. And indeed this came to pass after a short time. In the end when the widow of Pieter Koeck was living in Brussels, he courted her daughter whom, as we have said, he had often carried about in his arms, and married her. The mother, however, demanded that Breughel should leave Antwerp and take up residence in Brussels, so as to give up and put away all thoughts of his former girl. And this indeed he did. He was a very quiet and thoughtful man, not fond of talking, but ready with jokes when in the company of others. He liked to frighten people, often even his own pupils, with all kinds of spooks and uncanny noises. Some of his most important works are now with the Emperor,[1] for instance a *Tower of Babel*[2] with many beautiful details. One can look into it from above. There is also a smaller picture of the same subject.[3] Further, there are two paintings of *Christ Carrying the Cross*,[4] which look very natural, with some comic episodes in them. There is as well a *Massacre of the Innocents*,[5] in which we find much to look at that is true to life, as I have said elsewhere:[6] a whole family begging for the life of a peasant child which one of the murderous soldiers has seized in order to kill, the mothers are fainting in their grief, and there are other scenes all rendered convincingly. Finally there is a *Conversion of St. Paul*[7] with most beautiful rocks. We would be hard put to it to enumerate all the things he has painted, the weird and fantastic pictures, the pictures of Hell and of peasants. He did a *Temptation of Christ*[8] where one looks down from above, as in the Alps, on towns and countries immersed in clouds, with gaps in places which one can see through; he also painted a *Dulle Griet*[9] who is looting at the mouth of Hell. She stares with a vacant expression and is decked out in an extraordinary way. I think, this and some other pictures are also in the possession of the Emperor. An art lover in Amsterdam, Sieur Herman Pilgrims, owns a *Peasant Wedding*[10] painted in oils, which is most beautiful. The peasants' faces and the limbs, where they are bare, are yellow and brown, sunburnt; their skins are ugly, different from those of town dwellers. He also painted a picture in which Lent is shown fighting with Carnival,[11] another in which expedients of every kind are tried out against death,[12] and another with all manner of children's games,[13] and countless other small paintings of great significance. Two canvases painted in water colour are to be seen in the house of Mynheer Willem Jacobsz, an art lover who lives near the New Church in Amsterdam. They are a *Peasant Fair* and a *Wedding*, a picture with many comic figures, showing the true character of the peasants. Among

1 Rudolph II.
2 Now in Vienna (Plates 50, 52–54, 56).
3 Now in the Museum Boymans-van Beuningen, Rotterdam (Plates 51, 55, 57–59).
4 One of these is now in Vienna (Plates 63–74).
5 Probably the version now at Hampton Court (Plates 111 and 113).
6 In the theoretical introduction, in verse, to the *Schilder-Boeck*.
7 Now in Vienna (Plates 125–128).
8 Last heard of when in the collection of Rubens.
9 Now in the Musée Mayer van den Bergh, Antwerp (Plates 36–44).
10 This could be the *Peasant Wedding* now in Vienna (Plates 129–133), though this is far from certain.
11 Now in Vienna (Plates 6–12).
12 Now in Madrid (Plates 20–29).
13 Now in Vienna (Plates 15–19).

the people who bring gifts to the bride there is an old peasant who has a little money bag hanging from his neck; he is busy counting the money into his hand. These are outstanding paintings. A short time before his death the councillors of Brussels asked him to paint some pieces to show the digging of the Brussels-Antwerp canal. But his death interfered with the work. Many of his compositions of comical subjects, strange and full of meaning, can be seen engraved; but he made many more works of this kind in careful and beautifully finished drawings to which he had added inscriptions. But as some of them were too biting and sharp, he had them burnt by his wife when he was on his death-bed, from remorse or for fear that she might get into trouble and might have to answer for them. In his will he bequeathed to his wife a painting of a *Magpie on the Gallows*.[1] By the magpie he meant the gossips whom he would deliver to the gallows. Another work showed *Truth Breaking Through*. This was (according to his own words) the best thing he had ever done.[2] He left behind him two sons who are also good painters. One is called Pieter. He was a pupil of Gillis van Coninxloo and paints portraits from life.[3] Jan who had learnt the use of water colour from his grandmother, the widow of Pieter van Aelst, was instructed in the art of painting in oils by Pieter Goetkindt, in whose house were many beautiful things. He travelled to Cologne and thence to Italy. He has earned a great reputation for himself by his landscapes with very small figures, a type of work in which he excels.

Lampsonius addresses Breughel in these words, beginning with a question:[4]

'Who is this new Hieronymus Bosch, reborn to the world, who brings his master's ingenious flights of fancy to life once more so skilfully with brush and style that he even surpasses him?

Honour to you, Peter, as your work is honourable, since for the humorous inventions of your art, full of wit, in the manner of the old master, you are no less worthy of fame and praise than any other artist '[5]

1 Now in Darmstadt (Plates 153 and 154).

2 It is most likely that the subject of this work was *The Calumny of Apelles*, a drawing of which by Bruegel was recently acquired by the British Museum and subsequently published by Christopher White in *The Burlington Magazine* (CI, 1959, pp. 336 f., Fig. 45). It is not clear whether van Mander refers to this drawing or to a painting.

3 In the Appendix to his book van Mander corrects himself: 'I have been wrongly informed that Pieter Breughel the Younger paints from life. He copies and imitates his father's works very cleverly.'

4 For the original Latin version of Lampsonius' epigram see Frontispiece.

5 Van Mander's spelling of the artists' names has been preserved in our translation which tries to be as literal as possible.

WHILE modern research has extended our knowledge and understanding of the work, it has not found a great deal to add to van Mander's account of Bruegel's life. A few documents and the data provided by the works themselves supplement van Mander's report, but on the other hand modern historical criticism has taught us to be cautious about accepting van Mander's record at its face value. We have to examine and scrutinize carefully even what sounds like a statement of fact and to check it wherever possible.

Van Mander tells us that in 1551 Bruegel entered the painters' guild in Antwerp. This is confirmed by the entry under that year in the guild's lists, which gives the name as 'Peeter Brueghels'.[1] The form 'Brueghels', with an s at the end of the name, has some bearing on our views of the master's place of birth. According to van Mander he was born not far from Breda in an obscure little Brabant village from which he took his name. Unfortunately, unambiguous though it sounds, van Mander's statement does not tell us exactly what we want to know: for there are two villages with the name of 'Brueghel' or 'Brögel' and neither is near Breda in Brabant. One, in North Brabant (in present-day Holland), is some thirty-four miles to the east of Breda, the other, divided into 'Groote Brögel' and 'Kleine Brögel' (in present-day Belgium), lies in the Limbourg Campine, which in Bruegel's time was part of the territory of the bishop of Liège, outside the Netherlandish Provinces. It is even farther away from Breda - some forty-four miles - but it is quite near to the small town of Brée - a little above three miles. As in the sixteenth century Brée was called Breede, Brida or - in Latin - Breda, it has been argued that van Mander confused Breda (Brée) in Limbourg with Breda in Brabant and that Bruegel was born near Brée.[2]

Leaving aside the fact that it is hard to assume that a writer living in the Netherlands at the end of the sixteenth century would have confused Netherlandish and Liège territory,[3] the choice is probably not at all between the two villages: Bruegel may not have been born in either. As in Bruegel's lifetime

1 Until 1559 the artist spelled his name 'Brueghel'; from that year he changed over to 'Bruegel', mostly written in Roman capitals as 'BRVEGEL' (see René van Bastelaer and Georges Hulin de Loo, *Peter Bruegel l'Ancien*, Brussels 1907, p. 44). We do not know the reasons for this change in spelling and script.

2 Bastelaer-Hulin de Loo, *op. cit.*, p. 45, note, and R. van Bastelaer, *Les Estampes de Peter Bruegel*, Brussels 1908, p. 3, and other writers after Bastelaer.

3 Comte Charles Terlinden ('Pierre Bruegel le Vieux et l'histoire', in: *Revue Belge d'Archéologie et d'Histoire de l'Art*, XII, 1942, p. 233) has rightly remarked that the legal exclusiveness of the Brabant cities of Antwerp and Brussels would have imposed certain restrictions on the Liège 'foreigner', which could not have remained unnoticed by van Mander.

Ludovico Guicciardini (in his *Descrittione di tutti i Paesi Bassi, 1567*) called the artist 'Pietro Brueghel di Breda' and van Mander was writing only some thirty-five years after Brucgel's death, we cannot exclude the possibility that van Mander, knowing of a village in North Brabant called Brueghel and familiar with the painter's Breda origin on the one hand, and on the other deducing a peasant's extraction from the 'Peasant Bruegel's' work, easily assumed that the name Bruegel indicated the artist's place of origin. It should be remembered that several men of higher social standing, bearing the name Brueghel, are known to have lived at Antwerp and Brussels in the sixteenth and seventeenth centuries[1] – they may or may not have been relatives of the artist – but it has never been suggested that they were born in a village called Brueghel, although their families, as well as that of the painter, may have originally derived their names from the place they came from.

Considerations of this kind find some support in the form the name is spelt in the Antwerp guild lists: 'Peeter Brueghels' which, as has been pointed out,[2] according to Netherlandish custom could only be understood as 'Peeter, the son of Brueghel', not 'Peeter from Brueghel'. Whenever in the Antwerp painters' lists a name appears with the addition of an s, this s indicates a patronymic. A further example is provided by the name of the daughter of Pieter Coeck, Bruegel's bride, who in the wedding register appears as 'Mayken Cocks'.

This question is of more than academic interest, for if we reject van Mander's assertion of Bruegel's village origin, nothing except the subjects of a few paintings remain in support of what we must call the legend of Bruegel the peasant.

There is no less uncertainty about the date of Bruegel's birth. Van Mander does not give it. By taking various scraps of evidence into account, the years 1525-30 have been arrived at, recently even 1520 or 1522,[3] but the fact that Bruegel was admitted as a master to the Antwerp painters' guild in 1551 seems to speak more in favour of a date between 1525 and 1530, provided, of course, that he received the normal artistic training and had not been a master in another place, such as Breda, before he came to Antwerp.[4]

1 *Cf.* Bastelaer–Hulin de Loo, *op. cit.*, pp. 42 f.

2 Max J. Friedländer, *Die Altniederländische Malerei*, XIV, 1937, p. 1.

3 B. Knipping, *Pieter Bruegel de Oude*, Amsterdam, n.d. (1945), p. 1: 1520, and Ch. Bossus, in *Gazette des Beaux-Arts*, February 1953, pp. 124 ff., with arguments based on inaccurate premises: 1522.

4 The portrait in the Lampsonius series (Frontispiece) which probably reproduces a portrait of Bruegel taken towards the end of his life, may well represent a man of about forty to forty-five, though to modern eyes he may look older.

Van Mander says that Bruegel was apprenticed with Pieter Coeck van Aelst, but some scholars have doubted van Mander's words, as they could find no stylistic evidence for any connection between Bruegel and the Italianate Coeck, and have even suggested that van Mander assumed this relationship because he knew of Bruegel's marriage with Coeck's daughter Mayken, whom van Mander tells us, Bruegel used to carry about in his arms when she was a child.[1] However that may be, there are a few admittedly rather slender points which seem to support van Mander's account. The fact that Bruegel was familiar with Coeck's woodcut series *Moeurs et Fachons de faire de Turcz*,[2] published after Coeck's death in December 1550 by his widow Mayken Verhulst Bessemers, need not necessarily imply that Bruegel was a pupil of Coeck's, but it has also been suggested that Bruegel took part in Coeck's large-scale decorative work, the designing of tapestries.[3] Through this particular field of Coeck's activity, it seems to me, Bruegel came into contact with Jan Cornelisz Vermeyen, an echo of whose work we find in one or two of Bruegel's compositions. The bird's-eye view, the foreground filled with ships, the harbour placed far into the background – all this connects Bruegel's *View of Naples* (Plates 48 and 49), which in its composition has little in common with earlier marine pictures, with several of Vermeyen's cartoons in the Vienna Gallery, but most closely with the *Disembarkation* (No. 1862) and the *Capture of Goleta* (No. 1866), forming part of the series designed for tapestries in which the Tunis campaign of Charles V was commemorated. The tapestries, a set of which is in the (formerly) Royal collections of Madrid, were commissioned by Mary of Hungary, regent of the Netherlands, in 1546, and it has been suggested that Coeck was associated with Vermeyen in the preparation of the cartoons.[4] While the influence of Vermeyen in a comparatively late work does not militate against an early contact (since Bruegel also stored impressions received

1 Judging by her apparent age in the portrait group painted by Pieter Coeck about 1545 of himself, his second wife and their three children (Kunsthaus, Zurich), Mayken, Bruegel's later wife, may have been born around 1543 which would well agree with van Mander's account that she was a small girl when Bruegel worked with her father.

2 Edouard Michel, in *Mélanges Hulin de Loo*, Brussels 1931, pp. 266 ff., *cf.* also Berthold Riehl, *Geschichte der Sittenbildes in der deutschen Kunst bis zum Tode Pieter Brueghels des Aelteren*, Berlin 1889, pp. 127 f.

3 Julius Held, in: *Bulletin of the Detroit Institute of Arts*, XIV, 1934–35, pp. 107 ff. For further links between the art of Bruegel and Coeck see F. Grossmann, 'Bruegels Verhältnis zu Raffael und zur Raffael–Nachfolge', in *Festschrift Kurt Badt zum siebzigsten Geburtstage*, Berlin 1961, pp. 135 ff.

4 Heinrich Göbel, *Wandteppiche*, 1: Niederlande, 1, 1923, pp. 419 f., and later writers; most recently M. J. Friedländer, in: *Oud-Holland*, LIX, 1942, p. 12.

on his visit to Italy for use in much later works), it has to be considered whether the map-like character of both artists' views may not in fact owe something to cartography, which in the case of Bruegel would be easily explained by his friendship with the geographer and designer of maps Abraham Ortelius. There is, however, another connecting link between Vermeyen and Bruegel. An (at this time) rather unusual feature of the *Tunis* series, repeated five times, is the inclusion in the foreground of the artist sketching. Another early example of this motif is to be found in a *Landscape* by a follower of Patenier (London, National Gallery, No. 1298), a painting that has been attributed to several different artists, among others, though unconvincingly, to Bruegel. The etching of a *Landscape with Mercury and Psyche* after a design by Bruegel of 1553 (Bastelaer, *Estampes de Bruegel,* No. 1) also shows the artist sketching, in addition to some other features it has in common with the National Gallery *Landscape.* We do not know what, if any, connection there is between this painting and Vermeyen's cartoons, but in his work this motif is most conspicuous and also emphasized by its frequent repetition, and Bruegel, too, repeated this detail, in a landscape drawing of c. 1554-55,[1] i.e. in his early years. Finally one has to ask oneself whether a particular branch of Bruegel's art, the paintings in water colour or rather in a kind of tempera, was not inspired by Coeck's wife who, hailing from Malines, where this kind of painting was particularly popular, practised it herself and, as we know from van Mander, instructed her grandson Jan Brueghel in it.[2]

While not giving up his contacts with Antwerp, Coeck seems to have spent the last years of his life in Brussels, where he is known to have died on December 6, 1550. If Bruegel actually was with Coeck until his death, it may not just have been a coincidence that in the following year he became a free master at Antwerp, though one may wonder why he did not join the Brussels guild.[3] While quite generally the great and rising town of Antwerp seems to have offered

1 In the collection of Count Antoine Seilern, London (Charles de Tolnay, *The Drawings of Pieter Bruegel the Elder,* London–New York 1952, No. 21).

2 According to August Corbet, *Pieter Coecke van Aelst,* Antwerp 1950, p. 90, n. 8, Professor A. Vorenkamp, in a lecture held in Antwerp in February 1949, suggested that Mayken Verhulst rather than Coeck was Bruegel's teacher. S. Bergmans, in *Revue Belge d'Archéologie et d'Histoire de l'Art,* XXVI, 1958, p. 83, tentatively identified Mayken Verhulst with the Master of the Brunswick Monogram, whose influence on Bruegel has been stressed repeatedly. For Bruegel's connection with Malines see also p. 21, note 1.

3 In 1550/51 he seems to have worked at Malines with the Antwerp master Pieter Baltens (see p. 21, note 1). He may have entered the workshop of Baltens either when Coeck moved to Brussels or after Coeck's death.

better prospects to a young artist, van Mander's statement that Bruegel learned his art from Coeck and then went to Hieronymus Cock, points to a more specific explanation. We could assume that after the death of Coeck Bruegel was attracted to Antwerp (where at any rate at some time he may have worked in Coeck's workshop) by Cock who was a most enterprising and successful engraver and publisher and, once in Antwerp, he of course applied for admission to the guild. While in this case we have no reason to doubt van Mander's accuracy, it is, however, not before 1555 and 1556 that we have incontestable proof of Bruegel's collaboration with Cock: a drawing of a *Mountain Ravine* in the Louvre,[1] which was published by Cock in an engraving, together with other landscape prints after Bruegel's designs[2] is dated 1555, and of the figure compositions after Bruegel none bears an earlier date than 1556. But between 1551 and 1555 Bruegel had travelled, via France, to Italy, where he stayed in 1552 and 1553, if not longer. As the connection with Cock before 1555 is not quite certain (though, according to van Mander, Bruegel went to France and Italy after joining Cock), we cannot say whether, as sometimes has been suggested, Bruegel undertook the journey with a view to supplying Cock with landscape drawings for reproduction in engravings. Both Pieter Coeck and Hieronymus Cock had been to Italy and at that time it was quite usual for an artist to make the pilgrimage to Italy. As a matter of fact, in 1552, the year of Bruegel's journey, we find two other young Antwerp artists in Italy, the painter Martin de Vos and the sculptor Jacques Jonghelinck (for whose brother Bruegel worked at a later date), and we have reasons to believe that at least the two painters travelled together for some time.[3]

As we shall see, to earlier critics Bruegel appeared as the one Netherlandish artist of his time who was quite unsusceptible to the Italian spirit, whereas later scholars have tried to show Italian influences in his work. In view of this controversy the Italian journey deserves particular attention. And oddly enough it is exceptionally well documented, better than any other period of his life. From these documents, consisting of drawings, engravings, paintings, it is clear that he was not satisfied with going only to Rome and the other

1 Tolnay, *Drawings*, No. 23.
2 No. 9 of the *Large Landscape Series*, Bastelaer, *Estampes*, Nos. 3–17.
3 *Cf.* A. E. Popham, 'Pieter Bruegel and Abraham Ortelius', in *The Burlington Magazine*, LIX, 1931, p. 188. For Jonghelinck's stay in Milan in 1552 see E. Motta, in *Rivista italiana di numismatica*, 1908, Nos. 1–2.

places usually visited by artists. He extended his journey far to the south and wandered about a great deal in the countries to the north of Italy.[1]

He apparently left very shortly after being received into the guild as a master, for as early as 1552 he was in the southernmost part of Italy. A drawing, now in the Museum Boymans, Rotterdam, of *Reggio in Calabria,* with fires raging all over the place, gives us this information. By its style and by the fact that the conflagration of Reggio was the result of a Turkish attack in 1552, we are able to date Bruegel's drawing.[2] Bruegel must have crossed over from Reggio to Messina in Sicily, as in an engraving after his design of a *Sea Battle in the Straits of Messina* there appears opposite the Reggio scene (which is based on the Boymans drawing) a detailed view of Messina. He obviously continued his journey in Sicily at least as far as Palermo: the echoes of the famous fresco of the *Triumph of Death* in the Palazzo Sclafani at Palermo in Bruegel's painting in the Prado (Plate 20) leave no doubt about it.[3] The painting of the *Harbour of Naples* (Plates 48–49) is a further proof for Bruegel's travels in southern Italy.[4] A drawing in the Berlin Print Room, dated 1552, shows a landscape with unmistakably Italian architecture. This Italian landscape drawing and a drawing in the Louvre incidentally, are the earliest preserved dated works of Bruegel known to us.

In 1553 Bruegel was in Rome. Two etchings after Bruegel's designs, published by Joris Hoefnagel, are each inscribed: '*Petrus Bruegel fec: Romae A° 1553*'.[5] Hoefnagel, who owned a number of Bruegel's drawings, obviously

1 For Bruegel's itinerary see Otto Benesch, in *Kunstchronik,* VI, 1953, pp. 76 ff.

2 See F. Grossmann, in *Bulletin Museum Boymans,* V, 1954, p. 85.

3 The similarities between the two compositions were noticed by Dr. L. Goldscheider, who kindly informed me of his observation. Without giving his reasons Comte Terlinden, *op. cit.,* p. 247, suggests that Bruegel may have seen the *Triumph of Death* at Palermo. *Cf.* also Charles de Tolnay, *Pierre Bruegel l'Ancien,* Brussels 1935, p. 31.

4 I formerly thought that a drawing with a *View of Fondi* (now in the Fine Arts Gallery of San Diego, California, and originally known to me only from a reference to it in Gustav Glück, *The Large Bruegel Book,* Vienna 1952, p. 7) could be taken as a proof of Bruegel's having passed through this town which lies midway between Rome and Naples on the Via Appia. After seeing a good photograph of the drawing, I rejected the attribution to Bruegel (in *The Burlington Magazine,* CI, 1959, p. 345, n. 44), as also did Professor J. G. van Gelder and Ludwig Münz (*Bruegel. The Drawings,* London 1961, p. 231, No. A6). Professor Sir Anthony Blunt has drawn my attention to an engraving which is derived from the drawing. The engraving occurs in G. Braun and F. Hogenberg, *Urbium praecipuarum mundi theatrum quintum* (Cologne 1597), folio 62, and the direct preparatory drawing for it, now in the Albertina Collection, Vienna (O. Benesch, *Albertina . . . Die Zeichnungen der niederländischen Schulen,* 1928, No. 334), is by Joris Hoefnagel. He apparently made use of the San Diego drawing which has a more sketch-like character. It is hardly the work of Hoefnagel nor does it show any connection with the so-called Anonymus Fabriczy, to whom Münz tentatively ascribed it. An attribution to Cornelis Cort might perhaps be worth considering.

5 Bastelaer, *Estampes,* Nos. 1 and 2. These much discussed etchings were carefully re-examined by G. Glück, in *The Art Quarterly,* Summer 1943, pp. 167 ff.

repeated the inscriptions from the original drawings, although he seems to have been rather careless in the spelling of the name. Another print, the *View of Tivoli*, testifies to Bruegel's visits to the neighbourhood of Rome, and finally there is the drawing of the *Ripa Grande in Rome* (preserved at Chatsworth) which is the only Roman town view ascribed to Bruegel that has come to light so far.[1]

Bruegel's stay in Rome in 1553 is also confirmed in a rather unexpected way. We know from the inventory of his estate that Giulio Clovio, the celebrated miniaturist, owned a number of paintings and drawings by Bruegel. Among these was one which is described in the inventory as a miniature painted by Clovio in collaboration with Bruegel: '*Un quadretto di miniatura la metà a fatto per mano sua et altra da Mo Pietro Brugole*.'[2] We learn from this inventory entry that the renowned miniaturist who was held in high esteem by the great Italian patrons of his day and whom Vasari calls '*un piccolo e nuovo Michelagnolo*', a man who was by some thirty years Bruegel's senior, collaborated with the unknown young Fleming. Clovio had left Rome in 1551 to return only in 1553 and to remain there again for about three years. These dates agree perfectly with the period ascertained for Bruegel's stay in Rome from the two etchings. The contacts between the two men must have been very close. Not only have we the evidence of their direct collaboration, but also, according to the inventory, Bruegel painted a little picture of the *Tower of Babel* on ivory, which, as the necessarily small size of the material suggests, was a miniature, a type of work inspired by Clovio. Unfortunately none of Bruegel's paintings from Clovio's collection has come to light so far.

Among these lost pictures there was also one described as '*Un quadro di Leon di Francia a guazzo di mano di Mro Pietro Brugole*'. This was obviously a view of Lyons in France painted in watercolours and probably on linen, the technique of the Malines painters which Bruegel was also in the habit of using in later days. Confirming van Mander's account, this entry proves that Bruegel travelled to Italy via France and – this is perhaps more important – informs us that the

1 The claims by L. Münz, *op. cit.*, p. 234, No. A24, for Jan Brueghel do not seem justified. At most it might be conceded that Jan Brueghel added the foreground scene to an unfinished drawing of his father.

2 The last will and the inventory of Clovio were published in A. Bertolotti, *Giulio Clovio principe dei miniatori*, Modena 1882, p. 11. This inventory had been overlooked by Bruegel students until attention was drawn to it by Julius von Schlosser, in *The Burlington Magazine*, XLI, 1922, p. 198, and again in his collected essays, *Präludien*, Berlin 1927, p. 401. Tolnay, *Pierre Bruegel l'Ancien*, Brussels 1935, p. 9, was the first to draw conclusions from it for Bruegel's biography.

earliest painting of Bruegel, of which we here have definite, if indirect knowledge, was a landscape. And as a landscape painter Bruegel also appears in his earliest signed and dated painting so far known (Plate 2). All other paintings by Bruegel possessed by Clovio were likewise landscapes (among which we can include the *Tower of Babel*), and it may not be too bold to suggest that in the painting jointly produced by the two artists the figures were by Clovio and the landscape by Bruegel.[1]

As a landscape painter Bruegel went to Italy and on the return journey his passion for landscape, in particular the interest in the strange world of the high mountains, may have been the reason for his long wanderings in the Alps. Several of his works enable us to map, at least partly, his curious zigzag route. A drawing of the *Ticino Valley South of the St. Gotthard*,[2] a lost painting of the *St. Gotthard* that once belonged to Rubens and that may have inspired Joos de Momper's painting of the same region, now in Vienna, a drawing inscribed 'Waltersspurg'[3] which was recently identified as a view of Waltensburg on the Vorderrhein, in the Swiss canton of Graubünden, to the north-east of the St. Gotthard,[4] clearly indicate the route taken by Bruegel. He must have entered the mountain region near Lago Maggiore. If the course he pursued is not the usual one for travellers from Italy to the Netherlands, we find him later deviating even further from the ordinary route. For instead of following the Rhine down to Lake Constance and from there to the west, he continued his mountain wanderings and turned east, into the Tyrol where he went at least as far as Innsbruck, as we learn from his drawing of the *Martinswand*, a mountain near Innsbruck.[5] If several more of the many mountain drawings are identified, it will be possible to trace the route in greater detail.

1 A miniature of a *Stormy Harbour with Many Boats* in the lower border of a *Last Judgment*, folio 23 of the Towneley Lectionary (Public Library, New York), one of the major MS. volumes decorated by Clovio, has recently been attributed to Bruegel by Charles de Tolnay (in *The Burlington Magazine*, CVII, 1965, pp. 110 ff.), who also, though less confidently and less convincingly, ascribes to him some other border miniatures in the Towneley Lectionary.

2 In Dresden; Tolnay, *Drawings*, No. 18.

3 At Bowdoin College, New Brunswick, Maine, U.S.A.; Tolnay, *Drawings*, No. 16.

4 By O. Benesch, *loc. cit.*

5 In Berlin; Tolnay, *Drawings*, No. A4. Tolnay, who has identified the mountain as the Martinswand, thinks, in my view wrongly, that this is only a copy after a lost drawing by Bruegel, and Münz, *op. cit.*, p. 232 f., No. A16, attributes it to Roeland Savery and doubts that the Martinswand is represented here. Michael Auner, in *Jahrbuch der kunsthistorischen Sammlungen in Wien*, LII, 1956, p. 75, n. 115, queries, with insufficient arguments, most of the identifications suggested by Tolnay and Benesch, and thinks it more probable that both on the way out and on the return journey Bruegel took the same western route, via France. This view does not take into account the important eastern route over the Alps and via Munich chosen by other Netherlandish artists such as Joris Hoefnagel or Hendrick Goltzius.

No drawings or other documents throwing light on the further stages of the return journey have been discovered, nor can we say when exactly Bruegel arrived back at Antwerp. As the work with and for Clovio suggests a somewhat prolonged stay in Rome and as the mountain drawings made on the way home differ greatly in style from the dated drawings of 1552 and 1553, we can safely accept the date 1554 for these drawings and for the journey. Since it is most unlikely that Bruegel would have risked the then very hazardous crossing of the Alps in winter, we can even narrow down that date to the time between spring and autumn of 1554 (which is also confirmed by the character of the vegetation in these drawings). In 1555 he was certainly back and working on the designs for the *Large Landscape Series* which Cock was about to publish. The one preparatory drawing for this series that has come down to us and is preserved in the Louvre, is dated 1555.[1]

The dated works of the next year - drawings and engravings - show a surprising change of subject: Bruegel turns to figure compositions in which the landscape plays no part at all or only a very subordinate one, to didactic, satirical or religious subjects - often of a fantastic character - which earned him the title of a successor of Hieronymus Bosch. Significantly enough the first of these, *Big Fish Eat Little Fish*, was published by Cock with the inscription: '*Hieronymus Bos inventor*' (Bastelaer, *Estampes*, No. 139).[2] Bruegel continued to work for Cock until his last year.

It is only in 1557 that the series of extant dated paintings of the post-Italian period sets in, with the *Parable of the Sower* (Plate 5), which, however, does not mean that he did not produce any paintings between 1555 and 1557. Actually the Brussels *Adoration of the Kings* (Plate 4), which is hard to date, can best be inserted in this early period. From that time until his death Bruegel was engaged in the double activity of a painter and a designer for engraving. We have dated works for each year until 1568, though no undoubted paintings

1 Tolnay, *Drawings*, No. 23.

2 The original drawing by Bruegel, fully signed and dated 1556 (Tolnay, No. 74), which may in fact be based on a design by Bosch, is in the Albertina, Vienna. In another engraving of the same subject after Bosch, issued by the publisher Jan Tiel (Hollstein, *Dutch and Flemish Etchings . . .* , III, p. 139, No. 22) the motifs shown in Bruegel's drawing form only part of a more elaborate composition. Another engraving after Bosch published by Cock for which Bruegel may have supplied a drawing is possibly the *Last Judgment* (Hollstein, III, p. 131, No. 7).

bearing the dates 1558 and 1561 have come to light so far. But within this period we notice a shift of emphasis. Generally speaking, his interest seems to have centred in the prints until roughly 1562. After that date, in spite of continued and most important contributions for Cock's engravers, he seems to have devoted his energy mainly to painting, and within this period it is only in his last years, from c. 1565, that he finds in the representation of peasant life the best medium for the expression of his ideas.

To some extent the preponderance of painting from c. 1563 may be accounted for by the unavoidably less close contact with Cock after Bruegel's move to Brussels, where, according to the marriage registers of Notre Dame de la Chapelle,[1] he married Mayken, the daughter of Pieter Coeck and Mayken Verhulst, in 1563. As we know, van Mander suggests that Bruegel's mother-in-law insisted on his leaving Antwerp, because she wished him to break completely with a girl with whom he had kept house there. Recently it has been said that the wedding was only an excuse for what was principally a flight from Antwerp, where Bruegel may have been in fear of persecution, as he was possibly a member of a heretical sect, the so-called Family of Love.[2] But unless we assume that he was seized with panic before he was so much as suspected, it is hard to understand why he should have sought refuge in Brussels, the seat of the central powers and certainly an even more dangerous place for heretics than Antwerp.

However that may be, before moving to Brussels, he was probably away from Antwerp for some time in 1562, as a few drawings (at Besançon and Boston, Mass.)[3] of the *Towers and Gates of Amsterdam* (a city then staunchly supporting the Catholic cause), dated 1562, even though they are not direct nature studies, seem to point to a stay in that city.

At the latest after his arrival in Brussels, but more probably also earlier, Bruegel must have enjoyed the patronage of the most powerful man on the Catholic side, Cardinal de Granvelle, for Granvelle left the Netherlands early in 1564 and the *Flight into Egypt* (Plates 60-62), the one extant painting by Bruegel that we can trace with certainty to Granvelle's collection, is dated 1563.

1 Bastelaer – Hulin de Loo, *op. cit.*, p. 113.
2 Tolnay, *Pierre Bruegel l'Ancien*, p. 10.
3 Tolnay, *Drawings*, Nos. 41–43.

The second great contemporary patron of Bruegel, Niclaes Jonghelinck, residing in a palatial house in Antwerp, had among his sixteen pictures by Bruegel a *Tower of Babel* (probably the larger version dated 1563, Plates 50, 52-54, 56), and a *Procession to Calvary* (probably the Vienna picture of 1564, Plates 63-74). He continued to favour the artist after his move to Brussels and commissioned the series of the *Months* (1565), of which only five panels are known to survive (Plates 79-109). He was a brother of Jacques Jonghelinck, the sculptor who stood high in Granvelle's favour and even had a workshop in an annexe to his patron's palace in Brussels. To the sculptor Bruegel may have owed the connection with Niclaes Jonghelinck as well as with the cardinal.

We know of two close friends Bruegel left behind in Antwerp: Abraham Ortelius, the great geographer, and the merchant Hans Franckert, a native of Nuremberg, who was entered in the lists of the guild of St. Luke in Antwerp in 1546 and who, according to van Mander, was not only an intimate friend but also, like Ortelius, a patron of the artist. Unfortunately we have no further information about Franckert.

In Brussels, where he produced his late and greatest works, Bruegel was also held in high esteem. The Brussels City Council commissioned him to commemorate in some pieces ('*stucken*', according to van Mander, which could refer either to paintings or to cartoons for tapestries) the digging of the Brussels-Antwerp Canal which had been completed in 1565. But his death on September 9, 1569, prevented or interrupted the execution of the commission, news of which, incidentally, we have only from van Mander.[1] Bruegel was buried in Notre Dame de la Chapelle in Brussels, the church in which he had married Mayken Coeck. She survived him by nine years. After her death their two sons, both of whom became themselves painters and fathers of painters, Peter, born in 1564, and Jan, born in 1568, were taken care of by their grandmother

1 Henri Hymans, in the notes to his French translation of van Mander's *Schilder-Boeck* (Paris 1884, I, p. 303, n. 8) tentatively connects with this commission a painting sold by auction in Amsterdam on May 6, 1716: 'A View of the Scheldt with the Barge of Brussels, full with people,' by Breugel (G. Hoet, *Catalogus of Naamlijst*, I, 1752, p. 197: '65. *De Heu gelade met volk, zeylende in de Schelde na Brussel, van Breugel*'). Hymans adds rather diffidently the question whether this was really a painting by Pieter Bruegel the Elder. As the picture fetched only twenty guilders and the catalogue speaks only of 'Breugel' without any Christian name and finally as the subject agrees well with paintings by Jan Brueghel, I think it more likely that this was one of the small paintings by Jan Brueghel, or even by his son Jan Breughel II. On the other hand, a picture which apparently shows the actual digging of the canal recently turned up on the London art market. It seems to have been inspired by the lost composition which, judging by this copy or imitation, may have been further advanced than van Mander's account would lead us to expect.

Mayken Verhulst, who, we remember, also instructed Jan in the art of water-colour painting. Over the tomb of his parents Jan later erected an epitaph that was adorned with a painting of *Christ giving the Keys to St. Peter* by Rubens, who was a friend of Jan and a great admirer of Pieter Bruegel the Elder.[1]

1 Various documents published and discussed at length by A. Monballieu in *Handelingen van de Kon. Kring voor Oudheid-kunde, Letteren en Kunst van Mechelen*, LXVIII, 1964, pp. 92 ff., throw some new light on Bruegel's early years, add to the known *oeuvre*, and confirm in an unexpected way Glück's thesis of Bruegel's relationship with Malines, which I have supported with additional arguments in the *Encyclopedia of World Art*, II, 1960, pp. 631 ff. (article on Bruegel) and which is to be elaborated in the catalogue volume. According to the new documents, which range in date between 1550 and 1608, the Malines glovers' guild commissioned an altarpiece for the church of St. Rombout in 1550. The work, which was to be completed by October 11, 1551, was contracted with Claude Dorizi and the artists working on it in Dorizi's shop at Malines were Pieter Baltens (a member of the Antwerp painters' guild who had become a master in 1540) and Pieter Bruegel. The centre part was done by Baltens; the contribution of Bruegel was limited to the wings. As the altarpiece is lost, it is not clear whether, in addition to the grisailles on the outside of the wings, Bruegel also painted the inner sides, or whether this was done by Baltens. Nor do we know whether the altarpiece, to which some additions were made in 1556, was in fact delivered on the date stipulated. If this was the case, the grisailles represent the earliest recorded work of Bruegel, done before he was admitted as a master to the Antwerp painters' guild. This happened when Gommaer van Eerenbroeck and Kerstiaen van den Queeckborne were deans, *i.e.* between October 1551 and October 1552.

21

Bruegel and the Critics

JAN VAN EYCK, Pieter Bruegel the Elder and Rubens appear to our time as the three dominant figures of Flemish painting. Van Eyck and Rubens have constantly been recognized as the greatest Flemish artists of their periods and their fame has, on the whole, remained unaffected by the fluctuations of taste. The story of Bruegel's reputation is different: it is more chequered and more complicated.

His greatness, it is sometimes thought, has been discovered only in the twentieth century. This seems, however, too pretentious a claim. We could say in fairness that certain aspects of his art have only been revealed to our time, but otherwise we should rather speak of a rediscovery, after an admittedly long interval of neglect and misunderstanding, and remember that the impact of Bruegel's art on his contemporaries and the two or three succeeding generations was a very strong one. In fact they showed their interest in more than one way. His works were copied and imitated, collected and praised though, it is true, from the start they seem to have provoked a variety of reactions and interpretations. However, the fact that it has lent itself to more than one interpretation, and that from the rich mine of his creations many different ores could be extracted by later artists, is in itself a tribute to the inexhaustible wealth and complexity of Bruegel's art. A survey of the varying reactions it has called forth down to the present day is therefore not just one more contribution to the study of the tides of fashion but, revealing the immense range of Bruegel's art from the reflections in the observers' minds, it is a profitable approach to the work itself.[1]

The interest of contemporary collectors in Bruegel's paintings is the earliest tribute paid to his art. Several of his first patrons are known to us, to some of them we have already referred shortly. They acquired the paintings probably directly from the artist or, like Niclaes Jonghelinck, may even have commissioned some of them. They were all men of great discrimination, prominent in one field or another.

[1] A short survey of the varying interpretations of Bruegel, somewhat different from our approach to this question, has been given by Edouard Michel, in *Gazette des Beaux-Arts*, 1938, I, pp. 27 ff., and more recently, with some additional examples, by Hans-Wolfgang von Löhneysen, *Die ältere niederländische Malerei. Künstler und Kritiker*, Eisenach and Kassel 1956, pp. 141 ff., and *passim*.

Of these the Archbishop of Malines, Cardinal Antoine Perrenot de Granvelle, the trusted adviser of Philip II of Spain and until 1564 President of the Netherlands Council of State, owned the most splendid collection, indeed one of the most representative ones of his time. A highly cultivated diplomat and statesman, he was in constant contact with artists and men of letters, whom he assisted in many ways. Collecting on a truly international scale, he assembled in his residences in Brussels, Malines and Besançon paintings by the foremost Italian, Flemish, Dutch and German artists, in addition to sculpture, medals, tapestries and other works of art. He apparently valued Bruegel's paintings very highly, for when the archiepiscopal palace at Malines was sacked during the disturbances of 1572, his main concern seems to have been for the lost paintings by Bruegel, for the recovery or replacement of which he gave special orders, as we can deduce from a letter written in reply to the cardinal's order. We also learn from this letter that after Bruegel's death his pictures were more sought after than ever and had greatly risen in price.[1] Unfortunately we do not know which pictures Granvelle lost in 1572 and whether he succeeded in recovering them. As already stated, of Bruegel's extant paintings only the *Flight into Egypt* (Plates 60-62) has been traced with certainty to Granvelle's collection.

We do not know whether Bruegel had another patron in his lifetime of the same high social standing, though Niclaes Jonghelinck, who owned sixteen of Bruegel's paintings, was a most renowned connoisseur, linked with the cardinal through his brother, the sculptor Jacques Jonghelinck. Together with twenty-two works of Frans Floris - among them the famous *Labours of Hercules*, now lost - and a picture by Dürer, the sixteen Bruegels were pledged as a surety for sixteen thousand florins by Jonghelinck to the city of Antwerp on February 21, 1566 (1565 O.S.).[2] We see here Bruegel taking his place as an equal at the side of a great old master and of the artist who in his time was the most celebrated painter in Antwerp.

We cannot say how many of Bruegel's works were owned by his friend, the famous geographer and humanist Abraham Ortelius. Like his younger

1 Charles Piot (ed.), *Correspondance du Cardinal Granvelle*, IV, Brussels 1884, p. 524, letter dated December 9, 1572. The letter is also referred to and reprinted in Tolnay, *Pierre Bruegel l'Ancien*, p. 62.

2 J. Denucé, *The Antwerp Galleries. Inventories of the Art Collections in Antwerp in the 16th and 17th Centuries*, Antwerp 1932, p. 5. A more accurate transcription of the document has been published by Carl van de Velde in *The Burlington Magazine*, CVII, 1965, p. 123.

friend, the painter Joris Hoefnagel, he may have possessed drawings by Bruegel, but he owned at least one of Bruegel's paintings, the *Death of the Virgin* (Plate 77), and this grisaille must have meant a great deal to him, as he had it reproduced in an engraving for presentation to friends.

Finally, we remember, as early as in the sixteenth century, we find paintings and drawings by Bruegel even in Rome. Six of the paintings were in Giulio Clovio's estate in 1577. They do not seem to have come to light so far, but they were obviously early works, the earliest we know of, which the older artist, who was later to become the protector of Bartholomaeus Spranger, another Flemish artist, had prized highly enough to preserve them.

Since in his mature years Bruegel does not seem to have produced altarpieces for churches or other works for generally accessible places and indeed appears to have painted almost exclusively for friends and collectors, only such men as these, and the few who were privileged to share in their enjoyment, were familiar with Bruegel the painter. To a larger public he was known above all as the author of satirical, moralizing or fantastic prints, as the best among several other artists who reverted to the subjects and partly also to the style of Bosch - in fact he appeared as a latter-day Hieronymus Bosch. If generally prints reach a wider public than paintings and Bruegel's no less than Dürer's or Schongauer's and, to some extent, also Holbein's reputation rested on them, it was the subject-matter of Bruegel's engravings, their literary content, which also appealed to the learned bookmen and humanists of the time. It is therefore not surprising to find Bruegel described as a second Hieronymus Bosch by the first writers who refer to him, Ludovico Guicciardini, in his *Descrittione di tutti i Paesi Bassi* (1537), and Dominicus Lampsonius, in *Pictorum aliquot celebrium Germaniae inferioris effigies* (1572), a little volume of engraved artists' portraits published by the widow of Hieronymus Cock, to which Lampsonius contributed laudatory verses (Frontispiece).

Bruegel is also coupled with Bosch, though in a rather confused way, by Vasari in the second edition of his *Vite de' piu eccellenti Pittori, Scultori e Architettori* (1568), in which the short notes on the artists of the Netherlands are derived from Guicciardini's *Descrittione* and from communications sent by Lampsonius. If these references are very scanty, the detailed descriptions of several prints after Bruegel's designs (significantly following upon the dis-

24

cussion of a print after Bosch and with the artist's name here not given) show that the prints reached Italy very shortly after they had been produced and also that the Italian literati were impressed by them.

It is perhaps surprising that Lampsonius who, one would expect, was better informed about Flemish artists than either Vasari or Guicciardini, confined himself to repeating the popular verdict, which was based only on part of Bruegel's output. An explanation might be that living at Liège, outside the Netherlandish Provinces, he may have known of Bruegel's paintings in Antwerp and Brussels collections, but may not have seen them, and that he may have preferred to judge the artist only by the prints, works he had easily at hand. However that may be, though in his *Life of Lambert Lombard* (1565) he gives a knowledgeable and unconventional account of the Liège artist's work and ideas, known to him intimately through close personal contact, the verses in the *Pictorum aliquot effigies* of 1572 are not distinguished by great originality, and he certainly intended to bestow high praise upon Bruegel by comparing him with and even placing him above Bosch. Characterizing Bruegel as an artist who in his ingenious flights of fancy (*ingeniosa somnia*) followed and surpassed Bosch and who excelled in humorous inventions, full of wit (*ridiculo salibusque*), Lampsonius provided a cliché that later writers gladly took over from the widely read book.

Rather different is the picture of Bruegel drawn about the same time by his personal friend Abraham Ortelius, who in his *Album Amicorum* (preserved in Pembroke College, Cambridge) honoured his dead friend by a memorial notice composed in the form of a fictitious epitaph, a literary device popular with the humanists.[1] To the present-day reader the abundant use of quotations from authors of classical antiquity may seem a rather ostentatious display of erudition, but even if he is not familiar with the literary conventions of that time, he cannot fail to recognize in this *cento* a deeply felt personal tribute, a most exalted appreciation of the artist, not of the private person, who is in fact ignored. There is not a word about Bruegel's humour, nor is there any refer-

[1] Attention was first called to this epitaph by Popham, *op. cit.* It has been reprinted in extenso in Tolnay, *Pierre Bruegel l'Ancien*, pp. 61 f. A new transcript, with a few slight corrections, will be published in the second volume of this book. A detailed analysis of the epitaph was attempted by the present writer in lectures delivered in the University of Utrecht and at the Koninklijk Oudheidkundig Genootschap, Amsterdam, in May 1953. The identification of the sources of Ortelius, which formed the basis of this analysis, has since also been given in almost analogous form by Auner, *op. cit.* pp. 119 ff.

ence to his relation to Bosch. Ortelius compares Bruegel with the greatest artists of antiquity and sees in him the most perfect painter of his age (*pictorem sui seculi absolutissimum*). There are several more artists' epitaphs in Ortelius' *Album Amicorum* but nothing comparable to the high praise he bestows on Bruegel is to be found in any of them. None of the others is held up as Bruegel is, as a model for other painters. Bruegel's only master, in Ortelius' view, was nature, nature which, like Apelles, he was able to show in his works even in such aspects as seem beyond the reach of the painter. Ortelius concludes by particularly praising Bruegel's truth to nature in his rendering of the human figure and by contrasting his attitude with that of other artists who by trying to make their figures appear more graceful deviate from their models as well as from true beauty. This attack on other artists is clearly meant as a defence against classicist 'academic' critics of Bruegel. In Ortelius' analysis there is no room for description of Bosch-like subjects or peasant scenes. It is the earliest attempt to characterize essential features of Bruegel's art: his interest in nature, which here obviously stands for landscape, and his conception of the human figure, which was so different from that of the Romanists.

In the half-century that followed upon Bruegel's death his popularity was constantly on the increase. Most copies and imitations of his compositions date from this period, and posthumously he now became, as it were, the head of that section of the Flemish School which, superficially at least, seemed to be guided by the principles Ortelius had claimed as characteristics of Bruegel's art. More and new collectors tried to secure for themselves original paintings by Bruegel. Among them Archduke Ernst, from 1593 until his death in 1595 Governor of the Netherlands, must have been a particular lover of Bruegel's art, considering the great number of his paintings he was able to acquire within two short years. After Ernst's death his art treasures, or at least part of them, fell to his brother, the Emperor Rudolph II, that most insatiable of collectors, who acquired paintings by Bruegel also from other sources. The greater part of this Bruegel collection has survived in Vienna, together with that of Archduke Leopold Wilhelm (d. 1662), another admirer of the artist among the princes of the House of Austria. With this unrivalled array of the master's paintings assembled in Vienna and with the rest of his work scattered far and wide and reposing in less well-known collections after the dissolution of the great Ant-

werp galleries in the second half of the seventeenth century, it became increasingly difficult in Western Europe in the eighteenth and nineteenth centuries to form a clear idea of Bruegel's art. This fact will have to be borne in mind when considering the attitude of these later centuries to Bruegel.

The late sixteenth and the seventeenth centuries certainly saw the climax of Bruegel's first period of popularity. Collectors in the Netherlands and in Italy were serious rivals of the Habsburg princes. A letter from Bruegel's son Jan to the Archbishop of Milan, Cardinal Federigo Borromeo, written in 1609, throws an interesting light on the situation. We learn from it that Jan has not been able to find a picture by his father for the cardinal, because the Emperor Rudolph II had spared no expense to obtain all the artist's works. Jan Brueghel could offer the cardinal only a picture he owned himself, the grisaille of *Christ and the Woman Taken in Adultery* (Plate 78). Two of Bruegel's late paintings, the *Parable of the Blind* (Plates 147-151) and the *Misanthrope* (Plate 146), belonged to another Italian collector, Count G. B. Masi at Parma, by 1611 when they were confiscated from him by the Farnese. It goes without saying that the Antwerp patrons of art were the first in the field together with and after the Habsburg princes, but it must suffice here to mention only the two greatest Bruegel collectors of Antwerp: Rubens, who owned eleven or twelve, and Peter Stevens (died 1658), who had eleven of Bruegel's paintings[1].

If a number of pictures by Bruegel reached the Northern Netherlands at an early date, the fact that among them were *Peasant Weddings* and *Kermesses* (in the collections of Herman Pilgrims and Willem Jacobsz in Amsterdam) has some bearing on the later appreciation of Bruegel. These peasant pieces were the most easily accessible amongst the artist's works for Carel van Mander, living in nearby Haarlem, who in fact in his *Schilder-Boeck* does not list any other paintings by Bruegel in Dutch collections.

Van Mander's biography of Bruegel, in the *Schilder-Boeck* published in 1604, thirty-five years after Bruegel's death, is the first coherent account of the artist's life and work, a source of the first order which by the facts related and by the opinions expressed has influenced the judgement of Bruegel down to the

1 The Earl of Arundel, the greatest and most discerning English collector and connoisseur in the seventeenth century, owned a number of works by Bruegel, but none of these can be identified with certainty with any of the surviving paintings.

present day and which on account of its importance we have placed at the beginning of this volume.

Van Mander certainly tried to obtain as much accurate information as possible on the artists whose lives he wrote but, like Vasari, he did not hesitate to enliven his narrative by amusing anecdotes which, while often not literally true, can be accepted as an indirect and easily remembered comment on an artist and as an attempt to make certain aspects of his art clearly visible. Further, a similar anecdote might be told of two different artists, when van Mander found some features their art had in common. The anecdote then almost acquired the value of a quotation, a literary device which was so popular with the writers of van Mander's time.[1]

Van Mander was not content with simply reproducing Lampsonius' concise characterization of Bruegel as an artist of great wit and humour who followed Bosch in his fantastic subjects, but, embroidering on Lampsonius' short epigram, he not only bestowed the nickname Pieter the Droll on the artist but related that Bruegel was ready with all sorts of jokes when in the company of others and that he liked to frighten people with all kinds of spooks. At the same time the contradictory remark that Bruegel was a quiet and thoughtful man who was not fond of talking rings true, for the very fact that it contradicts the other statements, and may well go back to some direct information about Bruegel. In speaking of Bruegel as a man ready with jokes etc., van Mander transferred to the characterization of the man what he found in his work – as we are still fond of doing. Similarly he was inspired by the peasant pieces, which he knew best of all Bruegel's paintings, to explain the artist's interest in and understanding for the peasants and their doings by postulating a peasant origin for him, to turn the painter into a man of peasant stock, born in a little Brabant village, and though he did not go into details about Bruegel's peasant childhood, Vasari's stories of Giotto's and other artists' early shepherd days which made the later achievements appear even greater must have been at the back of his mind.

When, further elaborating on the peasant theme, van Mander describes how Bruegel went to country weddings and fairs in order to watch the peasants eat

1 For the significance of legends told about artists generally *cf.* Ernst Kris and Otto Kurz, *Die Legende vom Künstler*, Vienna 1934.

and drink and dance and caper and how he rendered everything he had observed skilfully in his paintings – when we read this passage, we are aware of a description of Bruegel's paintings turned into the lively narrative of an anecdote, and at the same time we cannot help suspecting that this anecdote was inspired by Leonardo's advice to artists to watch persons in real life, to observe their attitudes, the way they were talking, arguing, laughing or fighting and to note all this down for later use in painting.[1] In van Mander's time, it is true, Leonardo's *Trattato della Pittura* was not yet available in print, but it was not too difficult for a man of van Mander's interests to gain access to one of the several transcripts of Leonardo's notes which were being circulated in the sixteenth century. Van Mander was directed to Leonardo's writings, I think, by Vasari as well as by Lomazzo, whose *Trattato dell' Arte de la Pittura* (1584) contains so many references to Leonardo and among these also the curious story of Leonardo arranging a peasants' banquet and making his guests laugh by all sorts of jests and jokes in order to study their expressions, a story that also has the appearance of a transformation of Leonardo's recommendation into an anecdote.[2] That the incident reported, or invented, by Lomazzo was the model for van Mander's account of Bruegel's observation of peasants is all the more probable, as it agrees so well with his remarks about Bruegel being ready with jokes in the company of other people whom he could make laugh as well as frighten by his behaviour. Van Mander's, and Lomazzo's, intention is, of course, to impress upon the reader that Bruegel's, and Leonardo's, art is based on observation and how true to nature it is.

Thus, in his way, van Mander says essentially the same about Bruegel's figures as Ortelius, and in his interpretation of the landscapes he again agrees with Ortelius, using instead of Ortelius' abstract and erudite characterization the unforgettably vivid and pregnant phrase which like the anecdotes, but even superior to them, has the power to transform a pale abstraction into something tangible and concrete: 'When he travelled through the Alps, he swallowed all the mountains and rocks, and spat them out again, after his return, on to his canvases and panels, so closely was he able to follow nature here and in her other works.'

1 Leonardo da Vinci, *Trattato della Pittura*, ed. H. Ludwig, Vienna 1882 (Eitelberger's *Quellenschriften für Kunstgeschichte*, XV–XVIII), §§. 173 and 179.
2 Giovanni Paolo Lomazzo, *Trattato dell' arte de la Pittura*, Milan 1584, pp. 106 f. Professor E. Gombrich was the first to observe the similarity of Lomazzo's and van Mander's anecdotes and has kindly communicated his observation to me.

In this way Lampsonius' interpretation was greatly enriched by van Mander, for whom Bruegel was more than just a clever imitator of Bosch. How greatly van Mander admired Bruegel as an artist one can see in the theoretical part written in verse that precedes the artists' lives in the *Schilder-Boeck*. Here, when discussing colour, expression of emotions, composition of landscapes, van Mander extols Bruegel's paintings and recommends them as models for other artists.

But this theoretical introduction was no easy reading and was indeed very little read when van Mander's ideas on art had lost their topical interest. The biographies, on the other hand, with their lively anecdotes retained a popularity equal to that of Vasari's *Lives* and were repeated over and again by later writers. Thus, to mention just one famous example, Joachim van Sandrart's *Teutsche Academie* (1675) contains nothing but a literal though shortened translation of van Mander's life of Bruegel. Actually until the late nineteenth century few critics had anything relevant to add to van Mander's picture of Bruegel. The anecdotes were taken literally and the droll and peasant label stuck to the artist most successfully. To be fair, however, it should be recalled that in the West it was difficult to form an opinion of one's own after so many of Bruegel's paintings had been removed to Austria and after the great Bruegel collections of such distinguished seventeenth-century virtuosos as Rubens, Lord Arundel and Peter Stevens had been dispersed and the paintings had disappeared from view into many minor collections. This fact explains, at least partly, the lack of discrimination in the eighteenth century, when the numerous copies and imitations which preserved the subject-matter, but not the pictorial qualities of the originals, were easily mistaken for works by Bruegel himself. In his *Vie des Peintres Flamands, Allemands et Hollandais* (volume I, 1753) Jean Baptiste Descamps, basing his judgement probably on such inferior productions, allotted to Bruegel, while otherwise praising him in van Mander's terms, a secondary place after David Teniers the Younger,[1] whose pleasanter

1 Michel, in *Gazette des Beaux-Arts, op. cit.*, p. 29, erroneously attributes the comparison of Bruegel with Teniers – a view which was unlikely to be held in the seventeenth century – to Sandrart, basing his observation on the Sandrart edition of J. J. Volkmann, Nuremberg 1768, in which the comparison with Teniers is an interpolation of the editor who is clearly indebted to Descamps. The very high esteem in which Bruegel was held in the seventeenth century is also evident from Robert Herrick's poem *To his Nephew, to be prosperous in his art of Painting* (*Hesperides*, 1648, F. W. Moorman ed., Oxford 1915, p. 150) where he ranks Bruegel with the greatest artists such as Holbein, Raphael, Rubens and others.

interpretation of the peasant agreed better with the spirit of an age in which decorous academic critics such as Roger de Piles, in his famous *balance des peintres* (in *Cours de peinture par principes* 1708), simply ignored Bruegel.[1] Nor does Sir Joshua Reynolds mention Bruegel in his *Discourses*, in which he extols the great old masters whom he sets up as eternal models for the painter, though in his *Journey to Flanders and Holland in The Year MDCCLXXXI* he acknowledges what we would now call Bruegel's power of imagination: 'This painter was totally ignorant of all the mechanical art of making a picture; but there is here [in the *Massacre of the Innocents*] a great quantity of thinking, a representation of variety of distress, enough for twenty modern. In this respect he is like Donne as distinguished from the modern versifiers, who carrying no weight of thought, easily fall into that false gallop of verses which Shakespeare ridicules in AS YOU LIKE IT.'[2] (The picture which caused these remarks was only a copy after Bruegel's composition, though Sir Joshua was not aware of it.) This is a grudging acceptance of Bruegel, whose qualities are for Reynolds the qualities of the 'primitives'. Reynolds certainly agreed with Descamps in placing Bruegel below Teniers, as he greatly admired 'the elegance and precision of pencil so admirable in the works of Teniers' (*Sixth Discourse*). If such views were typical of the eighteenth century, and indeed became a cliché, curiously enough they never affected Bruegel's standing as a master of landscape. As a matter of fact, his reputation in this field, mainly based on the *Great Landscape Series* published by Hieronymus Cock, was constantly on the increase from his own time right into the nineteenth century. Lomazzo, who in his *Trattato dell' Arte de la Pittura* (1584) included Bruegel in his list of Netherlandish artists who excelled in landscape, must have been familiar with this series, as certainly was van Mander, who, however, also knew some of Bruegel's landscape paintings, and in his *Miniatura*, written in 1649, Edward Norgate states explicitly that the 'many strange yet very beautifull viewes' [in the Alps] 'most of which have been very well designed after the Life by Peter Brugell . . . remain in *stampe* to his great Comendation.'[3] It was, however,

1 In his *Abrégé de la Vie des Peintres*, Paris, 1699, pp. 373 f., however, de Piles has some praise for Bruegel.

2 *The Works of Sir Joshua Reynolds, Knt.* (ed. Malone), London 1797, II, p. 112. In his appreciation of the *Massacre of the Innocents* Reynolds seems to have been influenced by what van Mander had said about this composition.

3 Edward Norgate, *Miniatura or the Art of Limning*, ed. by Martin Hardie, Oxford 1919, pp. 43 f. *Miniatura* is an enlargement and revision of a MS. of about 1625. *Cf.* also H. V. S. Ogden and M. Ogden, *English Taste in Landscape in the Seventeenth Century*, Ann Arbor 1955, pp. 13 and 32.

only some hundred years later that Pierre-Jean Mariette, the foremost con-
noisseur of the eighteenth century, who no doubt also knew the engravings,
fully discovered the greatness of Bruegel's landscape drawings. He discussed
them in the carefully prepared sale catalogue of the celebrated Crozat Collec-
tion (Paris 1741), and his sharp eye even detected their indebtness to Venetian
art.[1] But it was only about 1831, towards the very end of his life, that one of the
greatest eighteenth-century figures, Johann Wolfgang von Goethe, basing
his judgement again on the engravings, and apparently independent of earlier
writings, attributed to Bruegel an important role in the development of Euro-
pean landscape painting and found in his landscapes 'the serious character of the
sixteenth century.'[2]

If the eighteenth century, otherwise unable to see the difference in stature
between Bruegel and his followers, only knew about the master from the
prints and van Mander, there was still, for this very reason, a certain aura of
renown attached to his name and especially to his paintings in the Imperial
collection, several of which van Mander had described. When in 1809 the
French carried away from Vienna the most important paintings they could lay
hands on, the opportunity was not missed to take also several of the Bruegels
to Paris and to include them in the grandiose display of European art arranged
there at the orders of Napoleon. All the Bruegels were, however, later again
returned to Vienna, except for one which is now in New York (Plates 99-103)
and which the French commander in Vienna, Count Andreossy, who also
owned a collection of Bruegel drawings, had kept for himself. Apart from the
special attraction of the great accumulation of paintings glorified by van
Mander, the renewed interest in Bruegel, to which the events of 1809 testify,
may to some extent also have been due to the new and positive attitude to the
Middle Ages and late Gothic and the new historical conception generally which
characterize the Romantic Movement. The early Netherlandish School, the
'primitives', gained increasingly in popularity. Bruegel was seen as one of the
primitives - and for some critics who were not aware that his so-called

1 It is possible that in his judgment of Bruegel, as in many other cases, Pierre-Jean Mariette was indebted to his father
Jean Mariette (1660–1742), who owned a fine collection of prints after Bruegel (see Hélène Adhémar, *Watteau. Sa vie,
son oeuvre*, Paris 1950, p. 69, n. 2).

2 Johann Wolfgang von Goethe, *Landschaftliche Malerei*, published posthumously 1832 (*Werke*, Hamburg edition,
XII, p. 219). *Cf.* also Löhneysen, *op. cit.*, p. 150.

'archaism' was deceptive, and really concealed chosen stylistic principles which he deliberately adopted, he has remained a 'primitive' to the present day.

In the nineteenth century from the Romantic period onwards the emphasis was at first more on the droll and Bosch-like aspect with its literary connotations,[1] and here the best, and very personal, was said by Charles Baudelaire, who divided Bruegel's graphic oeuvre into two groups: the political allegories which are hardly decipherable for us, and - more important - what is usually called whimsical or fantastic, which for Baudelaire is rather a kind of mystery, the 'devilish pandemonium which can only be interpreted as a special case of satanic grace'.[2] Later the interest shifted to the genre elements in Bruegel's art,[3] but throughout this period most critics described him as coarse and vulgar and saw in him only a minor master.[4]

With the last decade of the century a new chapter began in the history of Bruegel's posthumous reputation. Now at last an intensive and serious study of Bruegel's art set in, a brief survey of which may show how once more a dominant position was accorded to him, and may also help to focus attention on the problems Bruegel's art offers to the modern student.

The new chapter opened with the first careful and conscientious attempt to assemble and survey the whole oeuvre. On the one hand more was collected than appeared in van Mander's account, on the other dubious accretions to the oeuvre were excluded and Bruegel's place in the history of Flemish art was assessed anew. From this first critical study, undertaken by Henri Hymans in 1890–91,[5]

1 *Cf.* for instance Jules Renouvier, *Des Types et des manières des Maîtres Graveurs*, II, Montpellier 1854, p. 143.

2 '. . . que notre siècle, pour qui rien n'est difficile à expliquer, grâce à son double caractère d'incrédulité et d'ignorance, qualifierait simplement de fantaisies et de caprices, contient, ce me semble, une espèce de mystère . . . Or je défie qu'on explique le capharnaüm diabolique et drôlatique de Breughel le Drôle autrement que par une espèce de grâce spéciale et satanique. . . .' Baudelaire, 'Quelques caricaturists étrangers', first published in *Le Présent*, October 15, 1857, and *L'Artiste*, September 26, 1858, reprinted in his *Curiosités Esthétiques*, Paris 1868. Our quotation is from the edition of *Curiosités Esthétiques* by Jacques Crépet, Paris 1923, p. 445. An interesting analysis of Baudelaire's remarks on Bruegel was given by Ludwig Münz in *Alte und Neue Kunst*, III, 1954, p. 135 f.

3 Berthold Riehl, *Geschichte des Sittenbildes in der deutschen Kunst bis zum Tode Pieter Brueghels des Aelteren*, Berlin 1884, pp. 124 ff. Riehl was one of the first critics in the nineteenth century to allocate to Bruegel a place high above his Flemish contemporaries.

4 The view expressed by G. F. Waagen, *Handbook of Painting, The German, Flemish, and Dutch Schools. (Based on the Handbook of Kugler)*, London 1869, p. 233, is typical: 'He was the first who applied himself to the study of various forms of peasant life, and made it the chief subject of his art. His mode of viewing these scenes is always clever but coarse, and even sometimes vulgar.' Waagen devotes not quite a page to Bruegel and more than six pages to Teniers. On the other hand, an artist such as Jean François Millet (1814–1875), in Waagen's time still a controversial figure, did not hesitate to call himself, and with some justification, a follower of Bruegel.

5 Henri Hymans, 'Pierre Bruegel le Vieux', in *Gazette des Beaux-Arts*, 3rd period, III, 1890; IV, V, 1891, reprinted in Henri Hymans, *Oeuvres*, III, Brussels 1920, pp. 230 ff.

Bruegel emerged as a great and original artist who expressed most eloquently the spirit of his people and, unlike his Romanist compatriots, remained faithful to the old national tradition. These views were accepted by many later students and by 1902 the general climate of opinion was such that Alois Riegl could speak of Bruegel as an equal of Rubens and Rembrandt, as their precursor, and could maintain that Bruegel's work represented the point of departure not only for Flemish genre painting, but for all later non-religious Flemish painting.[1] In 1905 Bruegel's development was for the first time critically examined in greater detail, by Axel Romdahl, who compiled the first catalogue of the paintings he considered authentic.[2] Romdahl's paper was soon followed and partly superseded by the monumental catalogue raisonné of the painted oeuvre which Georges Hulin de Loo contributed to René van Bastelaer's large-scale biography and discussion of all Bruegel's works (paintings, drawings and engravings) published in 1907.[3]

For these scholars, as well as for Louis Maeterlinck, who linked Bruegel more strongly with the satirical tradition of his country,[4] Bruegel was above all the unique national artist of the sixteenth century, who in spite of his visit to Italy remained unaffected by Italian art. Van Bastelaer, in particular, tried to demonstrate how closely Bruegel's work mirrored the popular beliefs and customs of the Netherlands and he, as well as Hulin de Loo, were able to explain some compositions, or certain features within some compositions, as illustrations to proverbial sayings current in the Netherlands. (It may be added in parenthesis that the idea of Bruegel as essentially an illustrator, in a more general sense, has dominated the conception several modern critics have of his art.) It was quite in keeping with this picture of Bruegel as a national artist to attribute to him strong nationalist anti-Spanish sentiments, as in his days the tension between the Netherlandish Provinces and their Spanish masters developed into a violent and open conflict. One began to look for political allusions, which, in contrast to Baudelaire's opinion, one hoped to be able to decipher. Whether such an

1 Alois Riegl, 'Das holländische Gruppenporträt', in *Jahrbuch der Kunsthistorischen Sammlungen des Ah. Kaiserhauses*, XXIII, Vienna 1902, published as a book, Vienna 1931. The passages on Bruegel and the rise of genre painting on pp. 104 ff. of the 1931 edition.

2 Axel L. Romdahl, 'Pieter Brueghel der Ältere und sein Kunstschaffen', in *Jahrbuch der Kunsthistorischen Sammlungen des Ah. Kaiserhauses*, XXV, Vienna 1905.

3 René van Bastelaer and Georges Hulin de Loo, *Peter Bruegel l'ancien, son oeuvre et son temps*, Brussels 1907.

4 Louis Maeterlinck, *Le genre satirique dans la peinture flamande*, Ghent 1903.

approach is justified or not, it is understandable, as Bruegel's works seem to contain more than meets the eye, and this fact has also tempted students who disagree with the political interpretation to search for a hidden message in Bruegel's compositions.

Observations of this kind helped to undermine the tradition of Bruegel the peasant, created by van Mander and still accepted by Bastelaer, until at last in 1910 Gustav Glück[1] came to the decisive conclusion that Bruegel was a townsman, not at all the peasant whom van Mander had deduced from the portrayer of peasants. But above all Glück attempted to find an answer to the perplexing question why Bruegel's art differed so greatly from that of the contemporary Netherlandish Romanists, by trying to discover the formative influences Bruegel had undergone. While supporting the general view of Bruegel's indebtedness to Bosch, he suggested a connection in subject-matter, style and technique with the painters in water-colour or tempera on canvas, who represented a very strong tradition in the Netherlands, very much alive at Malines in Bruegel's time, and who were hardly affected by the current Italianizing fashion. A little later, in 1918, the problem of the origins of Bruegel's style was re-examined by Ludwig von Baldass for one particular field of his activity, for his landscape art,[2] in which he so greatly surpassed his contemporaries and which was seen with new eyes and with new curiosity after the nineteenth century's triumphs in this field. Baldass interpreted Bruegel's landscapes, while they were inspired by a new feeling for nature, as the culminating point of a tradition which could be traced back to Patenier.

In such studies as these, as well as in publications of a more popular character which were the consequence of the growing general appreciation of and interest in Bruegel's art, but particularly by the brilliant books and essays of Max J. Friedländer,[3] who never ceased to extol the master's greatness, Bruegel appeared as the last great representative of the early Netherlandish School, whose

1 Gustav Glück, *Peter Bruegels des Aelteren Gemälde im Kunsthistorischen Hofmuseum zu Wien*, Brussels 1910. (The introduction 'Bruegel und der Ursprung seiner Kunst' reprinted in Glück, *Aus drei Jahrhunderten europäischer Malerei*, Vienna 1933, pp. 151 ff.)

2 Ludwig von Baldass, 'Die niederländische Landschaftsmalerei von Patinir bis Bruegel', in *Jahrbuch der Kunsthistorischen Sammlungen des Ah. Kaiserhauses*, XXXIV, Vienna 1918.

3 In addition to many articles published in periodicals and to frequent references in various books especially in the following monographs: *Pieter Bruegel der Ältere*, Berlin 1904; *Von Eyck bis Bruegel*, Berlin 1915; *Pieter Bruegel*, Berlin 1921; *Pieter Bruegel* (*Die Altniederländische Malerei*, vol. XIV), Leyden 1937.

imagination, power of observation and understanding of man and nature raised him high above his Flemish contemporaries. If at the root of such an appreciation there is, though in sublimated form, van Mander's conception of the realist painter, and if here Bruegel is only seen as an important figure in Flemish painting, a different approach was attempted by Max Dvořák in a short essay, first published in 1921,[1] which put the study of Bruegel on a new basis.

Dvořák looked at Bruegel as a European figure.[2] His positive attitude to Mannerism, at which he arrived by a penetrating analysis of the general ideas affecting the religious conceptions, the philosophy and literature, as well as the art of the age, led Dvořák to value Bruegel as the greatest exponent of Mannerism in northern painting. With the examination of the spiritual basis of Bruegel's art he combined an analysis of the qualities of form which, looking more deeply into the causes of Bruegel's attitude to life and nature, he was not content to measure in terms of realism. Bruegel no longer appeared as the last of the Flemish Primitives, but was joined to his great contemporaries outside the Netherlands. Dvořák also showed, contrary to the then prevailing opinion, that Bruegel had not ignored Italian art, but had assimilated it into his work organically, not in the superficial, imitative manner of his Flemish contemporaries.

Dvořák's essay has borne rich fruit and has stimulated the further study of Bruegel in several ways. The conception of art history as history of ideas (*Kunstgeschichte als Geistesgeschichte*) has dominated some of the important contributions of Charles de Tolnay (Karl Tolnai) to the interpretation of Bruegel's works. In two books[3] and in several articles he elaborated Dvořák's suggestions and tried to define more precisely 'Bruegel's position in the development of the history of ideas'.[4] He finds in Bruegel's work not only, as Dvořák did, 'a general affinity, but a factual relationship with the universal-religious

1 Max Dvořák, *Pieter Bruegel der Ältere*, Vienna 1921. (Reprinted in Dvořák, *Kunstgeschichte als Geistesgeschichte*, Munich 1924, pp. 219 ff.)

2 This view is already implicit in Heinrich Wölfflin's approach to the master, as expressed in his *Kunstgeschichtliche Grundbegriffe*, Munich 1915 (English translation: *Principles of Art History*, London 1929).

3 Karl Tolnai, *Die Zeichnungen Pieter Bruegels*, Munich 1924. (The second revised and enlarged edition published in English as: *The Drawings of Pieter Bruegel the Elder*, New York and London 1952). – Charles de Tolnay, *Pierre Bruegel l'ancien*, Brussels 1935.

4 Tolnay, *Drawings . . . , op. cit.*, p. 49.

theism, of which the greatest representative in the Netherlands was the engraver and humanist Coornhert'.[1] Tolnay assumes that Bruegel was acquainted with Coornhert, and that he shared his religious convictions, that like Coornhert he was one of the 'Libertines who placed themselves above the individual confessions and raised themselves to the apprehension of one truth common to all'.[2] Tolnay interprets Bruegel's paintings of religious subjects in this sense and his bold aim is to *'pénétrer à la secrète pensée de l'artiste'*[3] to whom he attributes a pessimistic view of mankind, of the 'topsy-turvy world'. The momentous article in which A. E. Popham called attention to Ortelius' appreciation of Bruegel and, by showing the humanist contacts of the artist, definitely put an end to the legend of Bruegel the peasant,[4] was welcomed by Tolnay as a confirmation of his views and inspired him to paint in greater detail a portrait of Bruegel the humanist and Libertine philosopher. While one may have some doubts whether it is at all possible (or, indeed always relevant), in order to understand his artistic achievement, to reveal an artist's secret thoughts, Tolnay has certainly presented a coherent picture and has contributed new interpretations of many details, the further elucidation of which has also been attempted by other scholars whose careful research has led to convincing results.[5]

Trying, as it were, to look behind the pictures and seeing in them above all illustrations to the artist's philosophy Tolnay paid less attention to the problems of form (though he did not ignore them). On the other hand some more recent students of Bruegel have made these their main concern. Hans Sedlmayr, developing certain ideas of Dvořák, has tried to determine the basic conception of form underlying Bruegel's compositions and has described as an essential

1 Tolnay, *Drawings...*, *op. cit.*, p. 49.

2 *Ibid.*

3 Tolnay, *Bruegel ...*, 1935, *op. cit.*, introduction.

4 Popham, *op. cit.*

5 Only a few can be quoted here. Wilhem Fraenger, *Der Bauern-Bruegel und das deutsche Sprichwort*, Erlenbach-Zurich 1923. – Ludwig Burchard's contributions to the second (and all later) editions of Gustav Glück, *Bruegels Gemälde*, Vienna 1935 ff. – Jan Grauls, *De Spreekwoorden van Pieter Bruegel den Oude verklaard*, Antwerp 1938. – Grauls, in *Annuaire des Musées Royaux des Beaux-Arts de Belgique*, II, 1939, and in *Gentse Bijdragen tot de Kunstgeschiedenis*, VI, Ghent 1939–40. – J. G. van Gelder and Jan Borms, *Brueghels deugden en hoofdzonden*, Amsterdam and Antwerp 1939. (Borms also contributed many valuable interpretations to Glück, *Bruegels Gemälde*.) – Louis Lebeer, in *Gentse Bijdragen tot de Kunstgeschiedenis*, V, 1938; VI, 1939–40; IX, 1943. – Otto Benesch, *The Art of the Renaissance in Northern Europe*, Cambridge (Mass.) 1945; revised edition, London 1965. – D. Bax, *Ontcijfering van Jeroen Bosch*, The Hague, 1949. – Franzsepp Würtenberger, *Pieter Bruegel d.Ä. und die deutsche Kunst*, Wiesbaden 1957. – Jan Grauls, *Volkstaal en volksleven in het werk van Pieter Bruegel*, Antwerp and Amsterdam 1957. – Michael Auner, 'Pieter Bruegel. Umriss eines Lebensbildes' in *Jahrbuch der kunsthistorischen Sammlungen in Wien*, LII, 1956 (an interesting, though controversial contribution to Bruegel studies with various new ideas, but unfortunately marred by some fanciful conjectures which are presented as facts).

characteristic of Bruegel's art the tendency to simplify and to reduce the natural forms to elementary stereometrical shapes (globes, cones, cylinders, etc.), which has the effect of making familiar things look unfamiliar and strange. He thus explains as a positive quality what appeared to earlier critics as 'primitive' or 'archaic'.[1] While attaching only subordinate importance to the estranging effect of Bruegel's simplifications, Fritz Novotny[2] has elaborated the idea of elementary form, which in his view is also a characteristic of some other great artists,[3] and although he observes Bruegel's positive attitude to nature, he stresses the lack of true naturalism in the paintings of the Months (Plates 79-109), where for the first time in Western art landscape is given the rank of an independent subject. At the same time he shows them to be composite landscapes ('*Mischlandschaften*'), built up from motifs freely invented or observed separately in different places and fused into a coherent and convincing new whole.

Due regard for the formal aspect as well as an interpretation of subject-matter distinguish the very detailed discussion of each single picture which Gotthard Jedlicka has provided in the most extensive book on Bruegel published since Bastelaer's and Hulin de Loo's monumental work.[4] Here, too, Bruegel's place in relation to Renaissance and Mannerism is carefully considered. An examination of this problem, of which one has become aware only since Dvořák, has formed the subject of several studies, among which the most important is a book by Walter Vanbeselaere,[5] who, on the other hand, has felt it necessary to re-assert Bruegel's connection with the Netherlandish tradition after Dvořák's views of the importance of Italian art for Bruegel had found a resounding echo in a number of serious studies.[6] Recently Stridbeck, a Swedish scholar, who has also tried to reach by a conscientious iconographical examination, a precise definition of Bruegel's attitude to religion, his *Libertinism*,[7] has suggested that the Italian elements in Bruegel's later work are less the

1 Hans Sedlmayr, 'Die "macchia" Bruegels', in *Jahrbuch der Kunsthistorischen Sammlungen*, N.F. VIII, Vienna 1934.
2 Fritz Novotny, *Die Monatsbilder Pieter Bruegels d. Ä.*, Vienna 1948.
3 Fritz Novotny, 'Über das "Elementare" in der Kunstgeschichte', in *Plan* I, Heft 3, Vienna, December 1945.
4 Gotthard Jedlicka, *Pieter Bruegel. Der Maler in seiner Zeit*, Erlenbach-Zürich 1938; 2nd edition 1947.
5 Walter Vanbeselaere, *Pieter Bruegel en het Nederlandsche manierisme*, Tielt 1944.
6 Frits Lugt, in *Festschrift für Max J. Friedländer*, Leipzig 1927. Auguste Vermeylen, in *Cahiers de Belgique*, I, 1928. Charles de Tolnay, in *Les Arts Plastiques*, September 1951. F. Grossmann, *op. cit.*, in *Festschrift Kurt Badt zum siebzigsten Geburtstage*, Berlin 1961.
7 C. G. Stridbeck, 'Bruegels Fidesdarstellung' in *Konsthistorisk Tidskrift*, XXIII, 1954.

result of the direct impact of Italian art than of the contact with the Brussels Romanists.[1] Thus the gulf that, in the view of earlier observers, separated Bruegel from his compatriots seems to have been narrowed down.

To conclude this short survey of the varying reactions to Bruegel's work: It is symptomatic of the constantly increasing interest in Bruegel that after Romdahl's and Hulin de Loo's catalogues of the paintings which were followed by separate catalogues of the engravings, in 1908,[2] and of the drawings, in 1925,[3] seven more catalogues of the paintings have appeared.[4] The most detailed of these was produced by Glück in 1932 and has since been published in several more enlarged and revised editions. But our rapidly advancing knowledge of Bruegel forces us to exclude from the master's oeuvre many paintings which were unhesitatingly accepted by earlier critics, and therefore a new catalogue will have to differ greatly even from the latest edition of Glück's volume, published only in 1952.[5]

The interpretation of Bruegel, the man and the work, from his day to ours presents a bewildering spectacle. The man has been thought to have been a peasant and a townsman, an orthodox catholic and a Libertine, a humanist, a laughing and a pessimist philosopher; the artist appeared as a follower of Bosch and a continuator of the Flemish tradition, the last of the Primitives, a Mannerist in contact with Italian art, an illustrator, a genre painter, a landscape artist, a realist, a painter consciously transforming reality and adapting it to his formal ideal – to sum up just a few opinions expressed by various observers in the course of four hundred years. With the exception of the peasant, whom I think we can decently bury, each of these views, even when apparently contradicted by another, contains some part of the truth. The apparent contradictions mirror the different aspects of an inexhaustibly rich personality. The man and the work are

1 C. G. Stridbeck, *Bruegel und der niederländische Manierismus*. Privately printed, 1953. These two studies are now incorporated in Stridbeck's *Bruegelstudien*, Stockholm 1956, the most important recent book on Bruegel, which is based on a detailed study of Coornhert's writings and contemporary emblem literature.

2 René van Bastelaer, *Les Estampes de Peter Bruegel l'ancien*, Brussels 1908.

3 Tolnai, *Die Zeichnungen . . .' op. cit.* Another catalogue has recently been provided by the posthumous publication of Ludwig Münz, *Bruegel. The Drawings*, London 1961.

4 References to these catalogues will be found in the second volume, which will also contain a bibliography of the literature on Bruegel. The most detailed bibliography was compiled by Edouard Michel (in his *Bruegel*, Paris 1931) to which the same author provided a supplement in *Musée National du Louvre. Catalogue raisonné des Peintures . . . Flamandes du XVe et du XVIe Siècle*, Paris 1953, pp. 39 ff.

5 Gustav Glück, *Bruegels Gemälde, op. cit.*, English edition: *The Large Bruegel Book*, Vienna 1952.

complex and, only by keeping in mind the various aspects and by re-examining the facts behind the many assertions and interpretations, can we hope to obtain, if not a perfectly balanced and unassailable picture, at least one that does more justice to the intricacy of the situation and to the prodigious artistic wealth of Bruegel's work.[1]

1 This re-examination will be attempted in a separate volume.

SIGNATURE OF BRUEGEL
from the *Conversion of St. Paul* (Plate 125)

THE PLATES

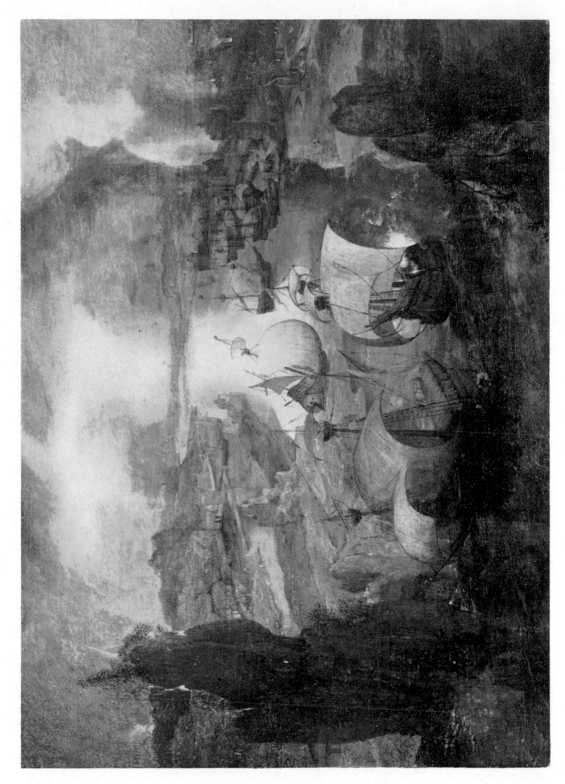

1. *Landscape with Sailing Boats and a burning Town.* Private Collection. 18 × 26 cm.

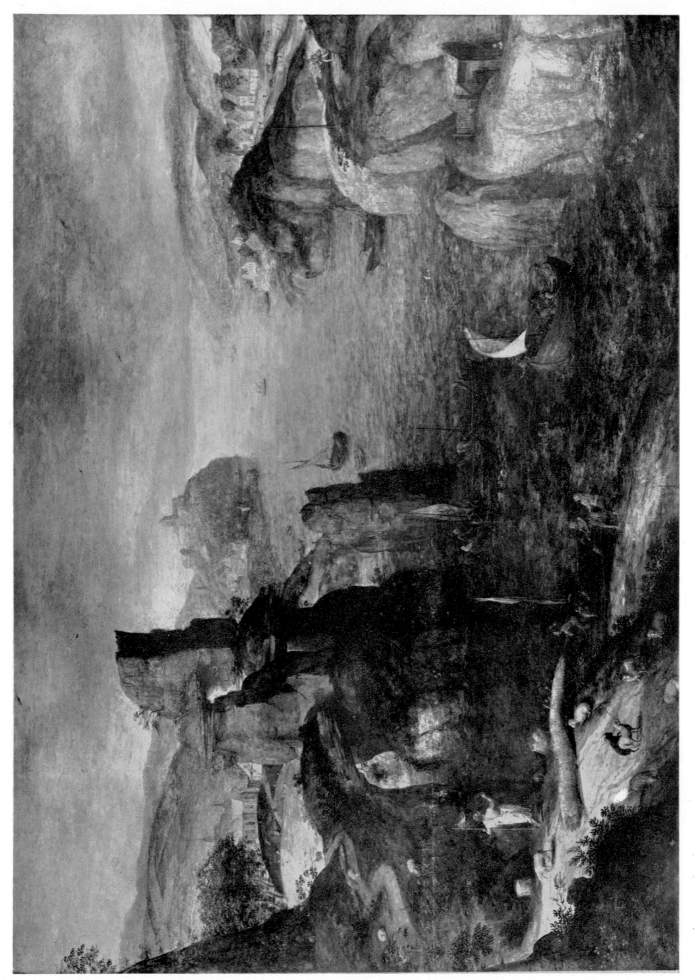

2. *Landscape with Christ appearing to the Apostles at the Sea of Tiberias.* 1553. Private Collection.

67 × 100 cm.

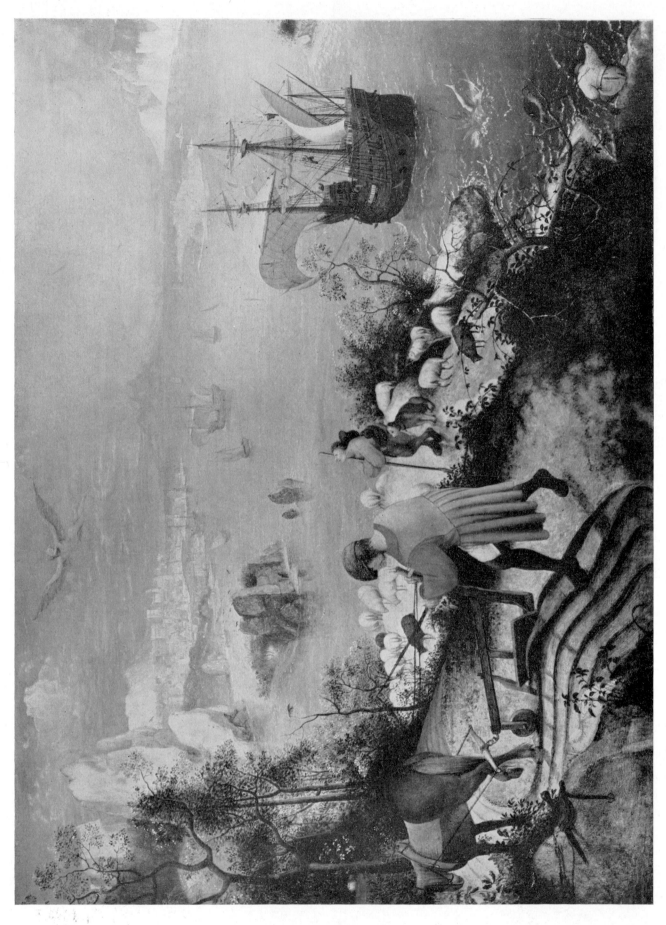

3. *Landscape with the Fall of Icarus.* New York and Brussels, D. M. van Buuren Collection. 63 × 90 cm.

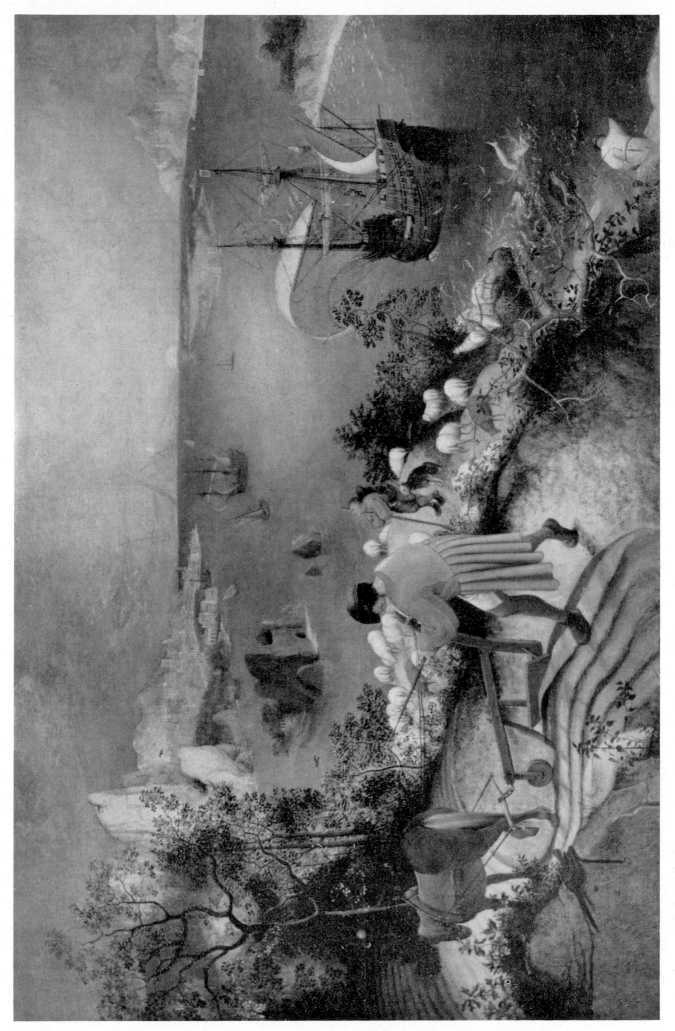

3a. *Landscape with the Fall of Icarus*. Brussels, Musées Royaux des Beaux-Arts.

73·5 × 112 cm.

4. *The Adoration of the Kings.* Brussels, Musées Royaux des Beaux-Arts. 115.5 × 163 cm.

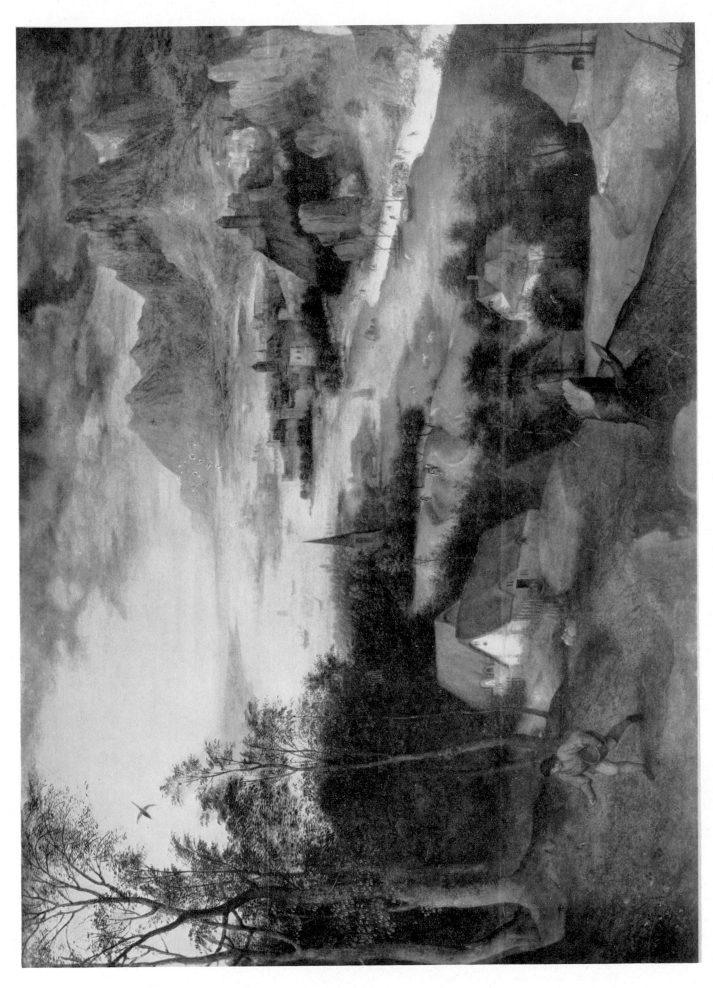

5. *Landscape with the Parable of the Sower.* 1557. San Diego, Cal., Timken Art Gallery. 74 × 102 cm.

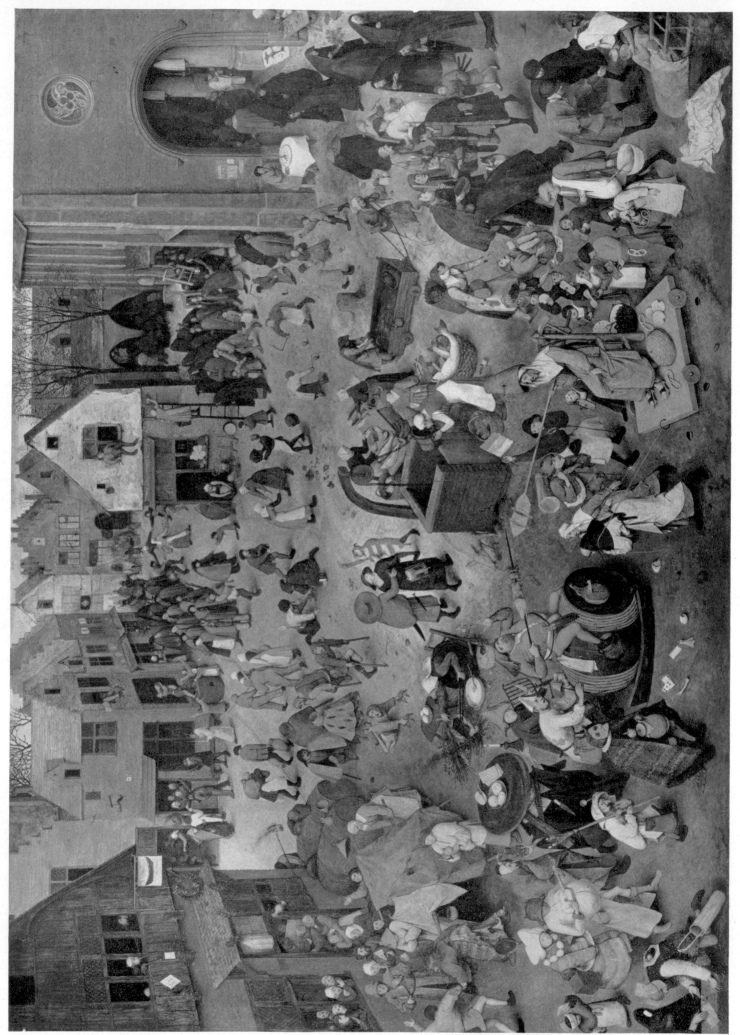

6. *The Fight between Carnival and Lent.* 1559. Vienna, Kunsthistorisches Museum. 118 × 164.5 cm.

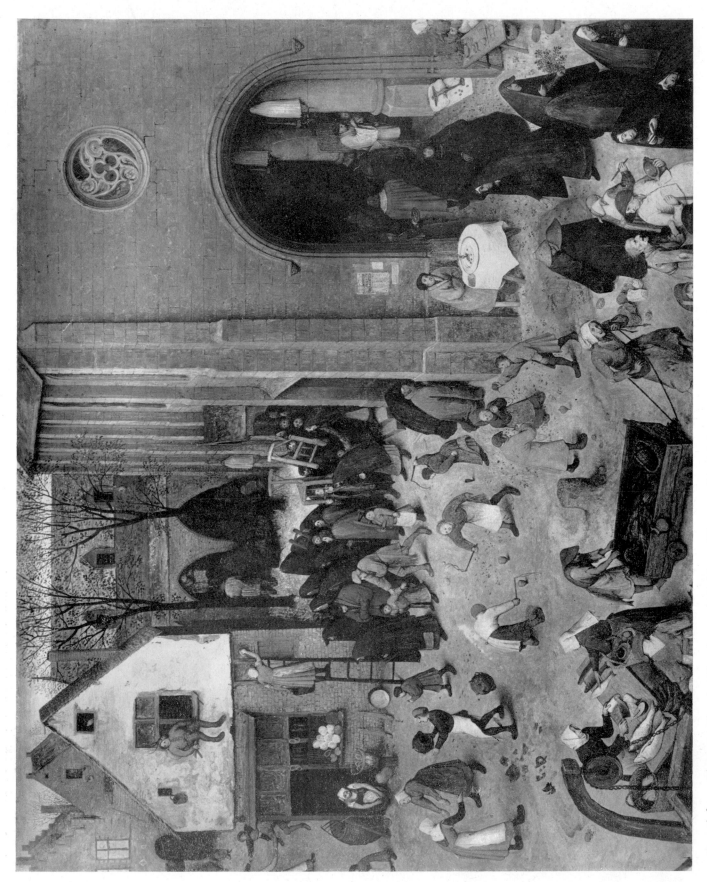

7. Detail from Plate 6: *Church, Church-goers, Children, Woman selling Fish.*

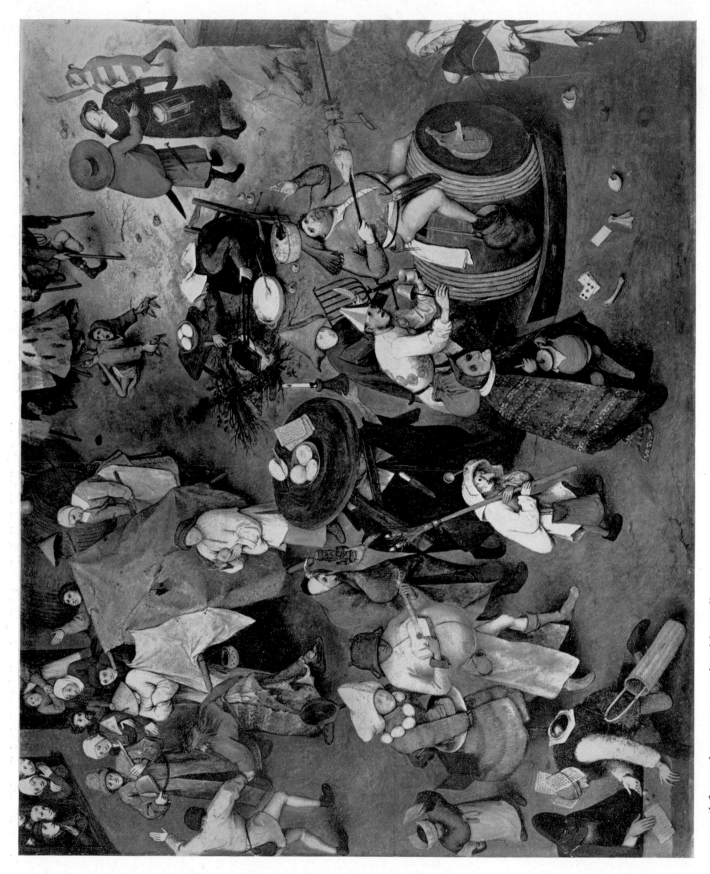

8. Detail from Plate 6: *Carnival and his Followers.*

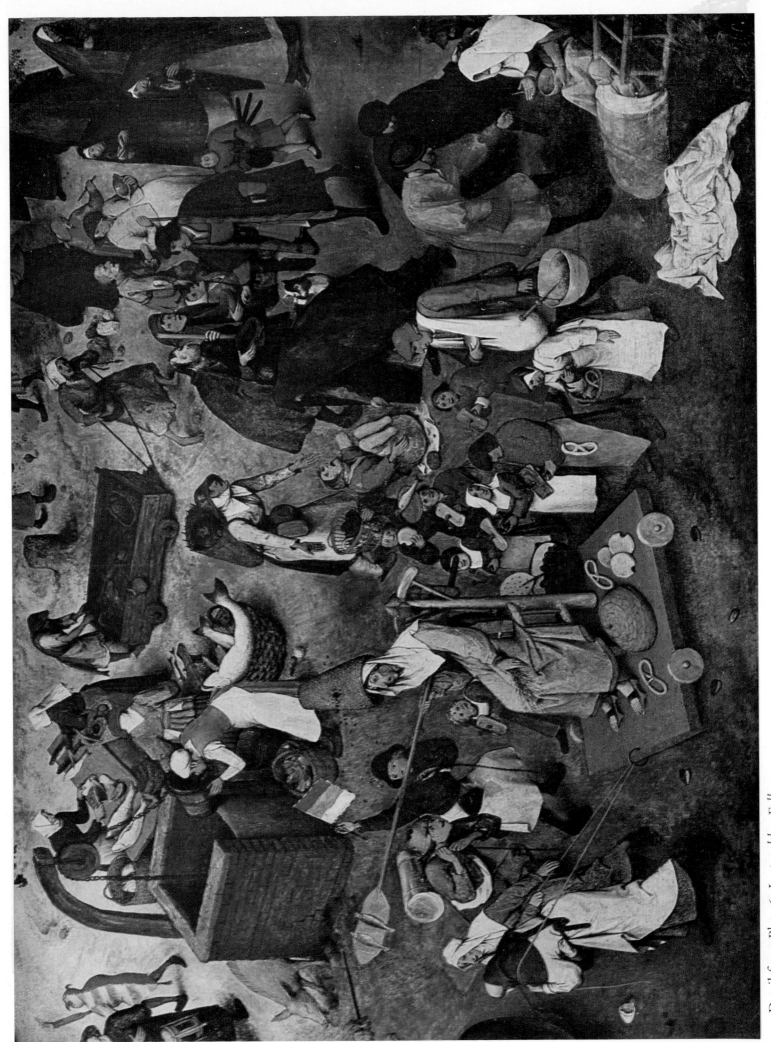

9. Detail from Plate 6: *Lent and her Followers.*

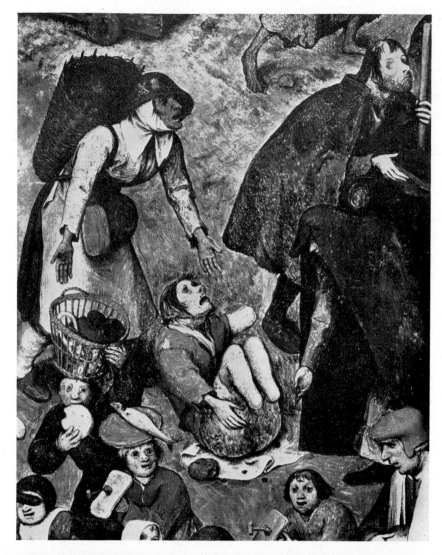

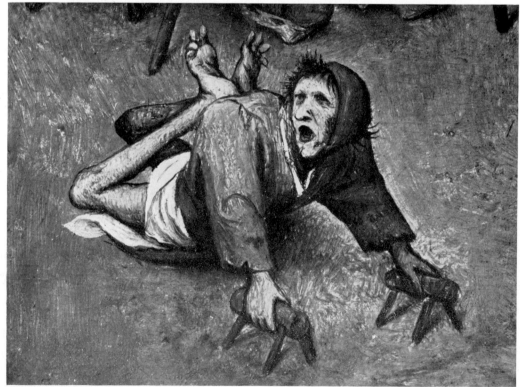

10–11. Details from Plate 6: *Beggars (Blind Man, Cripple, Woman with Pilgrim's Emblems on her Hat). A Cripple.*

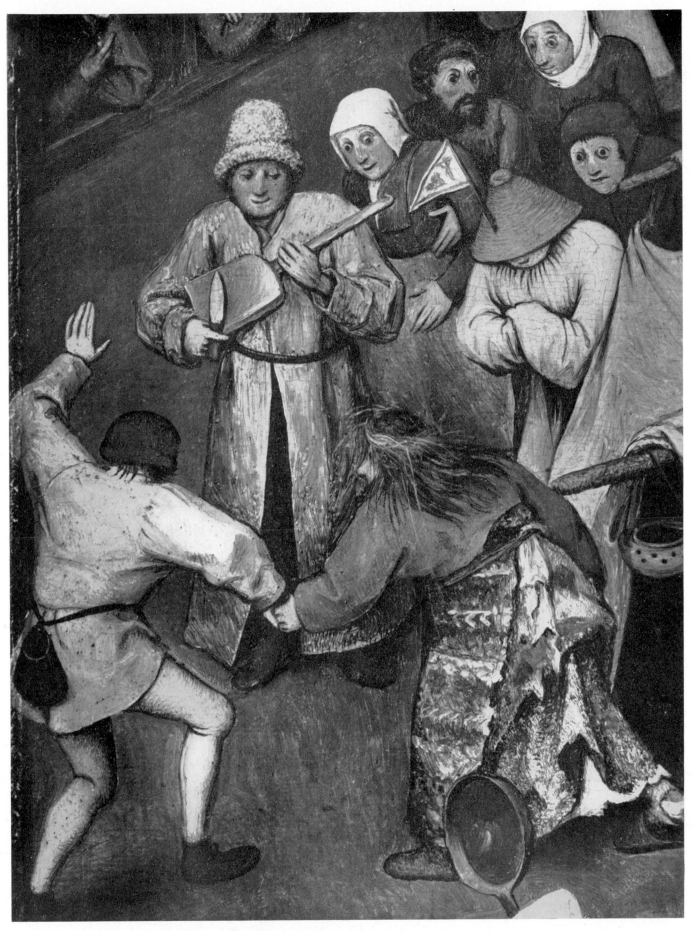

12. Detail from Plate 6: *The Carnival Play 'De Vuile Bruid' being performed in Front of the Inn on the left.*

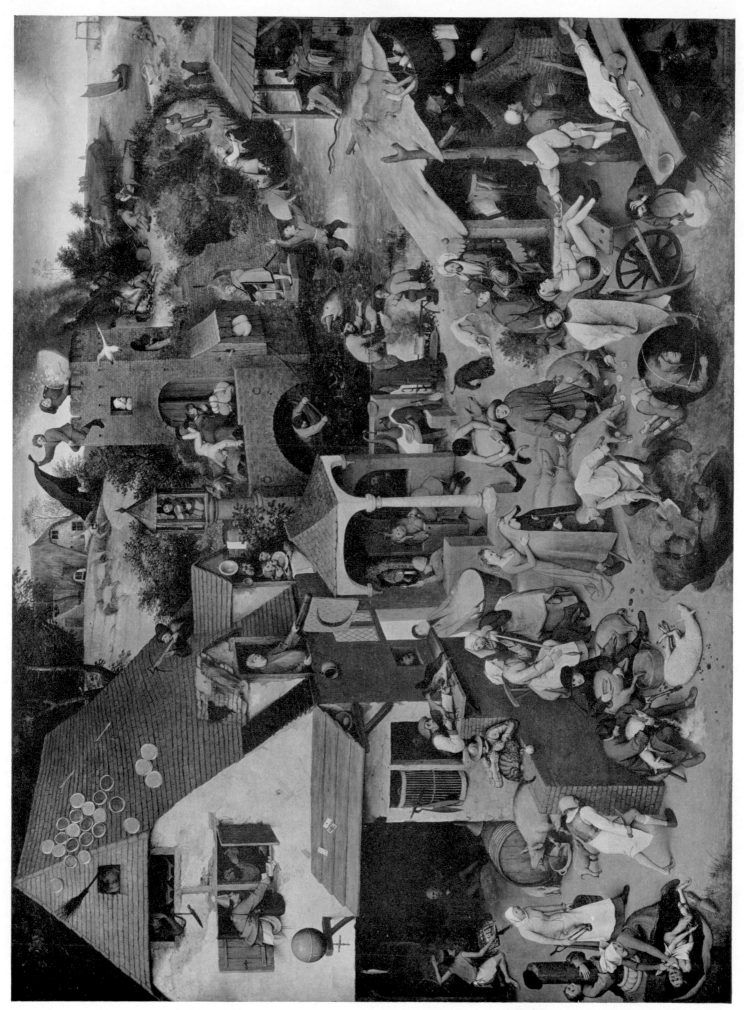

13. *The Netherlandish Proverbs.* 1559. Berlin – Dahlem, Staatliche Museen. 117 × 163 cm.

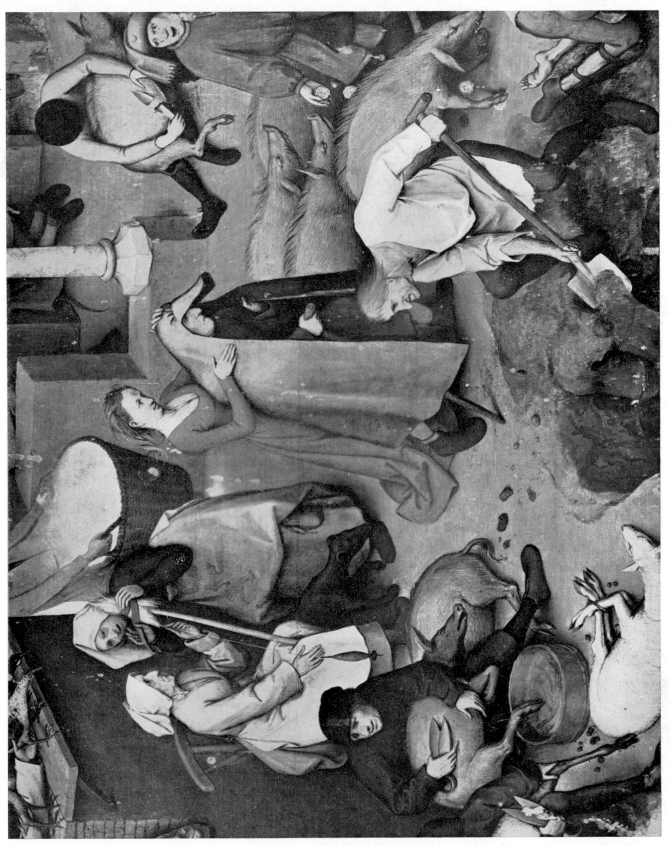

14. Detail from Plate 13: 'She hangs the Blue Coat round her Husband', 'He blocks up the Well after the Calf is drowned' and other Proverbs.

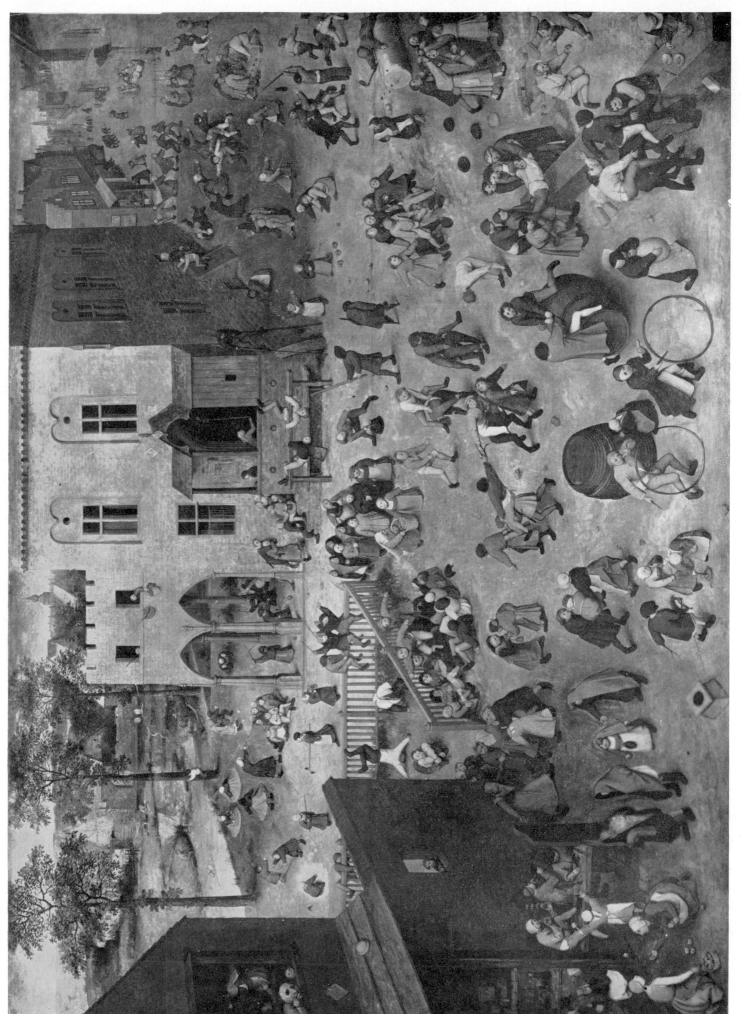

15. *Children's Games*. 1560. Vienna, Kunsthistorisches Museum. 118 × 161 cm.

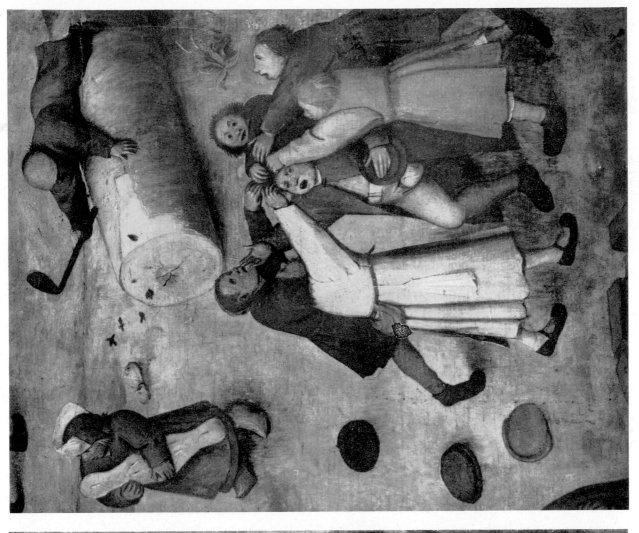

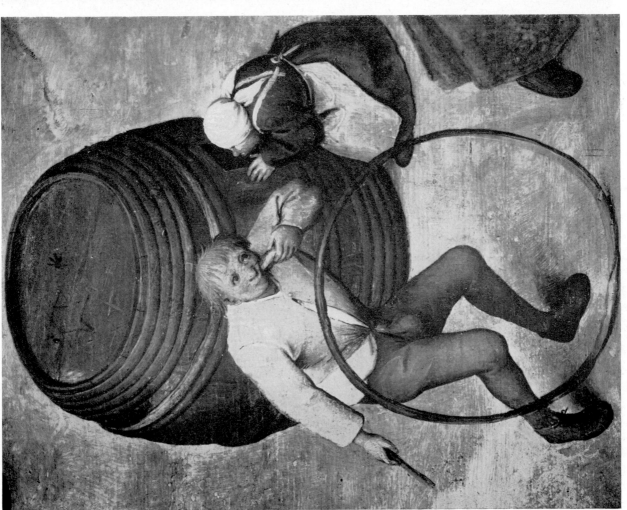

16–17. Details from Plate 15: *Two Games: Trundling a Hoop and Calling Down a Bung Hole. Three Games: Pulling Hair, Killing Flies, Running with a Cake.*

18. Detail from Plate 15: *The Mill, a Boy stripping for Swimming*.

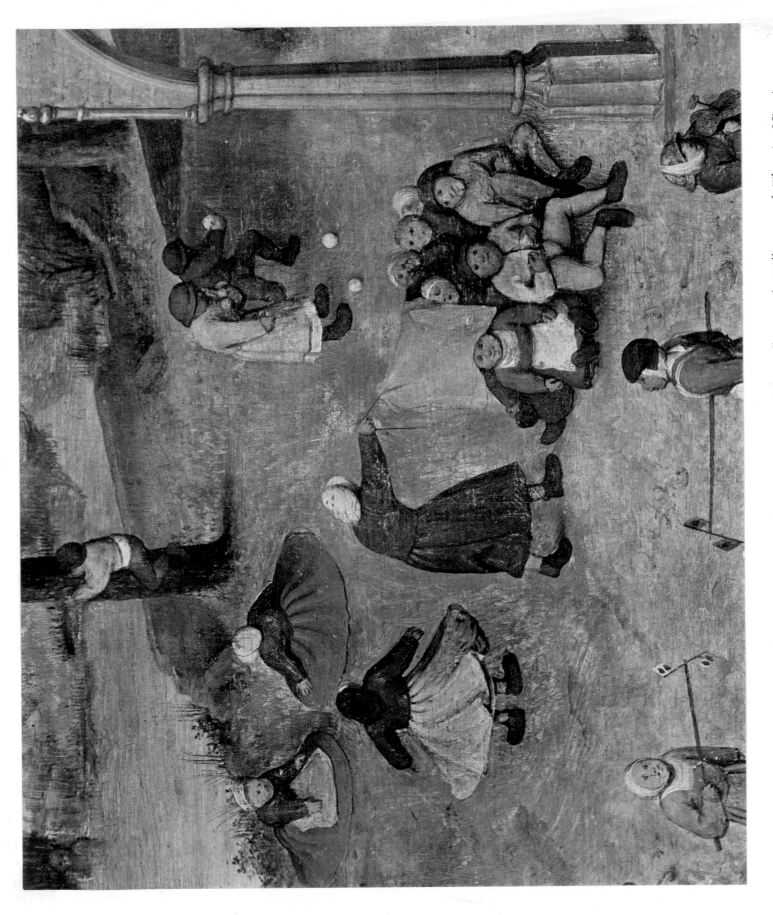

19. Detail from Plate 15: *Several Games: Guess whom I shall choose? Here we go round the Mulberry Bush, Milling around, Throwing Ninepins (or Marbles), Climbing a Tree, Tournament with Windmills.*

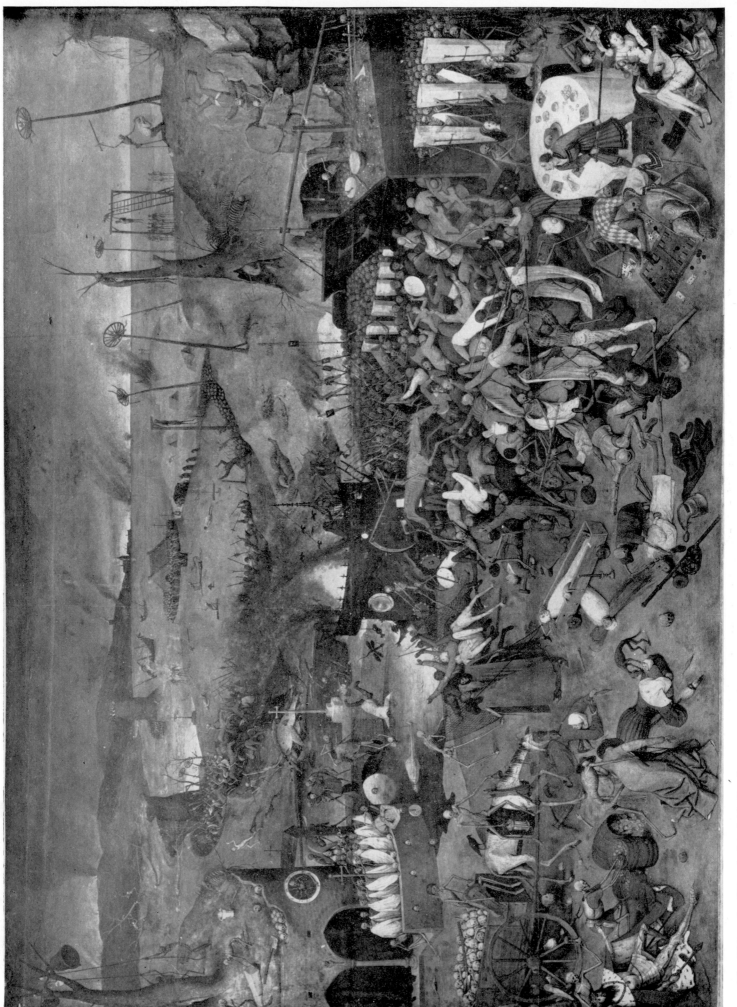

20. *The Triumph of Death*. Madrid, Prado. 117 × 162 cm.

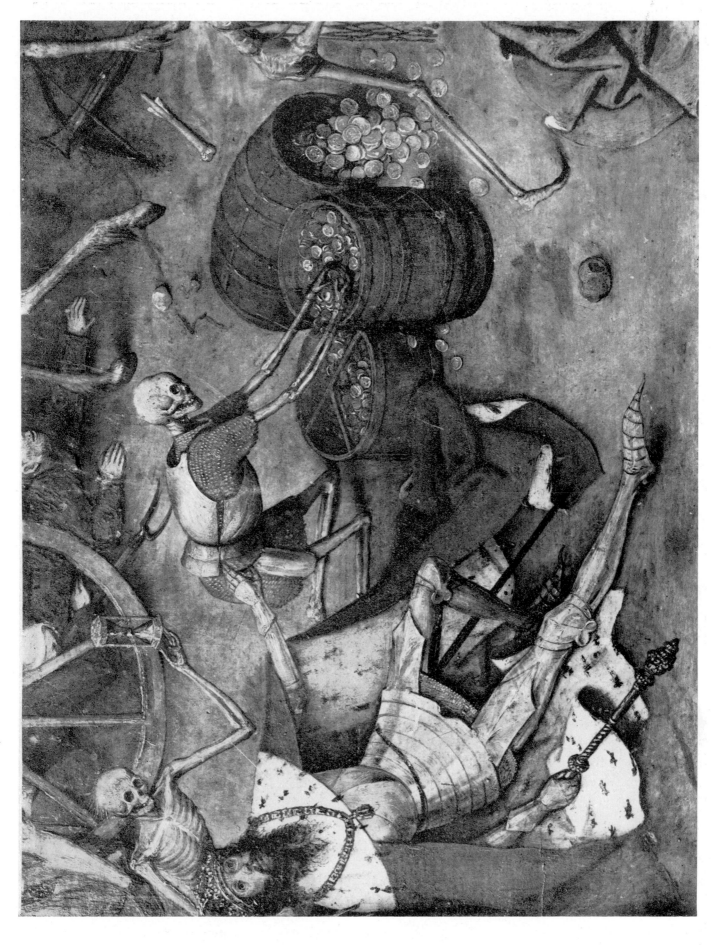

21. Detail from Plate 20: *The Emperor.*

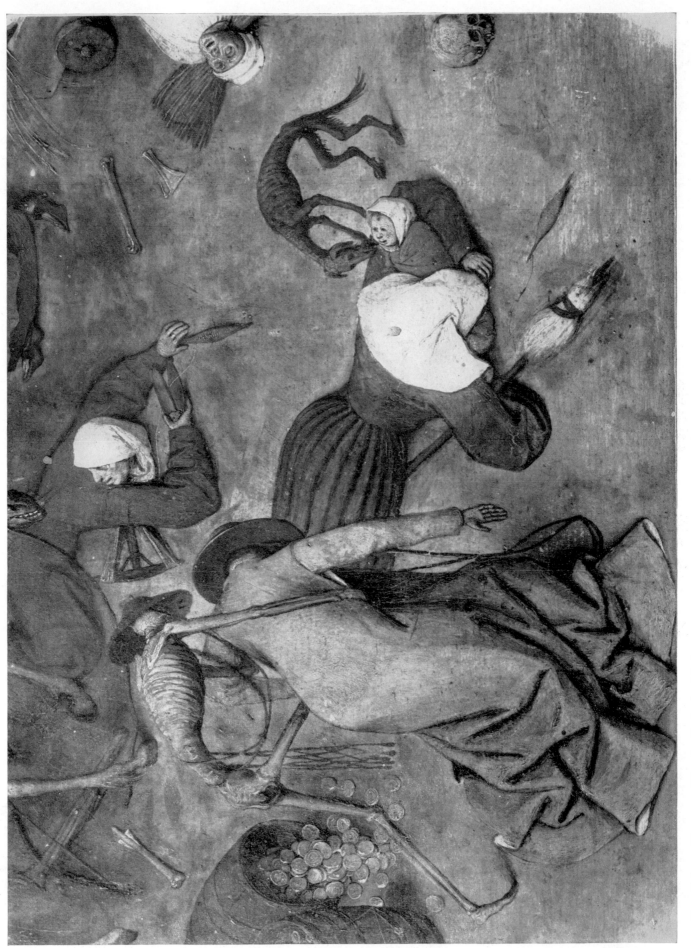

22. Detail from Plate 20: *The Cardinal, the Mother.*

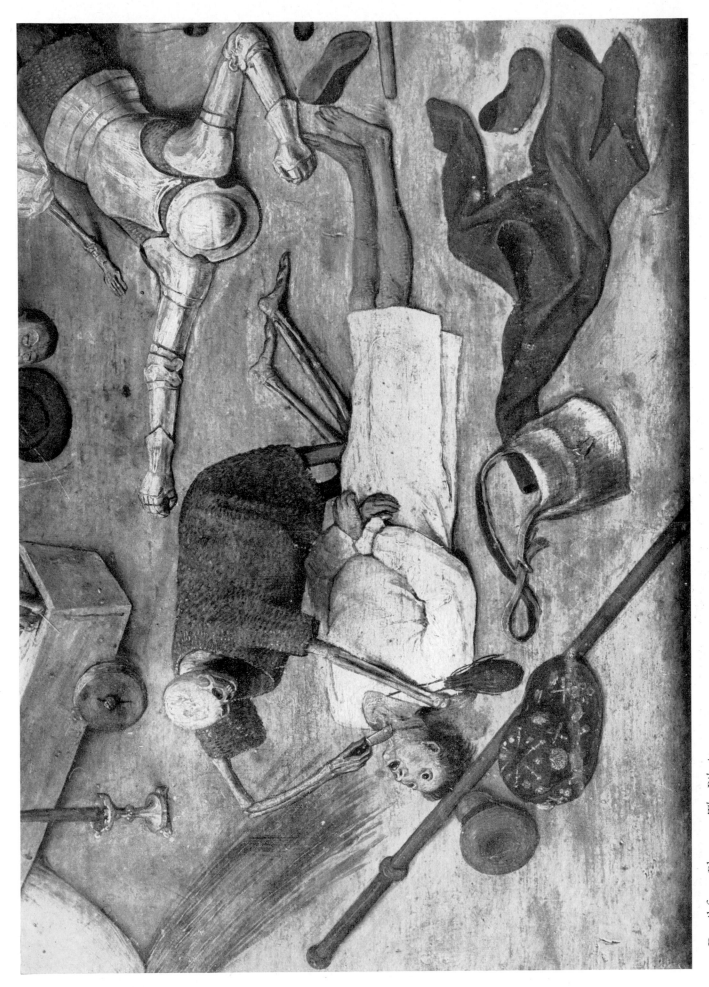

23. Detail from Plate 20: *The Pilgrim.*

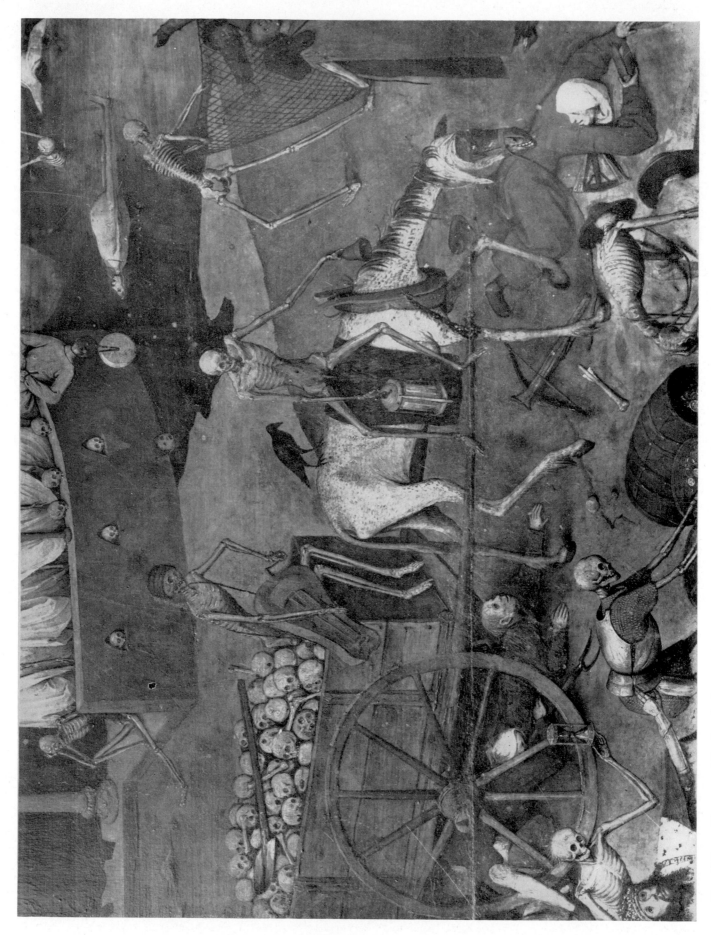

24. Detail from Plate 20: *The Death Cart.*

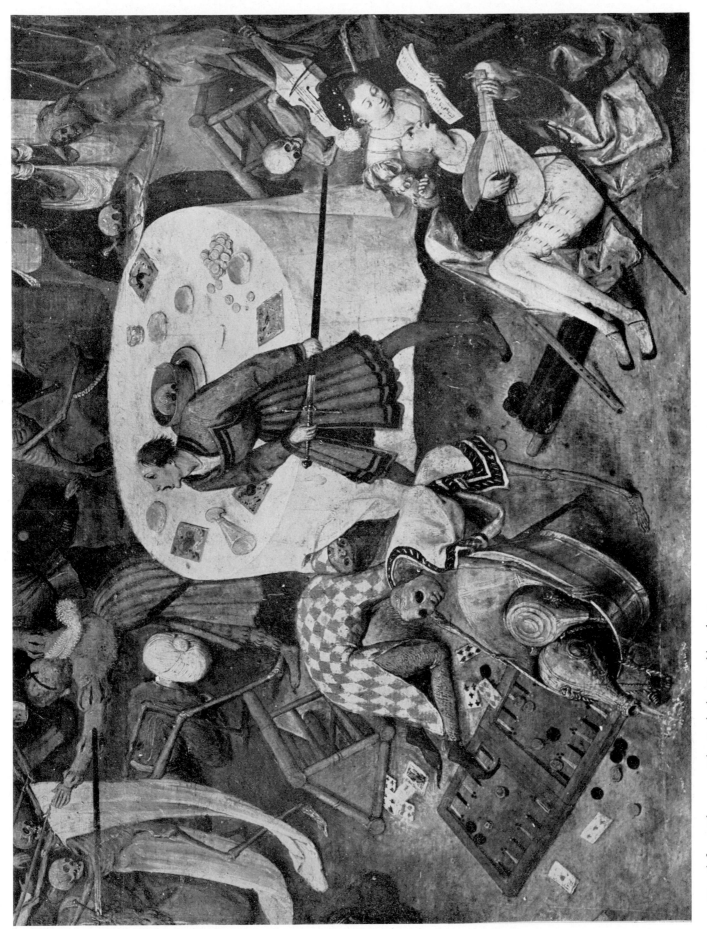

25. *Detail from Plate 20: The Fool, the Gambler, the Lovers.*

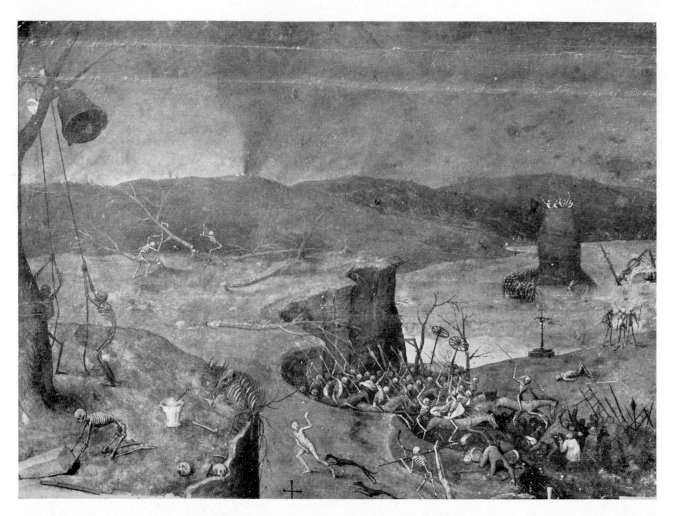

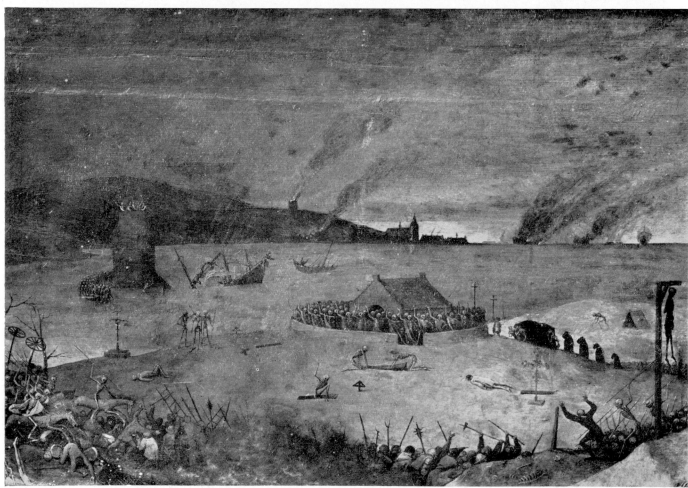

26–27. Details from Plate 20: *The Tolling Bell and the Army of the Dead. Shipwreck, Funeral, Death on the Gallows.*

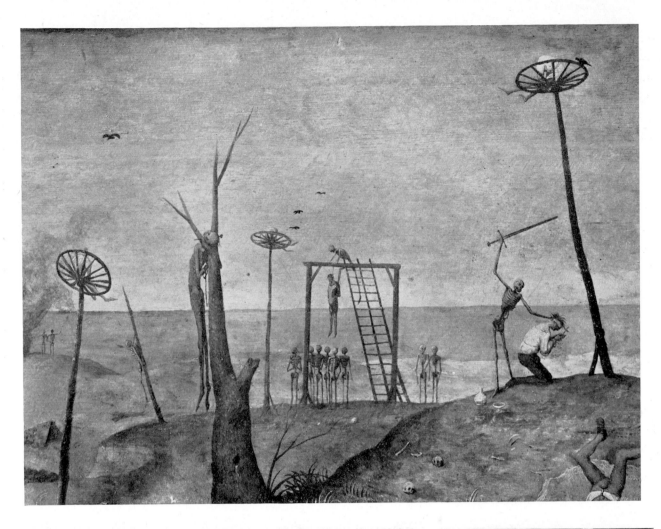

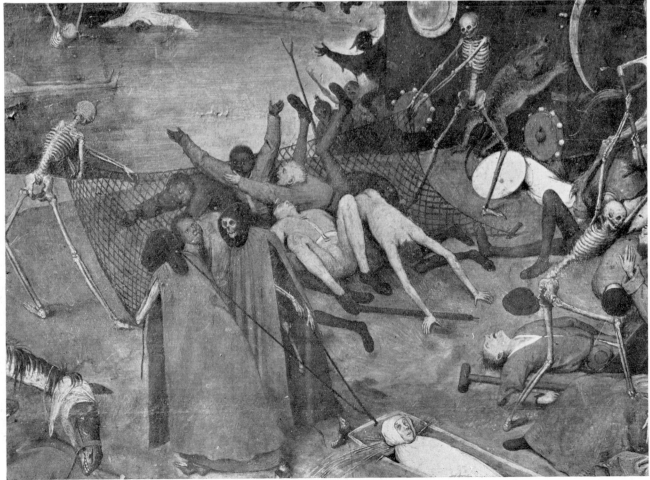

28–29. Details from Plate 20: *Death as Executioner. The Net of Death.*

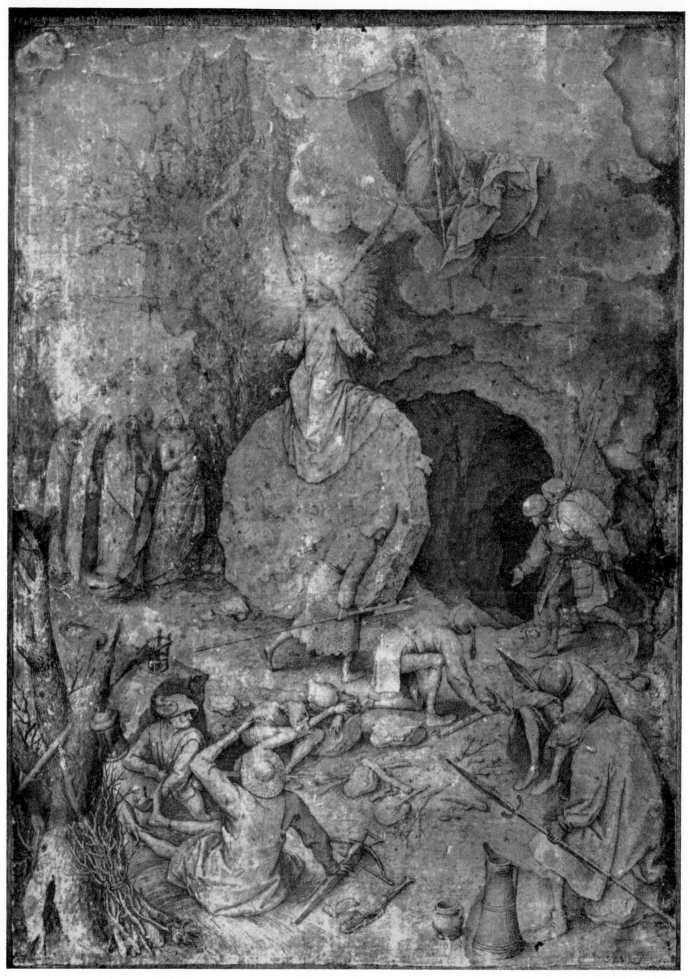

30. *The Resurrection of Christ*. Rotterdam, Museum Boymans - Van Beuningen. 43.1 × 30.7 cm.

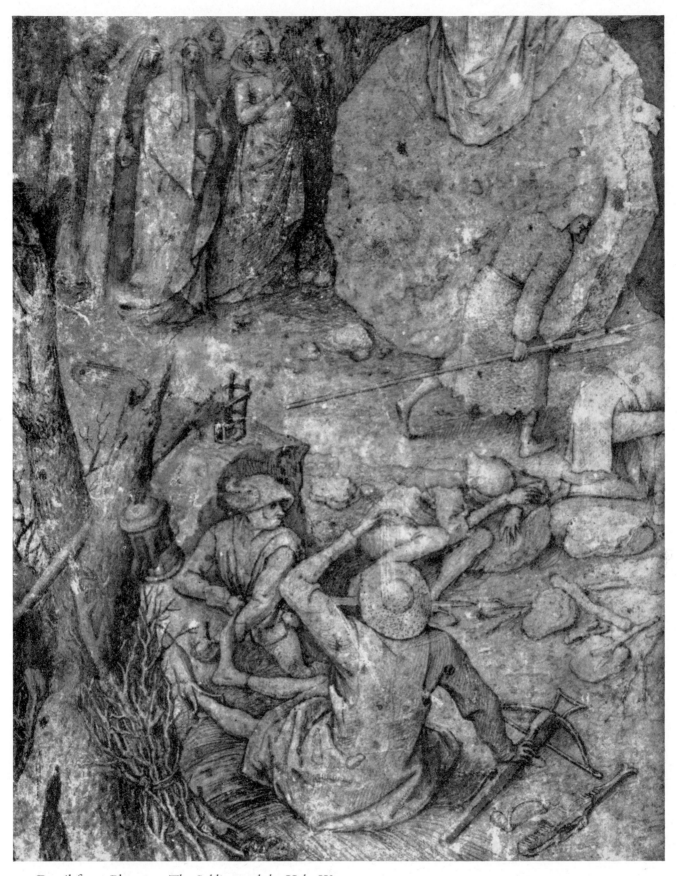

31. Detail from Plate 30: *The Soldiers and the Holy Women*.

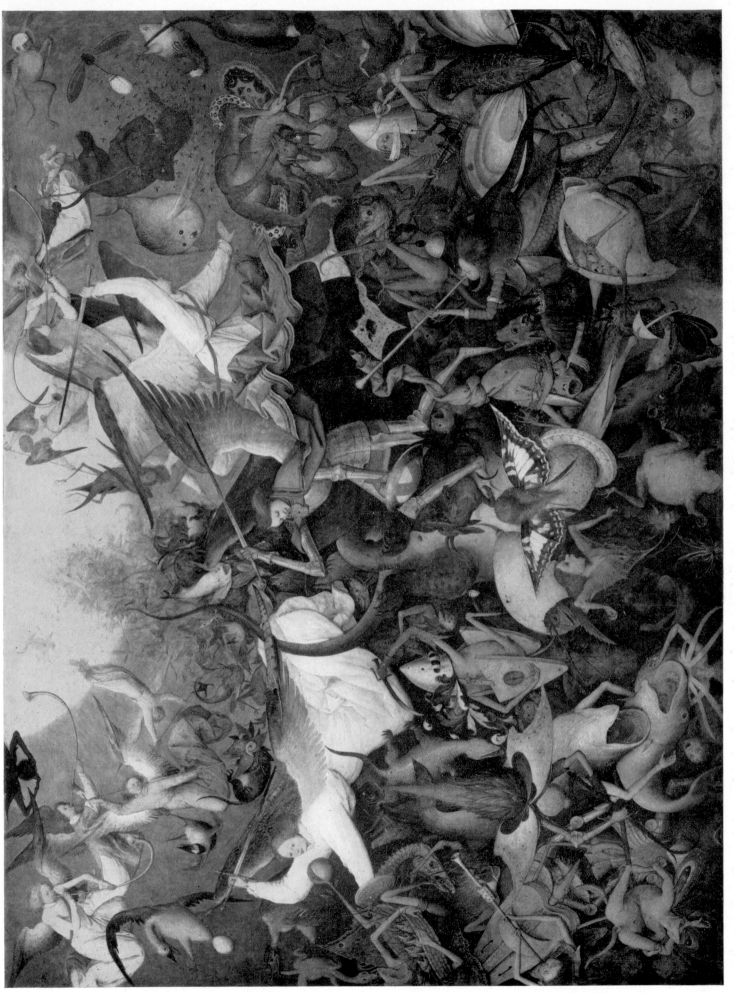

32. *The Fall of the Rebel Angels.* 1562. Brussels, Musées Royaux des Beaux-Arts. 117 × 162 cm.

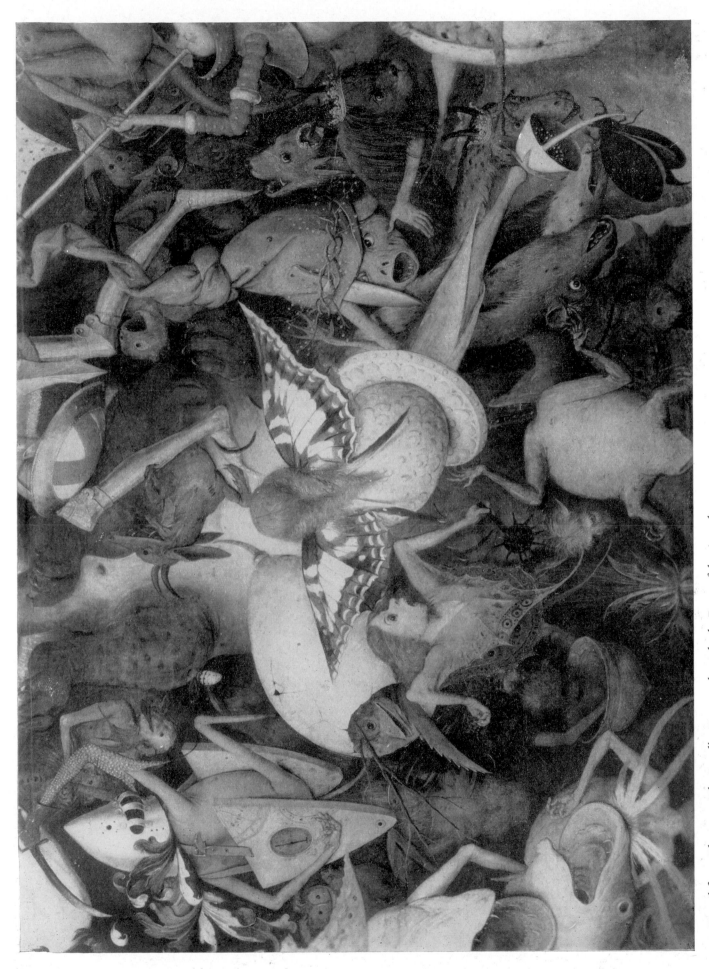

33. Detail from Plate 32: *The Deadly Sins, on the right the Beast of the Apocalypse.*

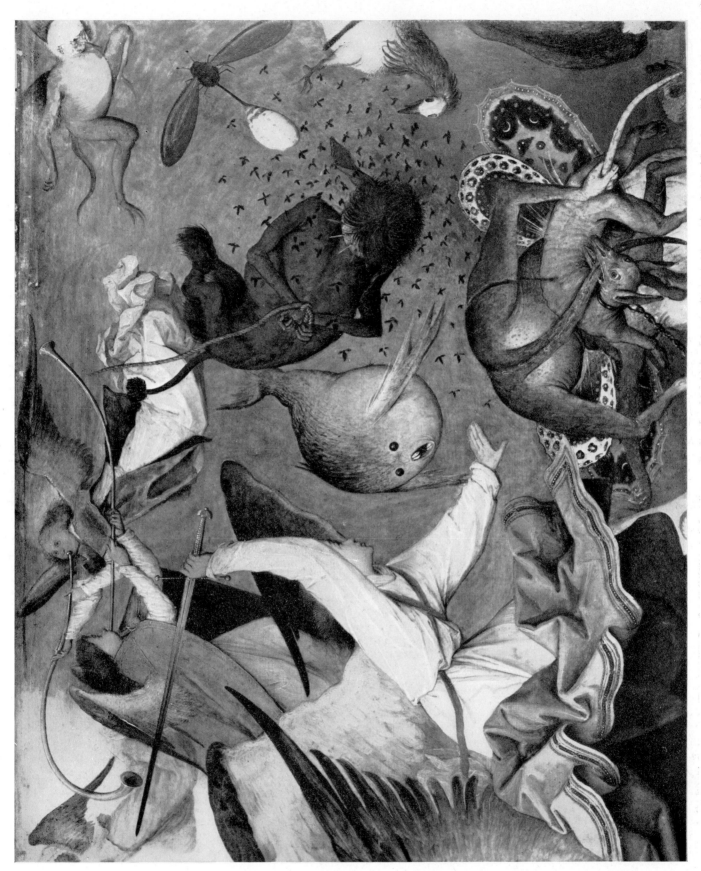

34. Detail from Plate 32: *Angel fighting Devils.*

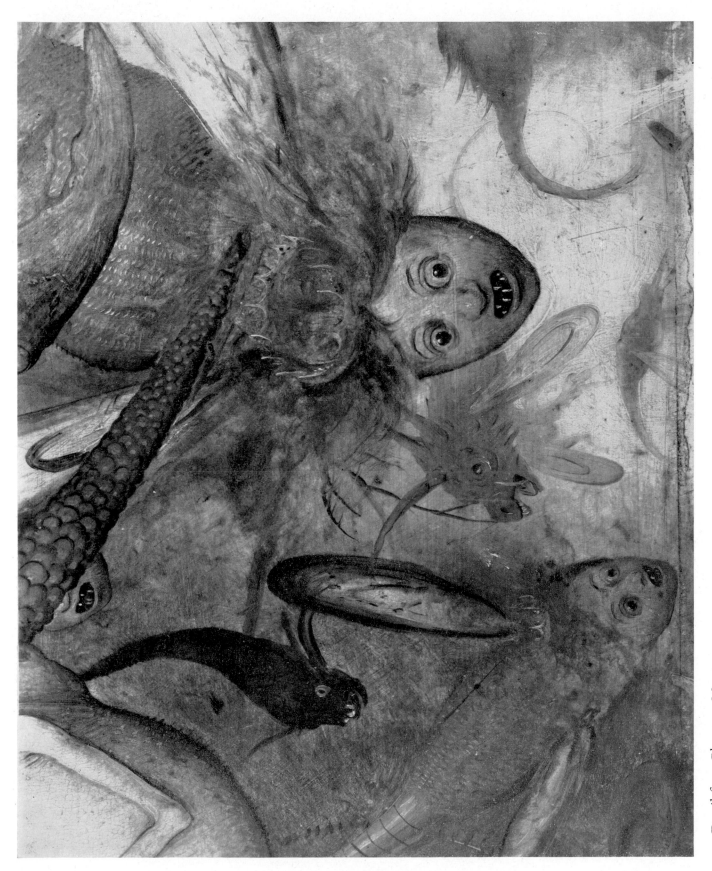

35. Detail from Plate 32: *Monsters*.

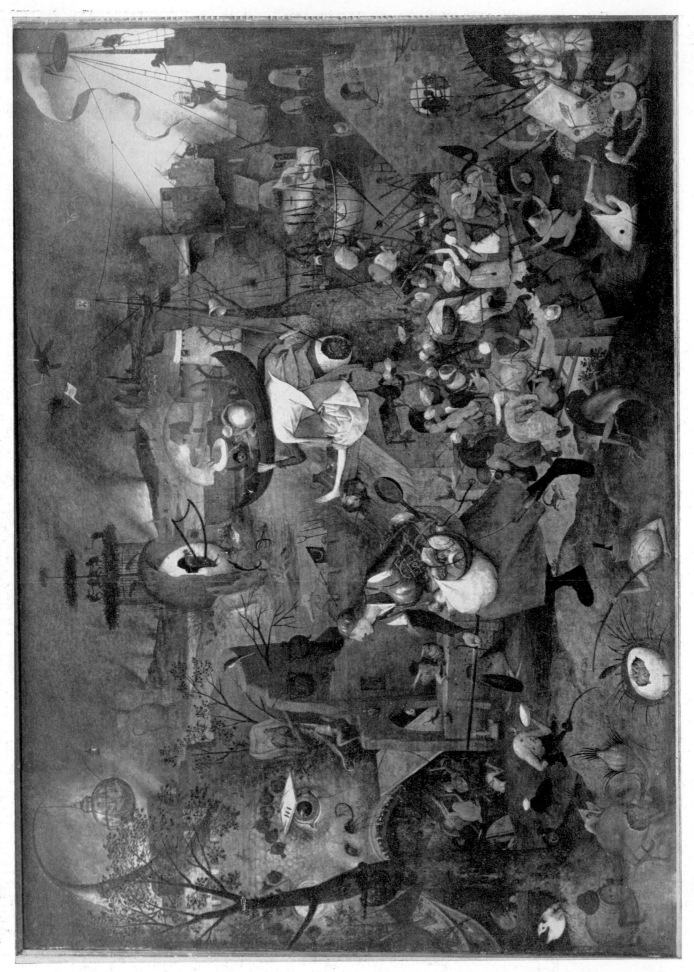

36. *The 'Dulle Griet' (Mad Meg)*. 1562. Antwerp, Musée Mayer van den Bergh. 115 × 161 cm.

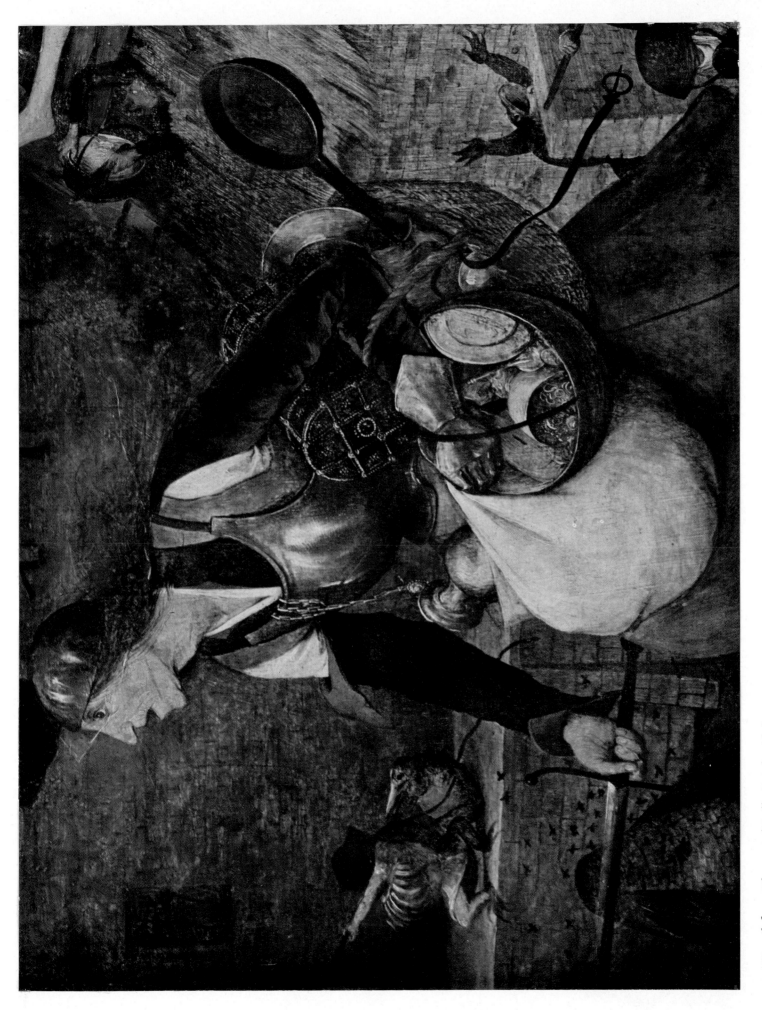

37. Detail from Plate 36: '*Dulle Griet*' *with her Loot.*

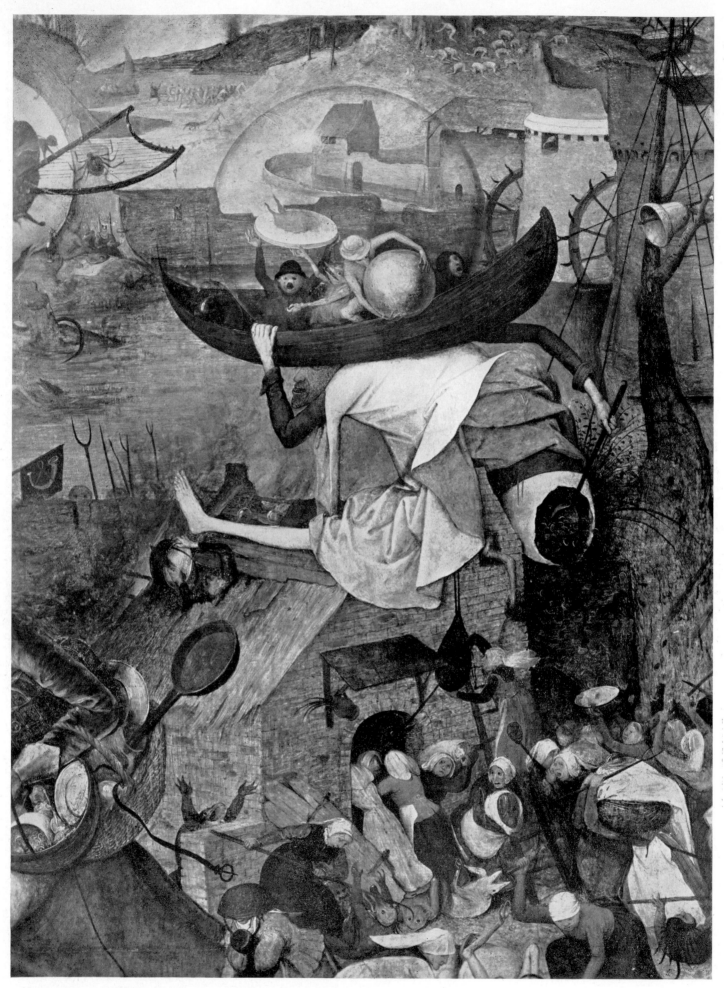

38. Detail from Plate 36: *The Tempter on the Roof and the looting Women.*

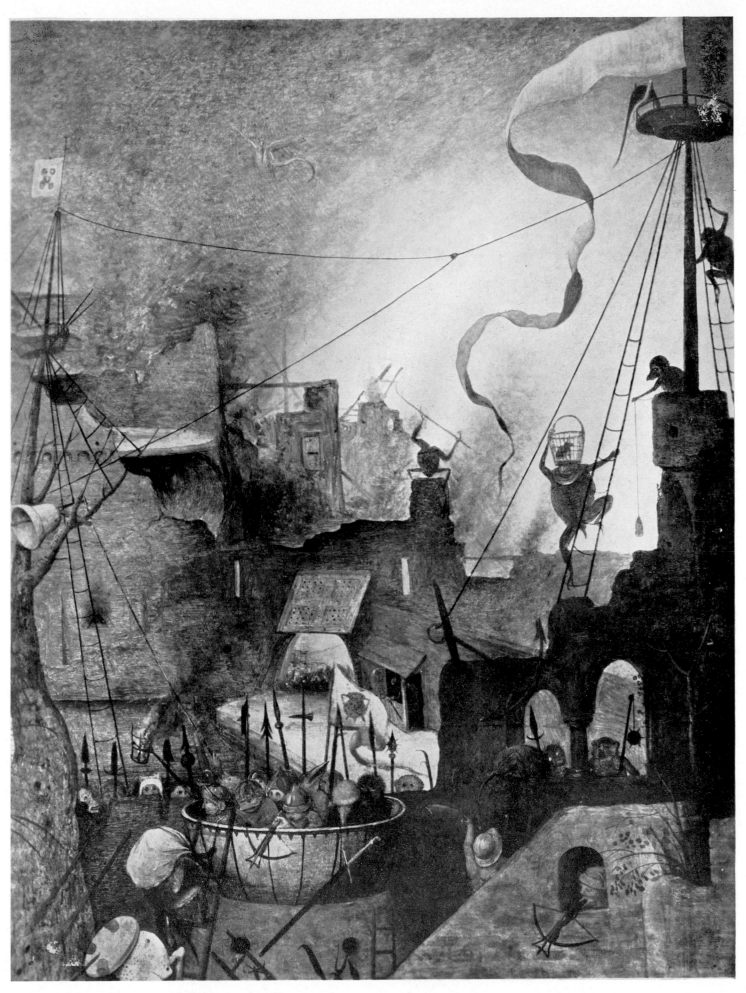

39. Detail from Plate 36: *The Fortress of Hell*.

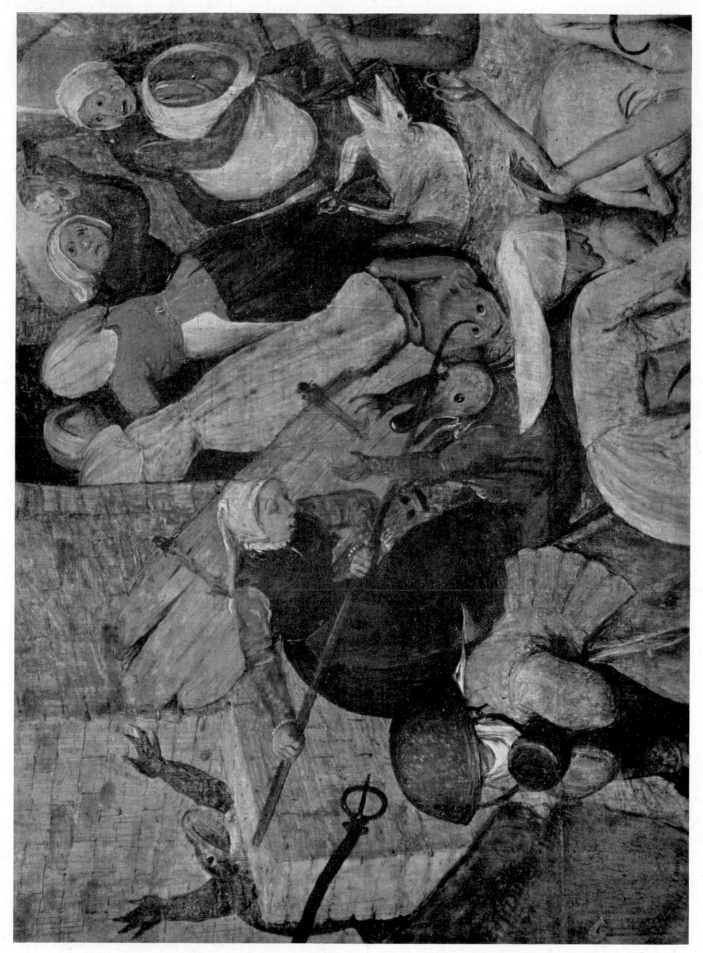

40. Detail from Plate 36: *The looting Women.*

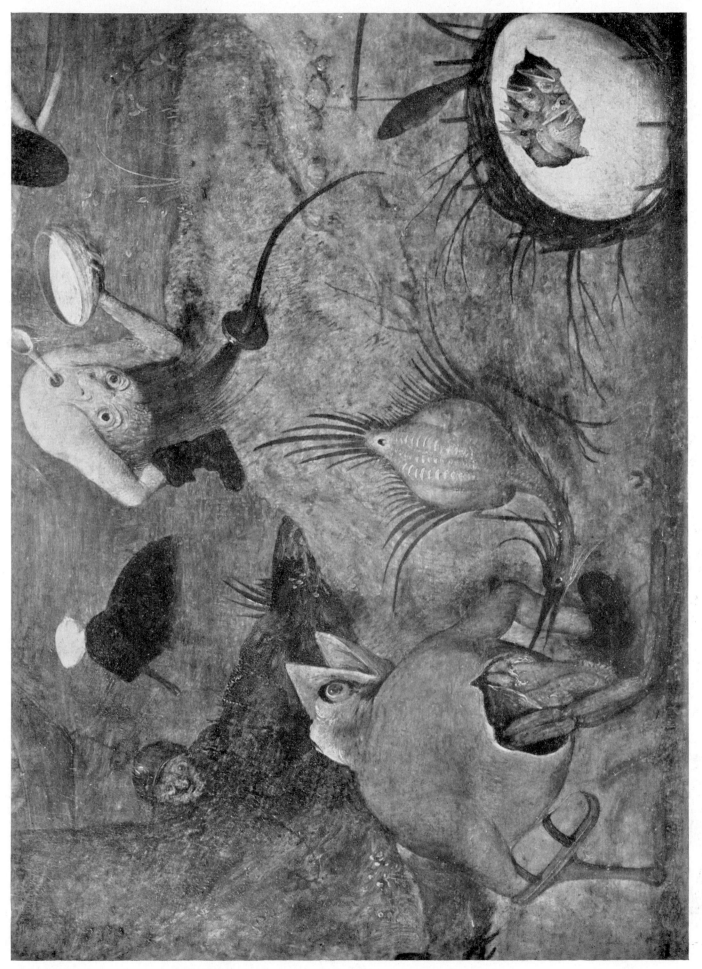

41. *Detail from Plate 36: Monsters representing Sins; in the Centre: Gluttony.*

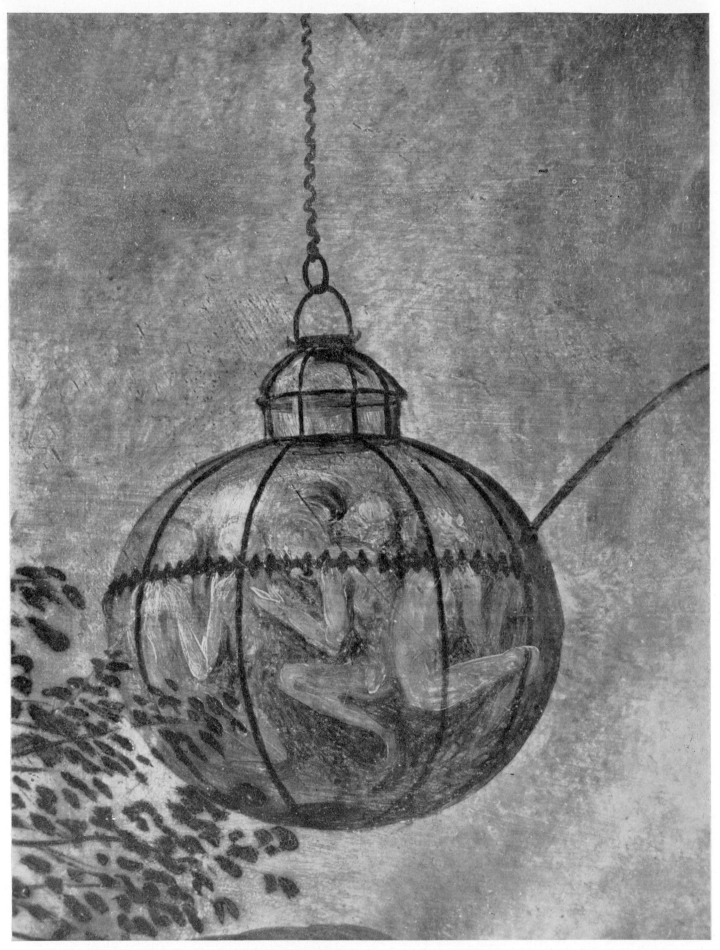

42. Detail from Plate 36: *The Sinners in the Glass Ball*.

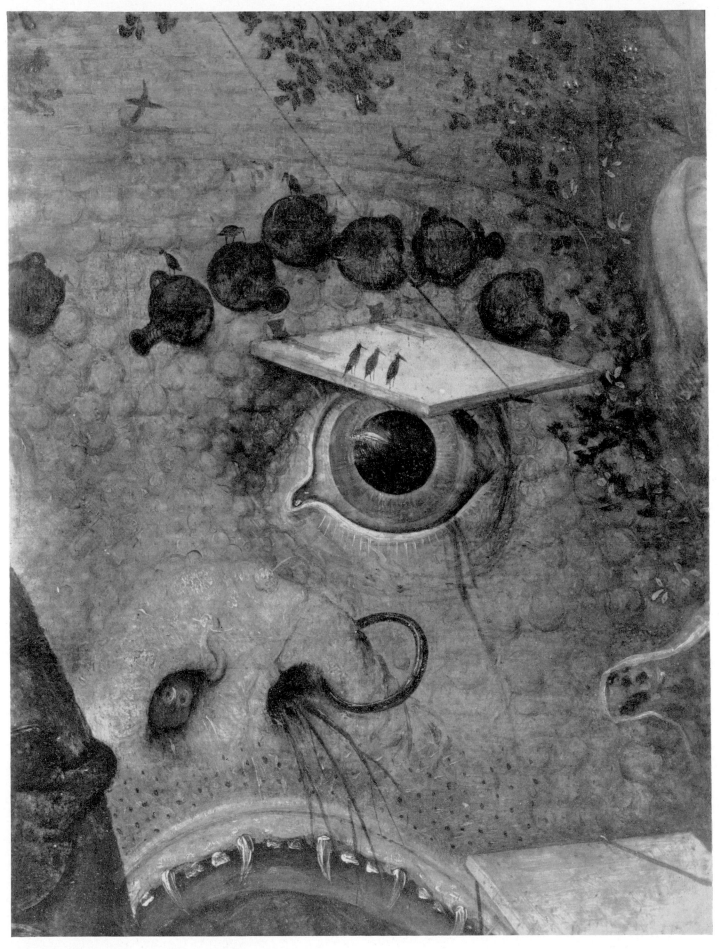

43. Detail from Plate 36: *Head of Satan*.

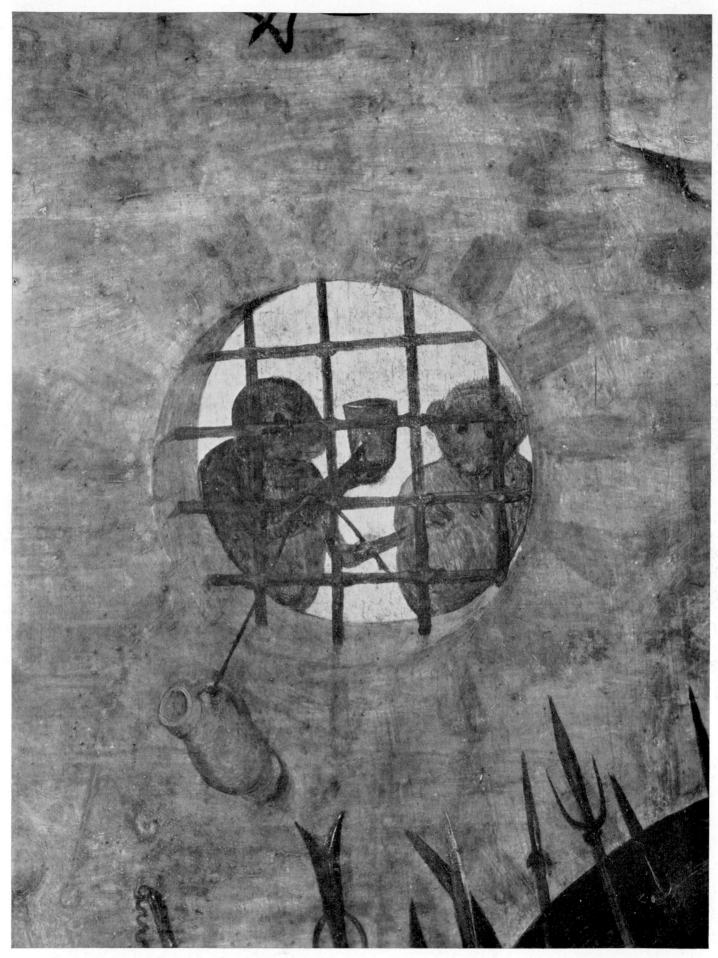

44. Detail from Plate 36: *Two imprisoned Animals.*

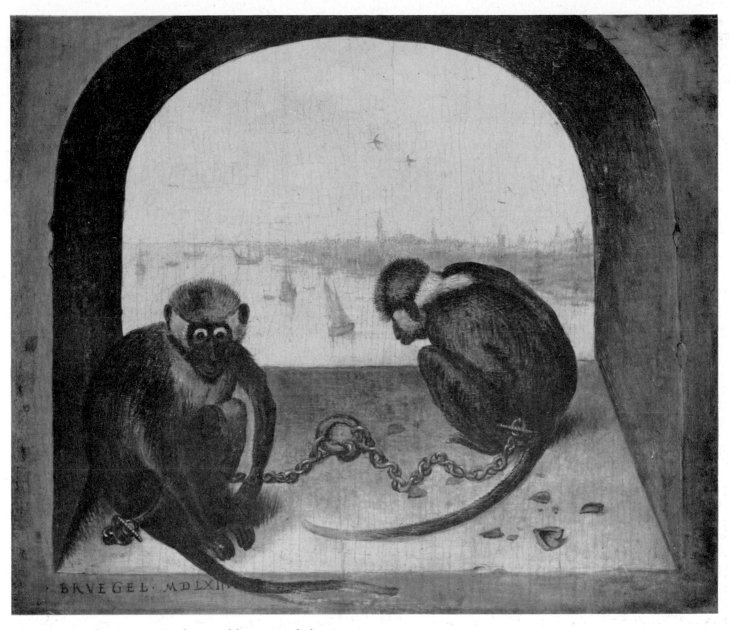

45. *Two Monkeys*. 1562. Berlin – Dahlem, Staatliche Museen.

20 × 23 cm.

46. *The Suicide of Saul.* 1562. Vienna, Kunsthistorisches Museum. 33·5 × 55 cm.

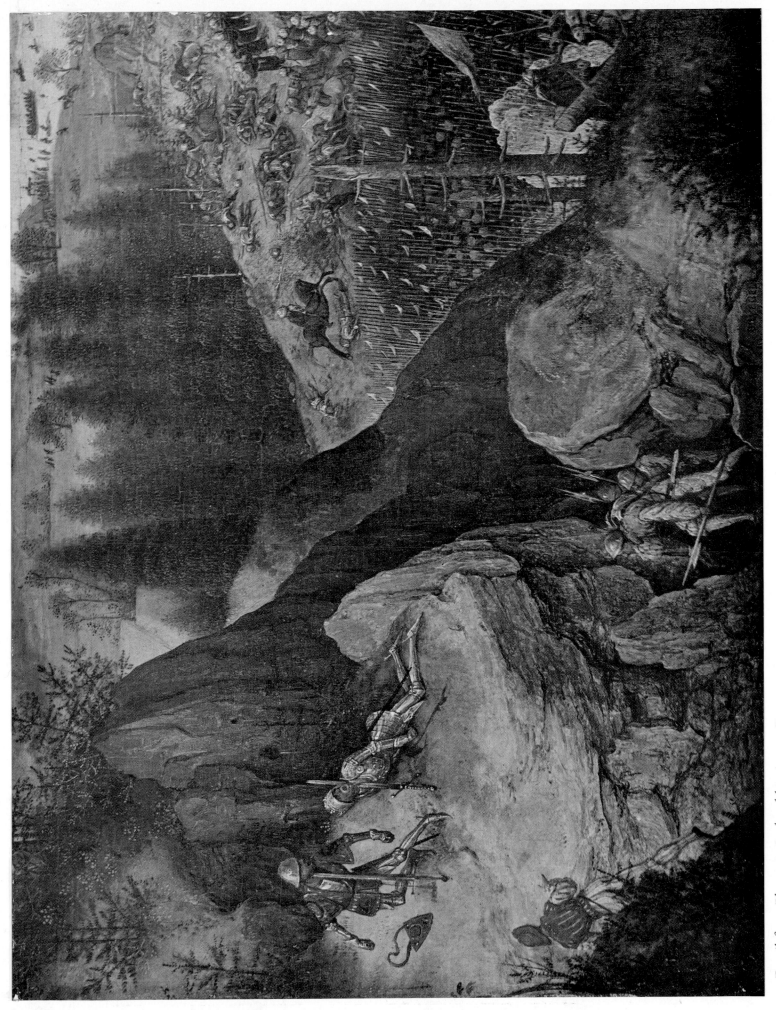

47. Detail from Plate 46: *Saul and his Armour-Bearer.*

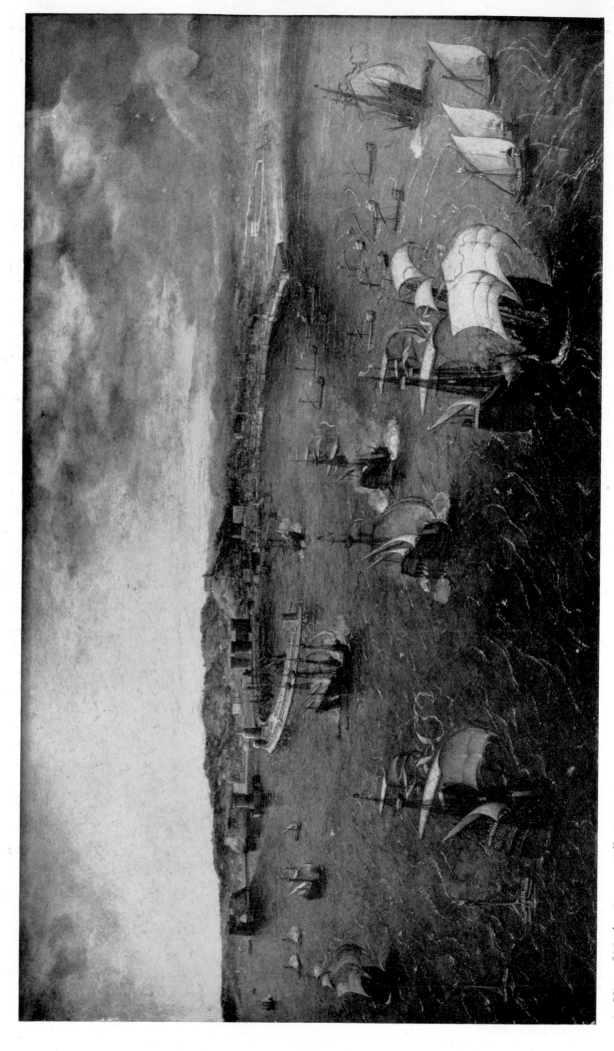

48. *View of Naples*. Rome, Galleria Doria.

39.8 × 69.5 cm.

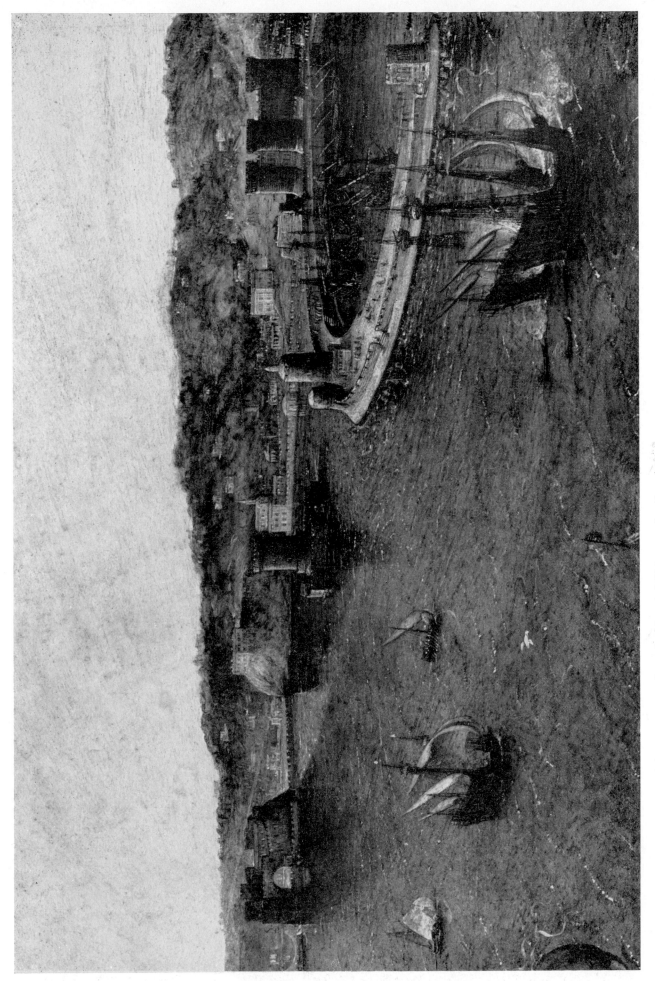

49. Detail from Plate 48: *View of the Coast Line from the Castel dell'Ovo to the Castel Nuovo.*

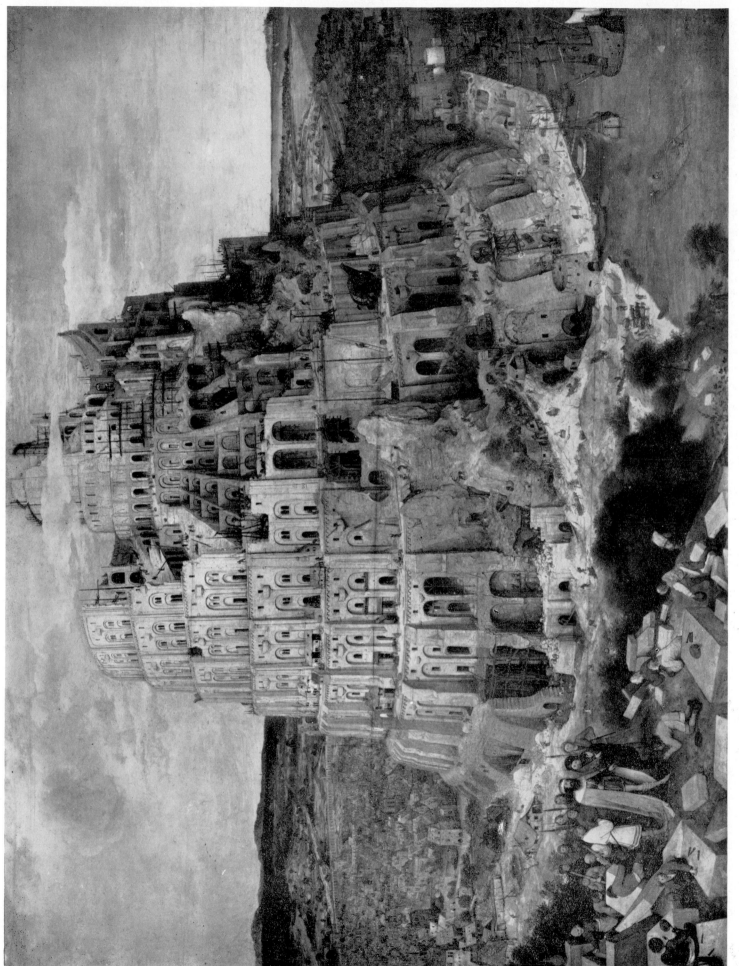

50. *The Tower of Babel.* 1563. Vienna, Kunsthistorisches Museum. 114 × 155 cm.

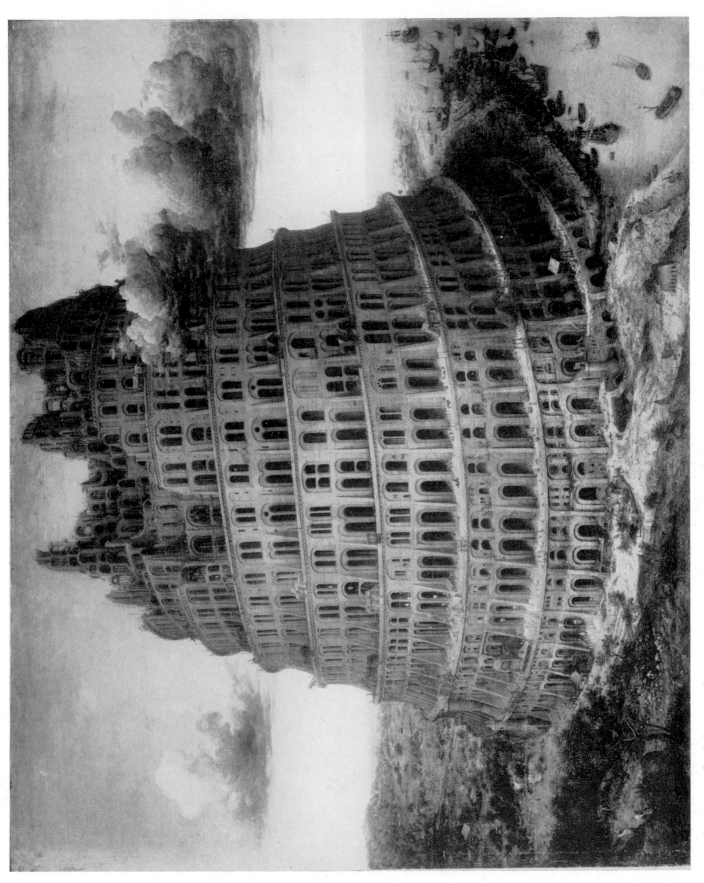

51. *The Tower of Babel.* Rotterdam, Museum Boymans – Van Beuningen.

60 × 74.5 cm.

52. Detail from Plate 50: *The Road leading up to the Tower.*

56. Detail from Plate 50: *Work on the Tower* (on the right).

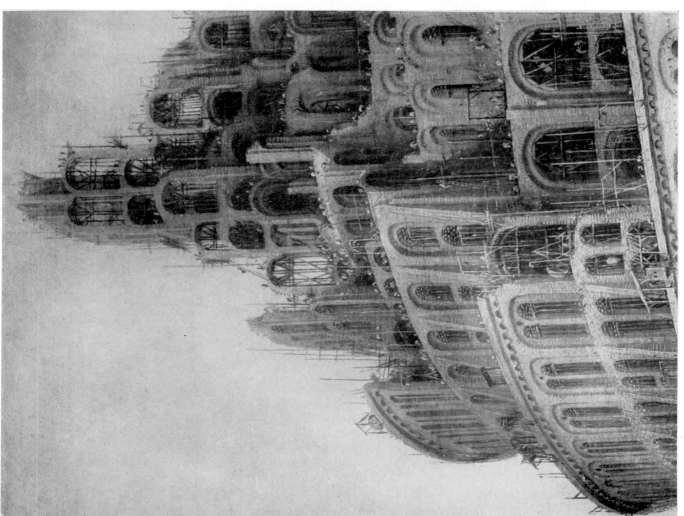

55. Detail from Plate 51: *The Top of the Tower*.

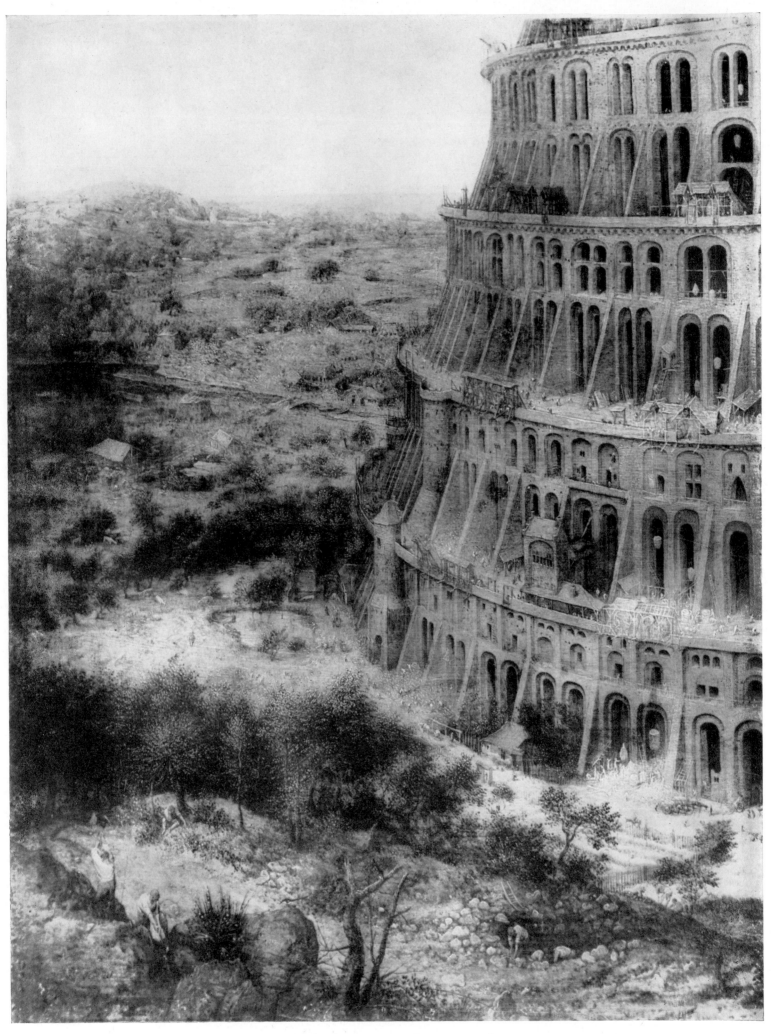

57. Detail from Plate 51: *The left Side of the Tower, with a Quarry in the Foreground.*

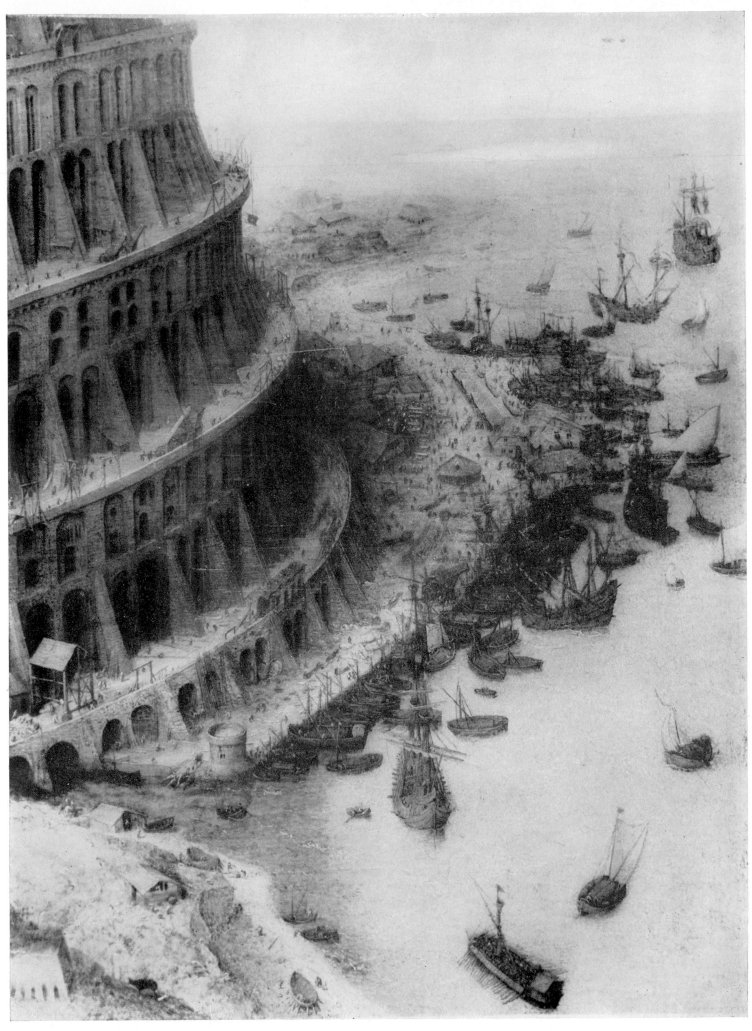

58. Detail from Plate 51: *The right Side of the Tower, with the Harbour.*

59. Detail from Plate 51: *The Pond to the left of the Tower.*

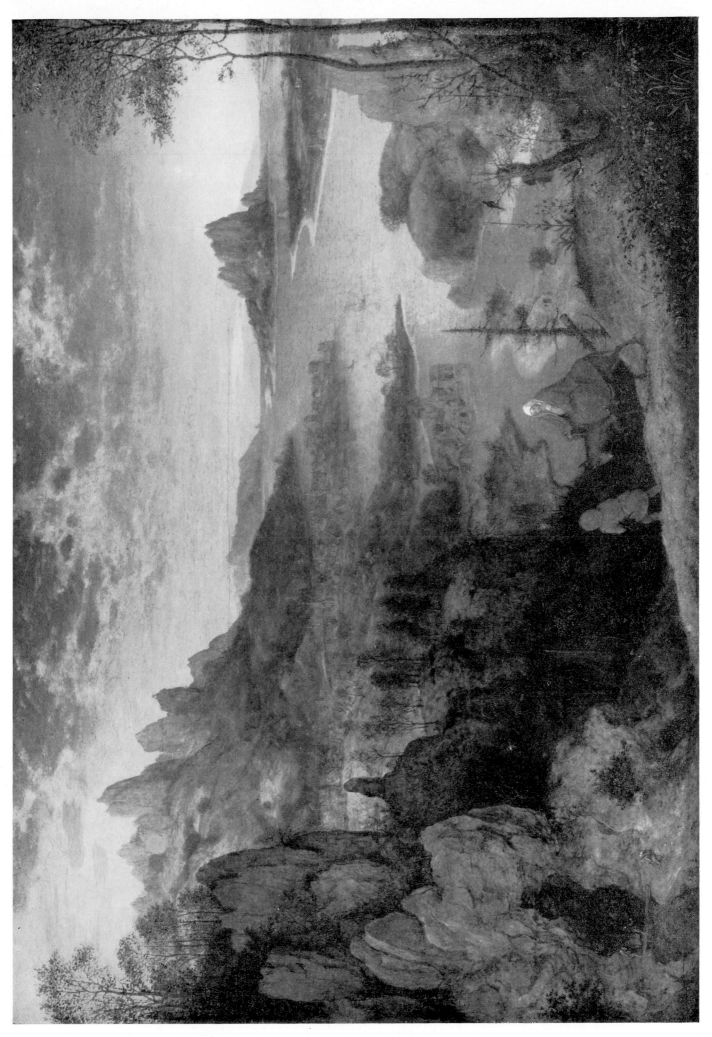

60. *The Flight into Egypt.* 1563. London, Count Antoine Seilern Collection.

37.2 × 55.5 cm.

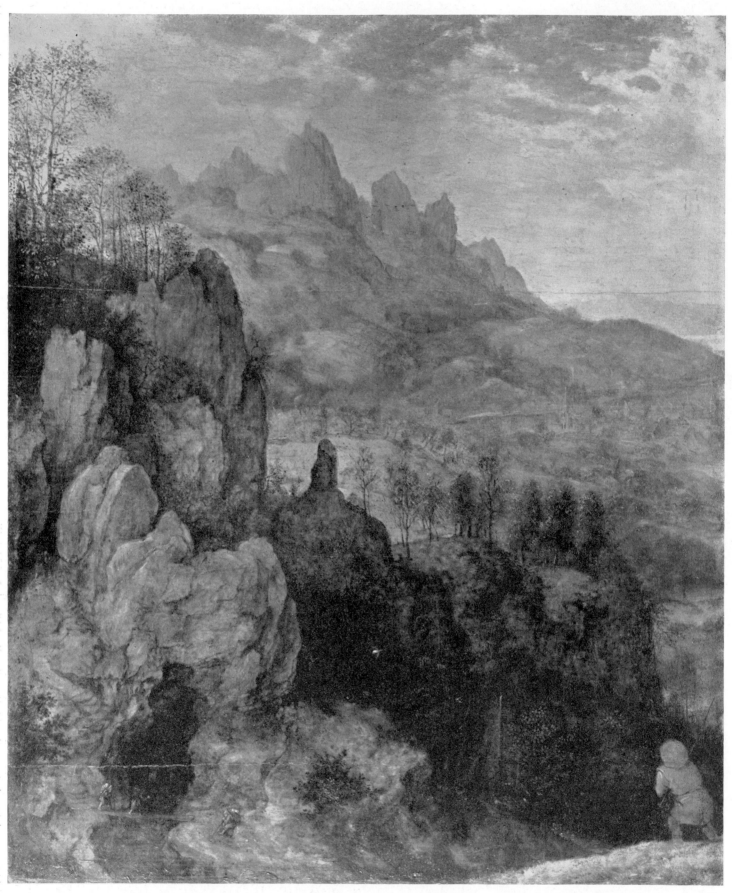

61. Detail from Plate 60: *The Rocks and Mountains on the left*.

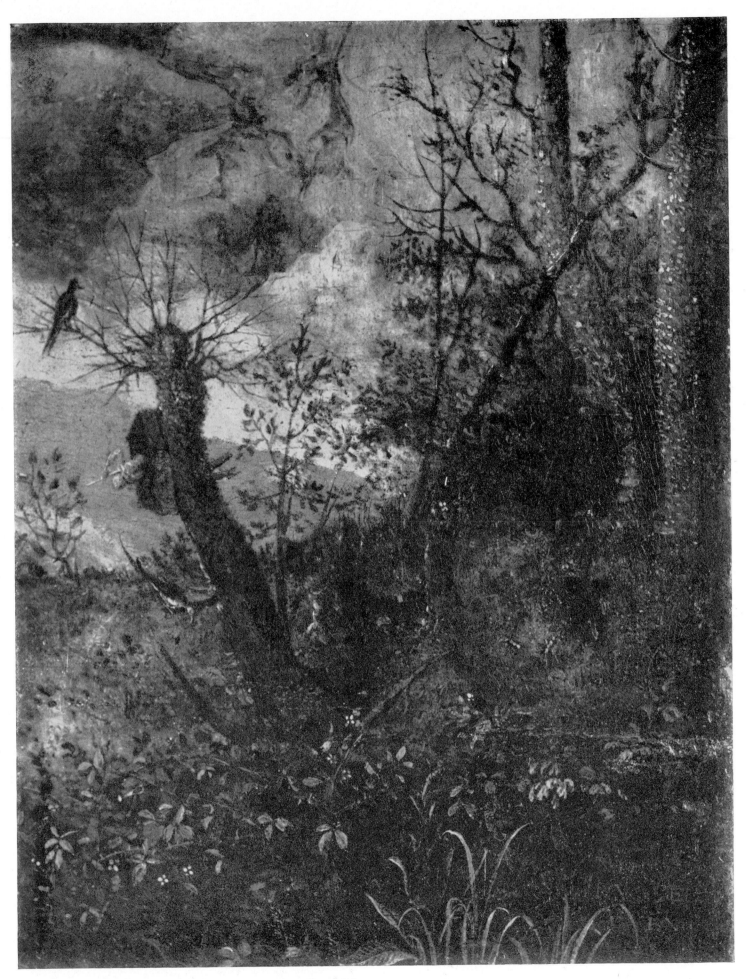

62. Detail from Plate 60: *Wayside Shrine with Falling Idol*.

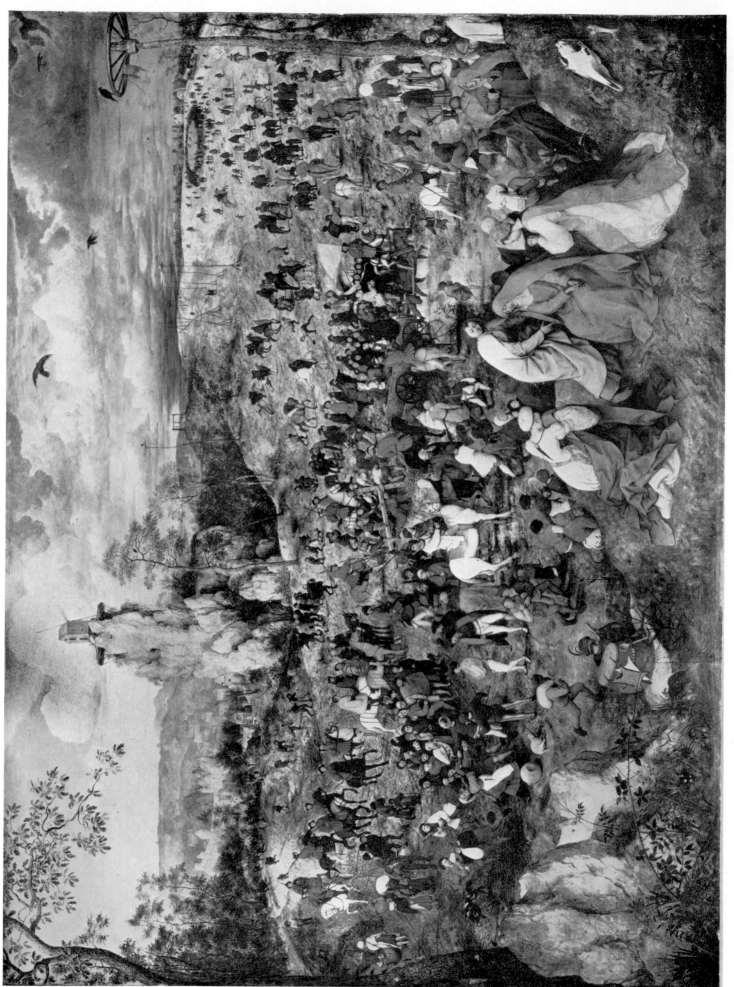

63. *The Procession to Calvary.* 1564. Vienna, Kunsthistorisches Museum.

124 × 170 cm.

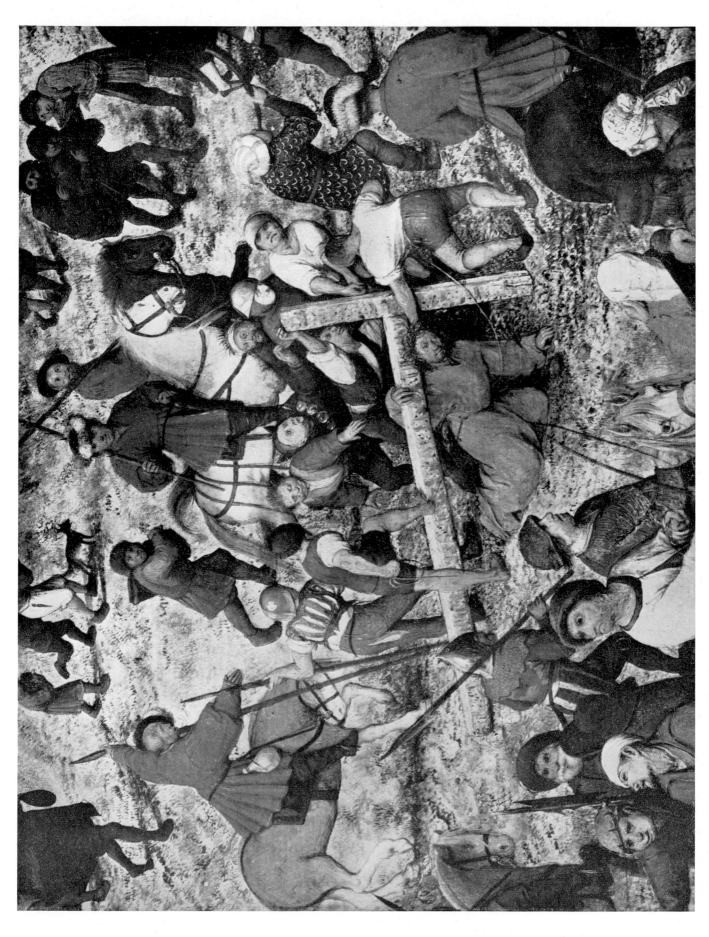

64. Detail from Plate 63: *Christ Falling beneath the Cross.*

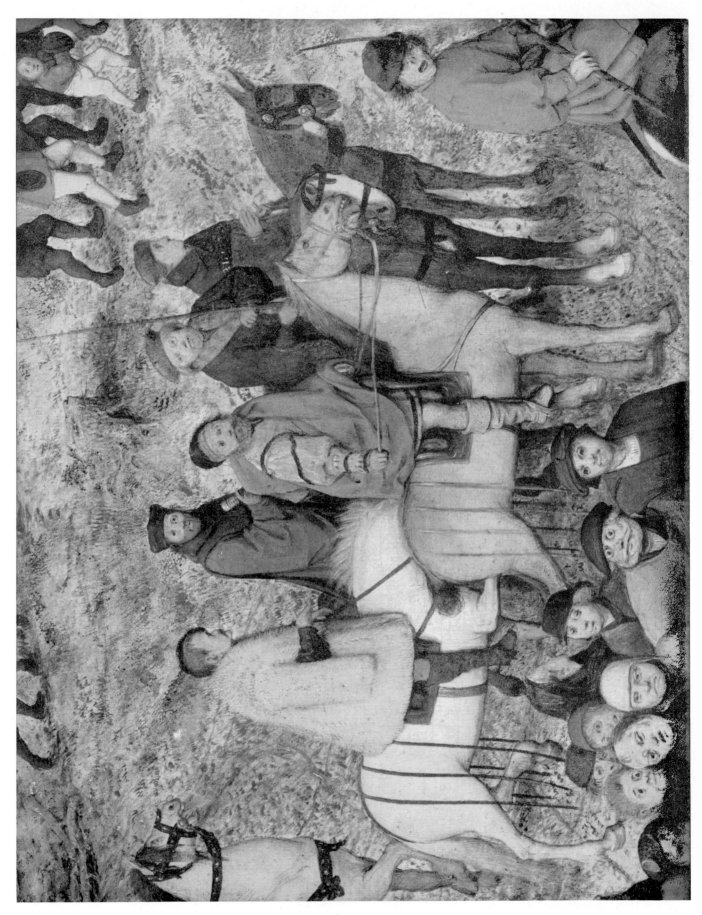

65. Detail from Plate 63: *Group of Riders behind Christ.*

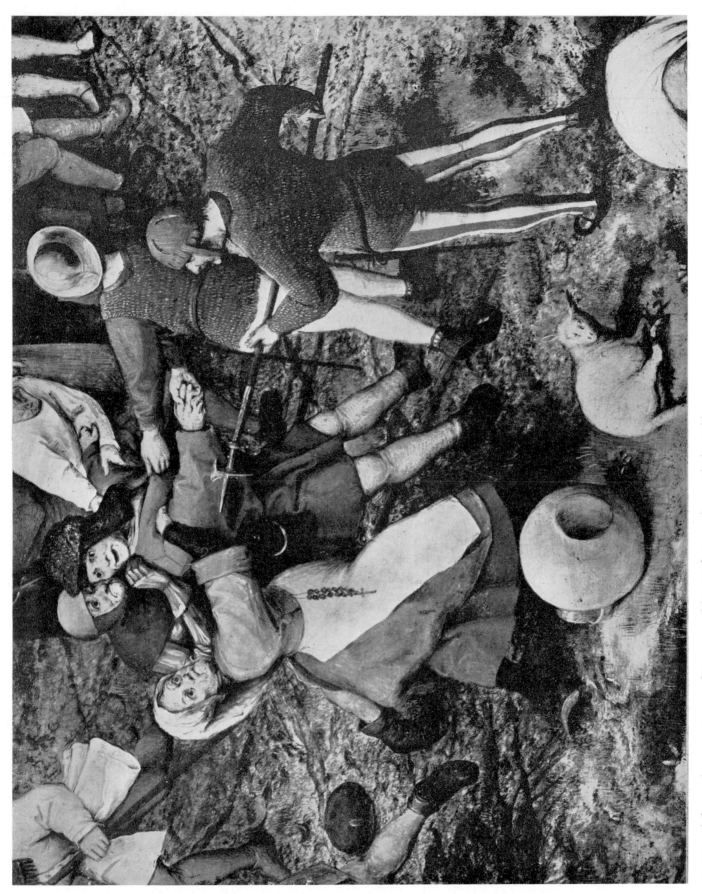

66. Detail from Plate 63: *Simon of Cyrene and his Wife Struggling with the Soldiers.*

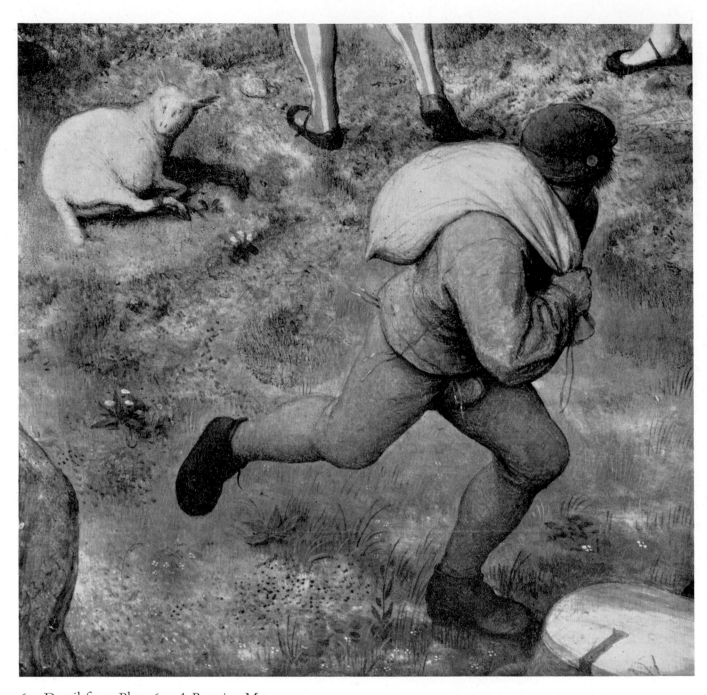

67. Detail from Plate 63: *A Running Man*.

68. Detail from Plate 63: *A Thistle*.

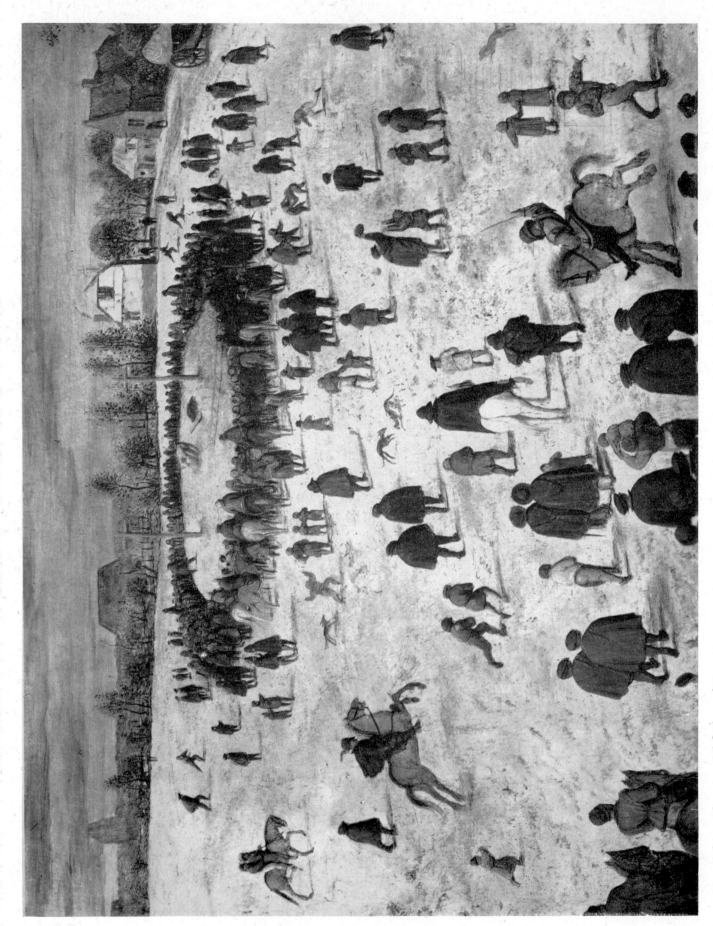

69. Detail from Plate 63: *The Place of Execution.*

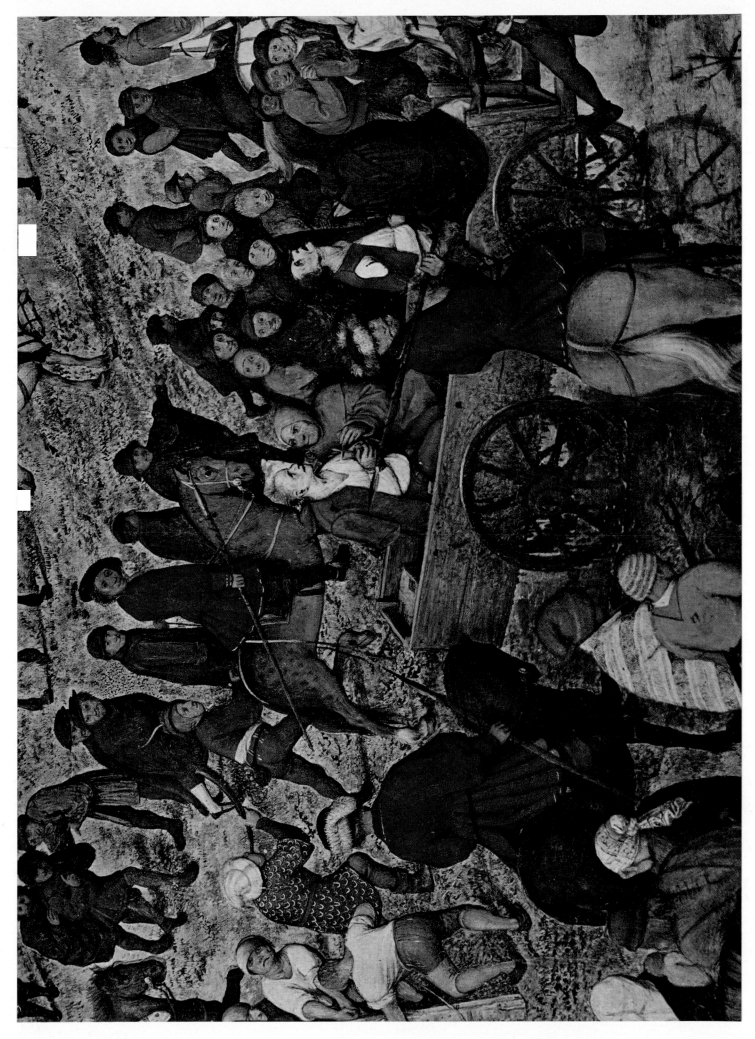

70. Detail from Plate 63: *The Two Thieves.*

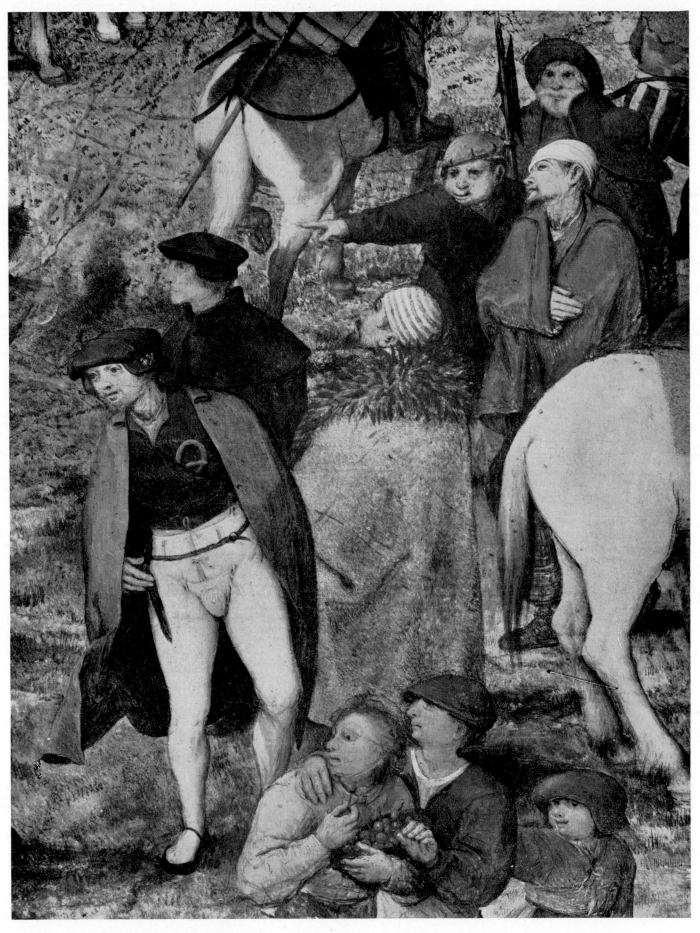

71. Detail from Plate 63: *Onlookers*.

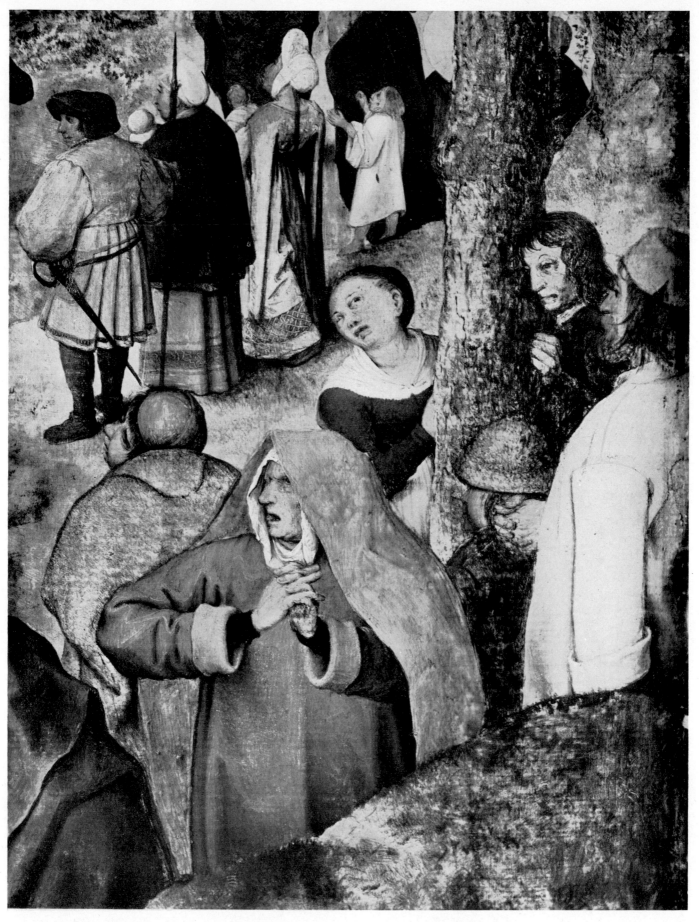

72. Detail from Plate 63: *Mourners and Onlookers*.

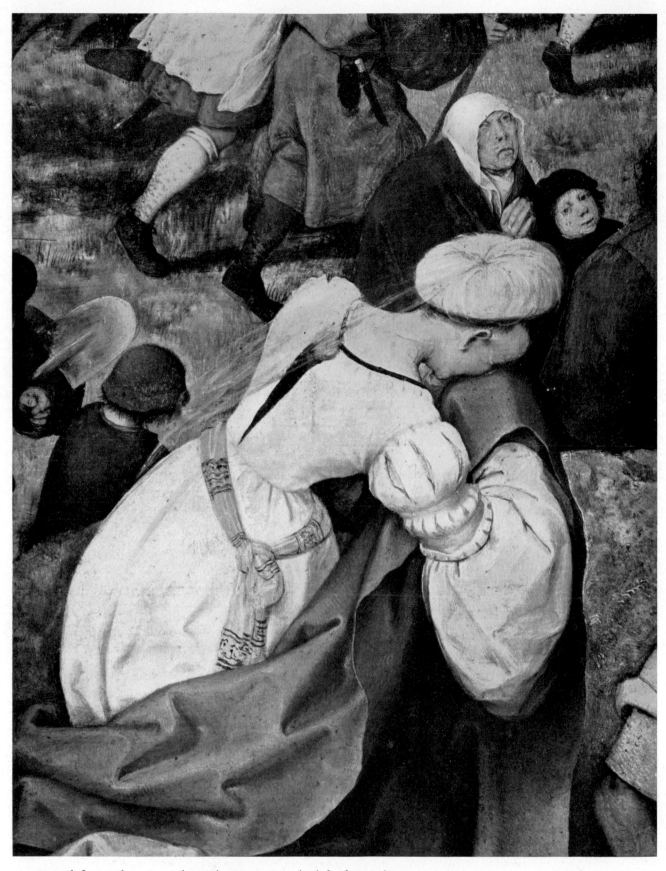

73. Detail from Plate 63: *The Holy Woman to the left of St. John*.

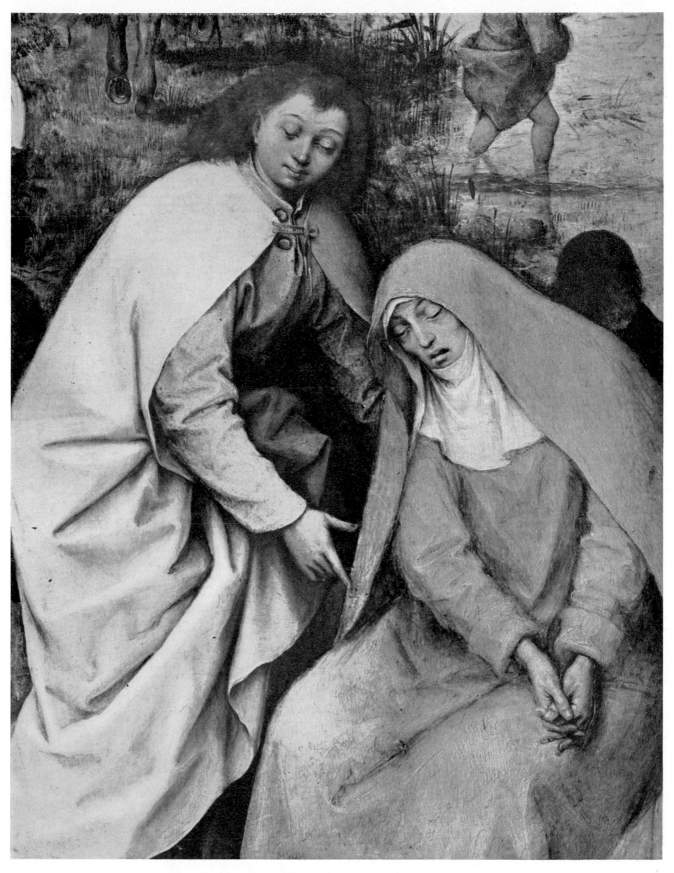

74. Detail from Plate 63: *The Virgin and St. John*.

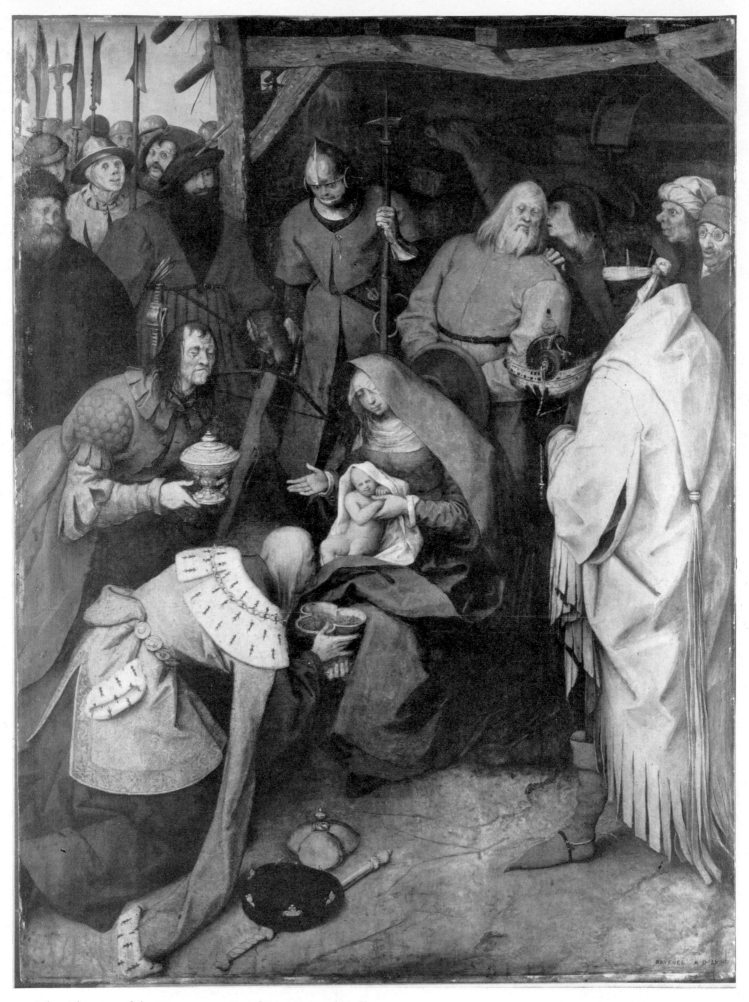

75. *The Adoration of the Kings.* 1564. London, National Gallery. 111 × 83.5 cm.

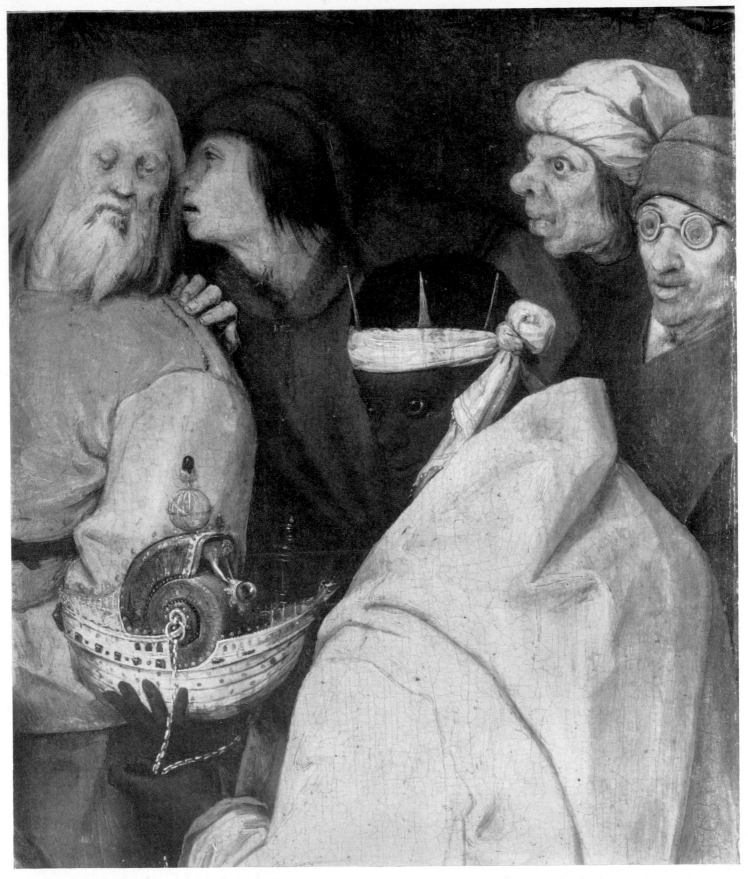

76. Detail from Plate 75: *St. Joseph and Onlookers*.

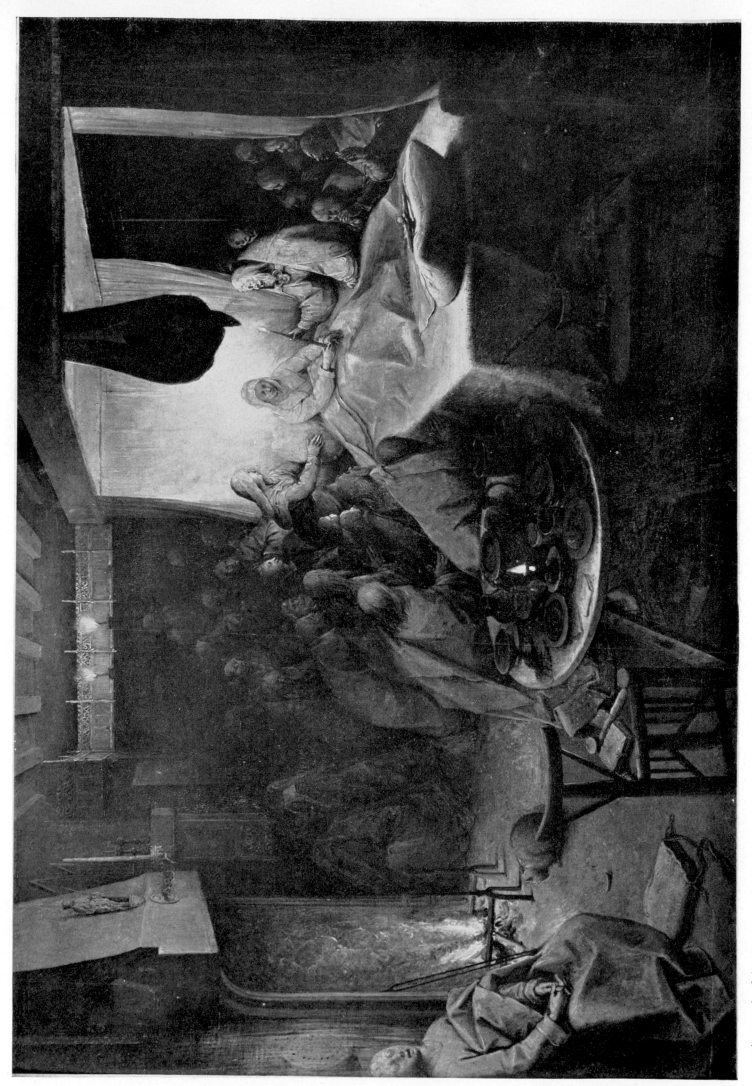

77. *The Death of the Virgin.* Banbury, Upton House, National Trust. 36 × 54.5 cm.

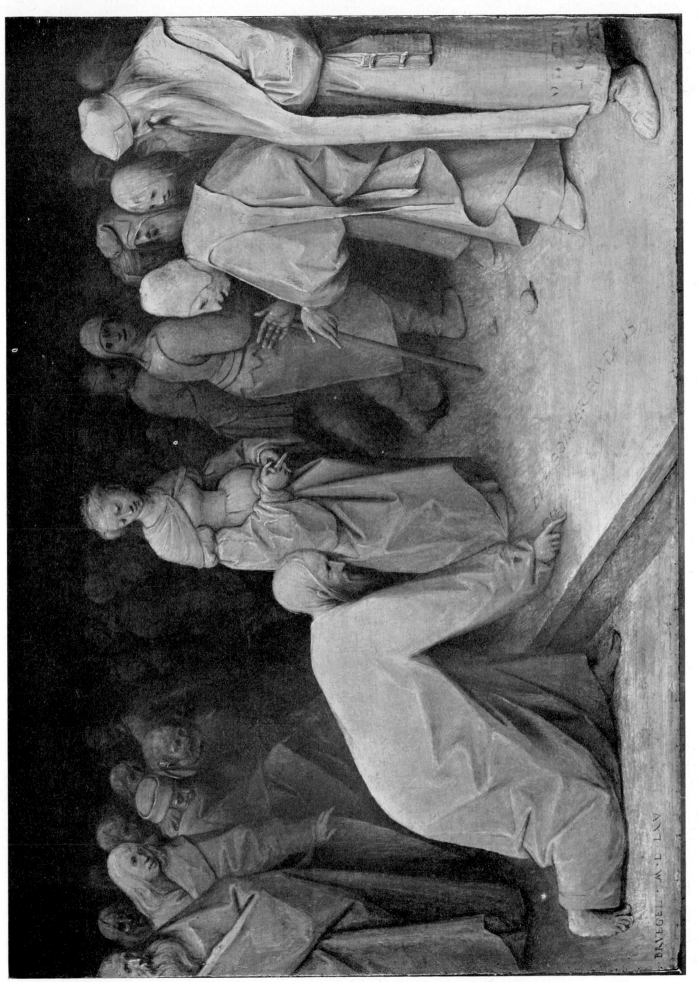

78. *Christ and the Woman taken in Adultery*. 1565. London, Count Antoine Seilern Collection. 24.1 × 34.4 cm.

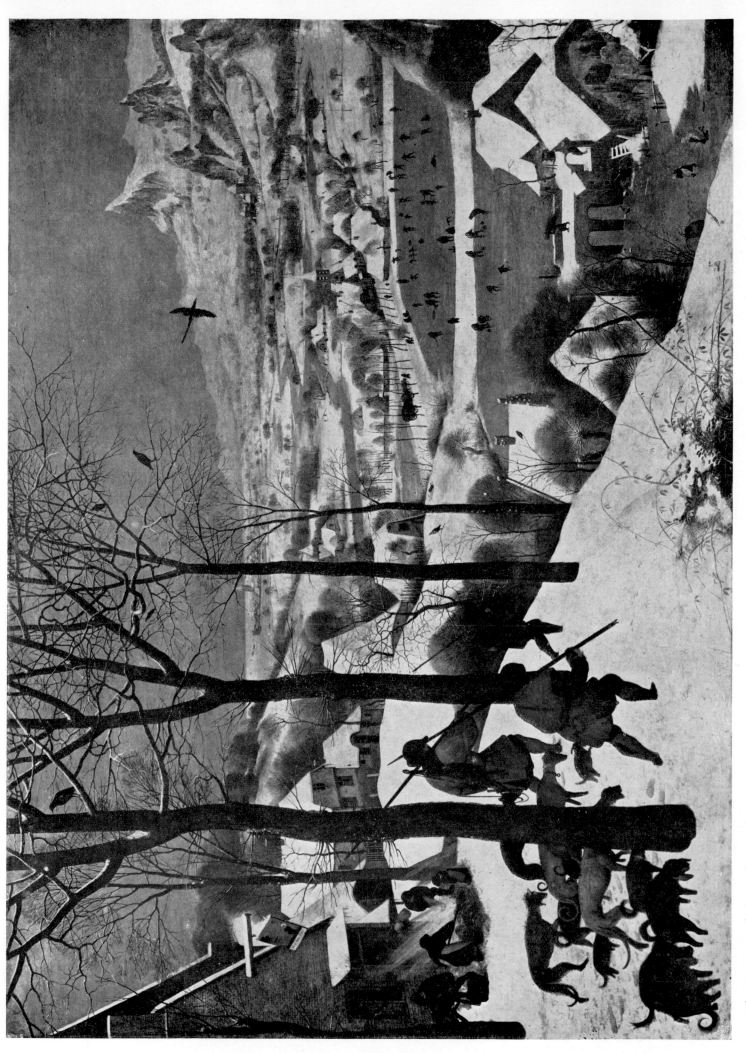

79. *The Hunters in the Snow (January)*. 1565. Vienna, Kunsthistorisches Museum. 117 × 162 cm.

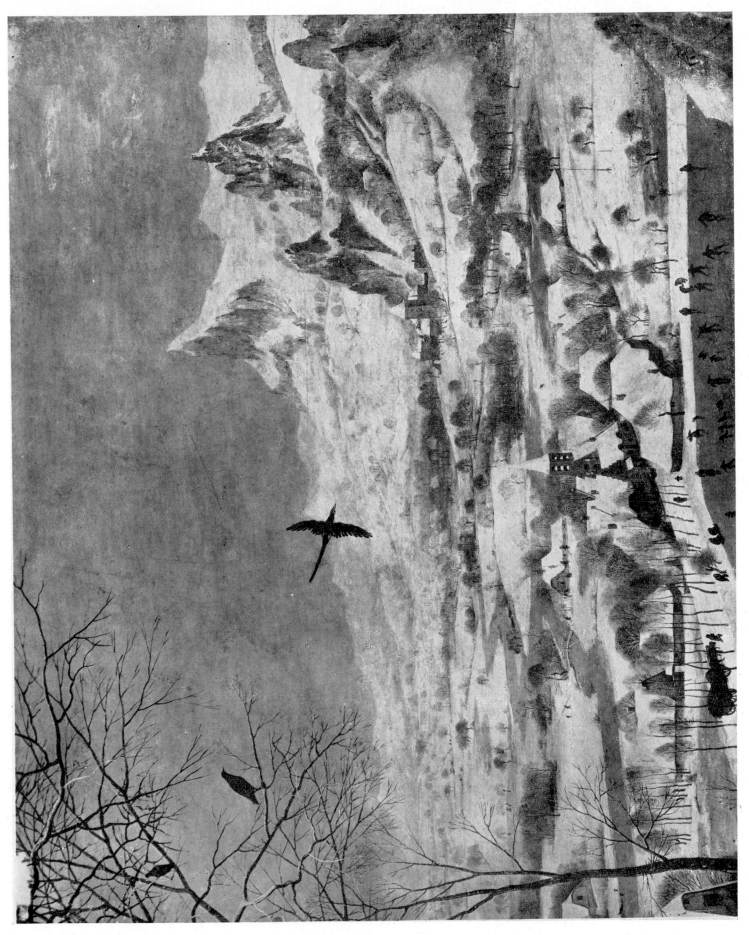

80. *Detail from Plate 79: The Village at the Foot of the Snow-covered Mountains.*

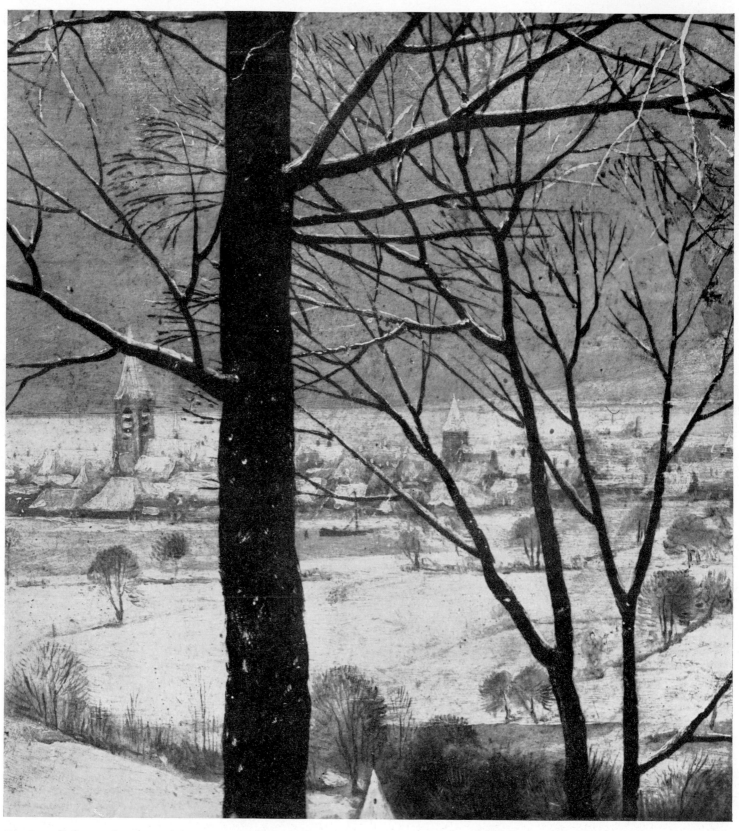

81. Detail from Plate 79: *A Distant Town seen through Trees.*

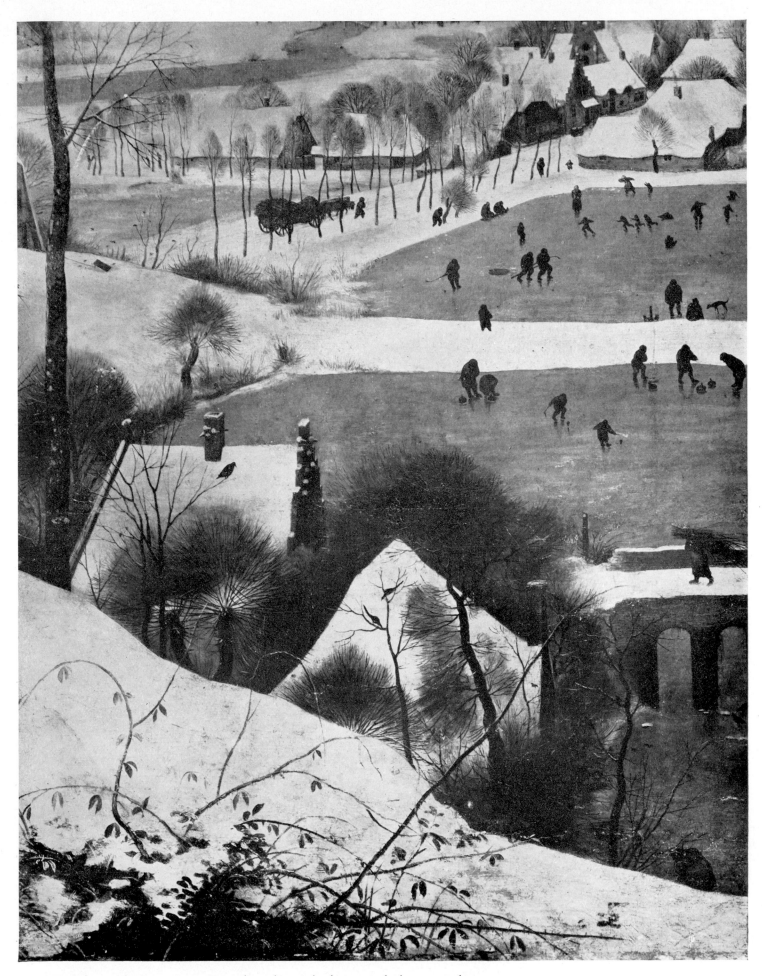

82. Detail from Plate 79: *Frozen Ponds with People skating and playing Hockey.*

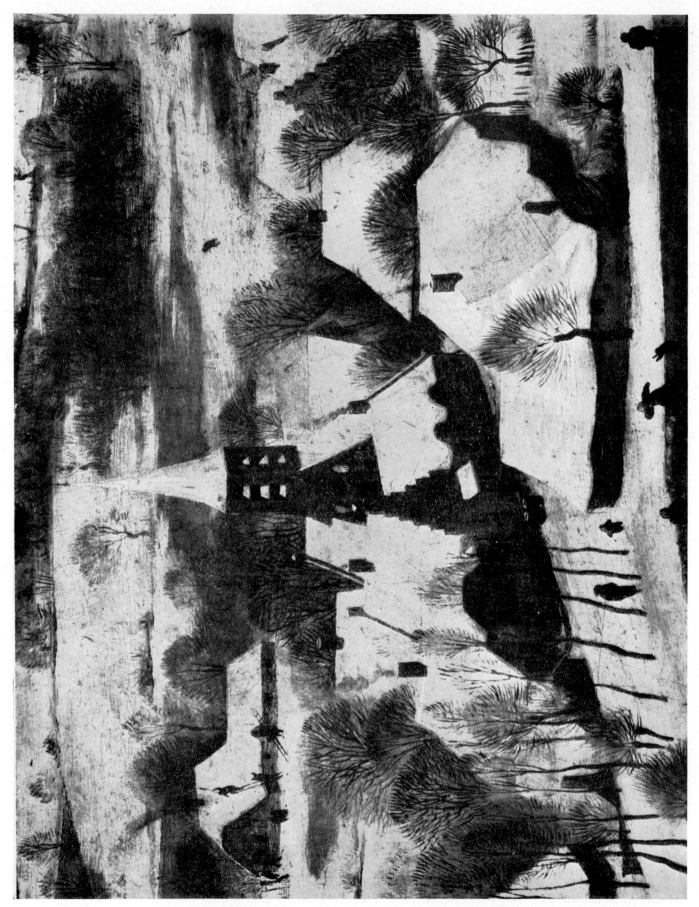

83. Detail from Plate 79: *Snow-covered Village*.

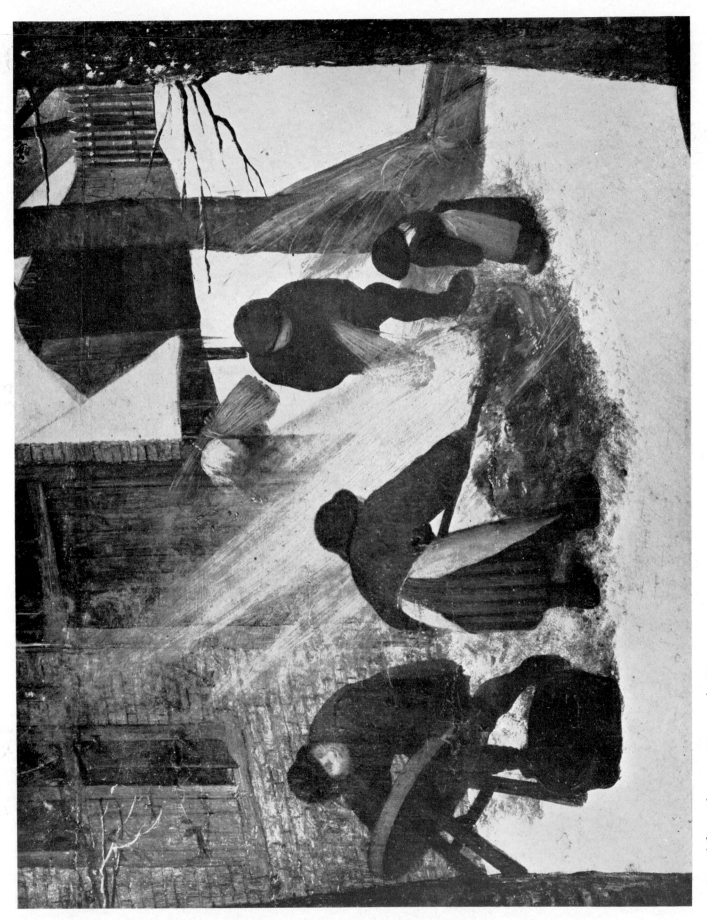

84. Detail from Plate 79: *Singeing the Pig.*

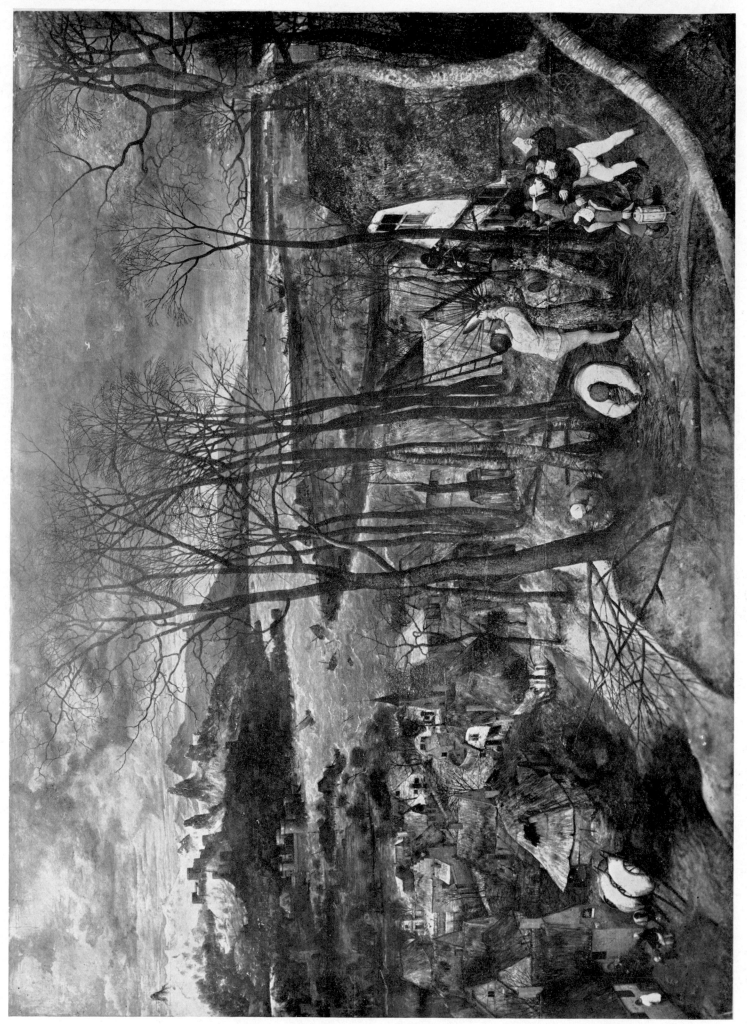

85. *The Gloomy Day (February)*. 1565. Vienna, Kunsthistorisches Museum.

118 × 163 cm.

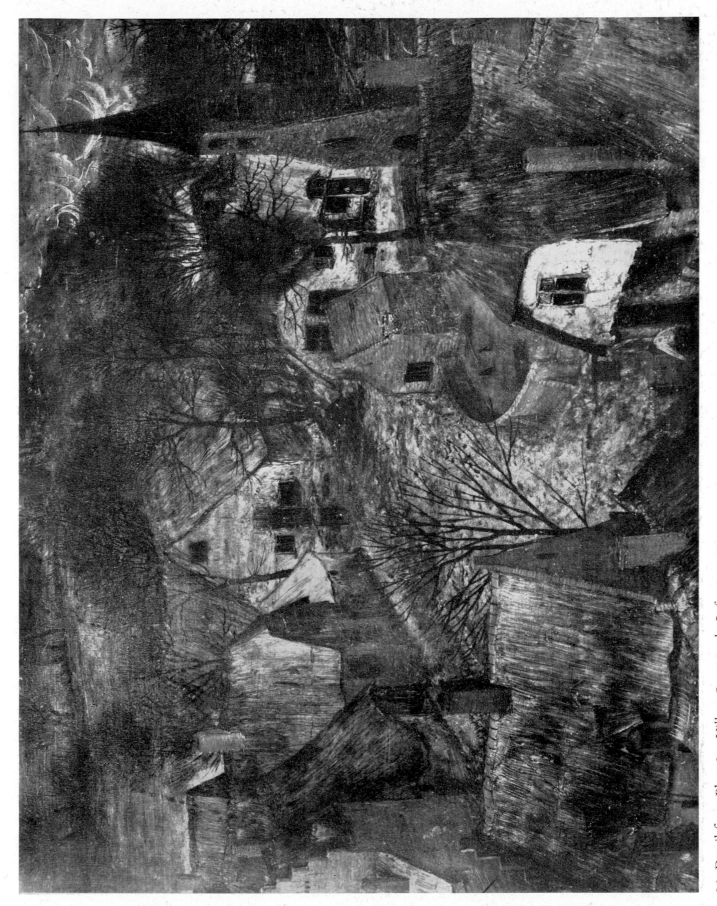

86. Detail from Plate 85: *Village Street on the Left.*

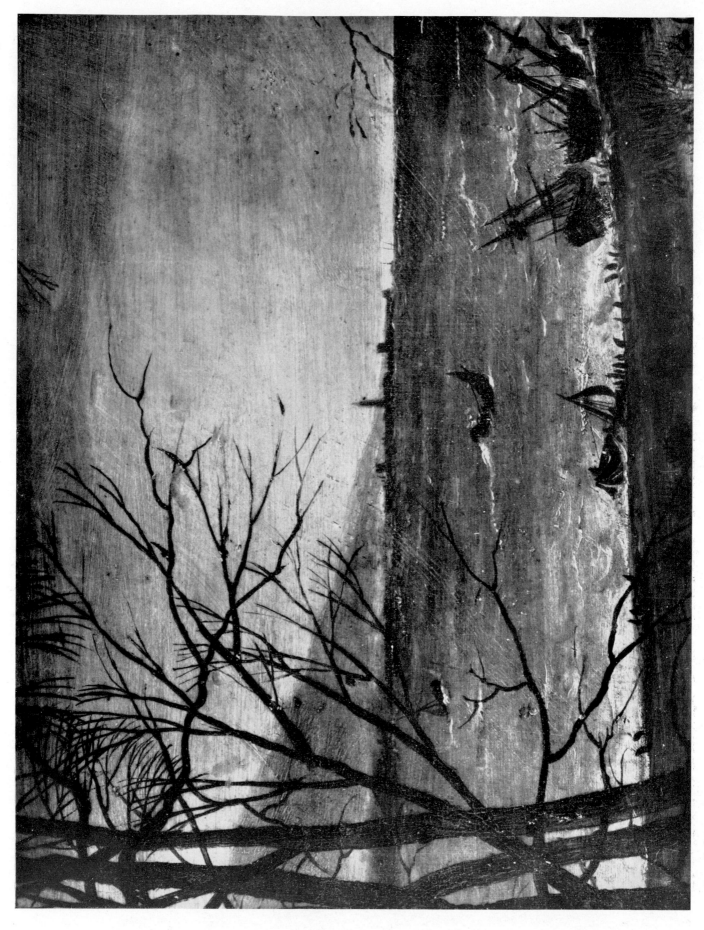

87. Detail from Plate 85: *Stormy Sea*.

88. Detail from Plate 85: *Trees*.

89. Detail from Plate 85: *Pruning Willows and Tying Twigs*.

90. Detail from Plate 85: *Carnival Revellers (Man eating Waffle, Child with Carnival Paper Crown led by a Woman).*

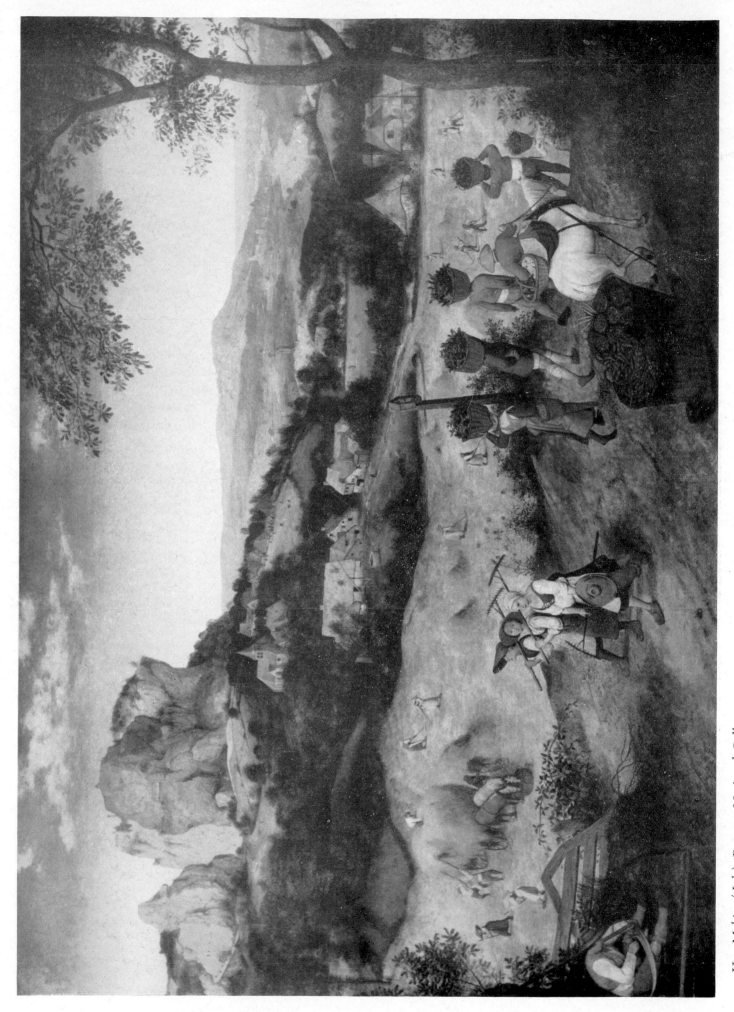

91. *Hay Making (July)*. Prague, National Gallery. 117 × 161 cm.

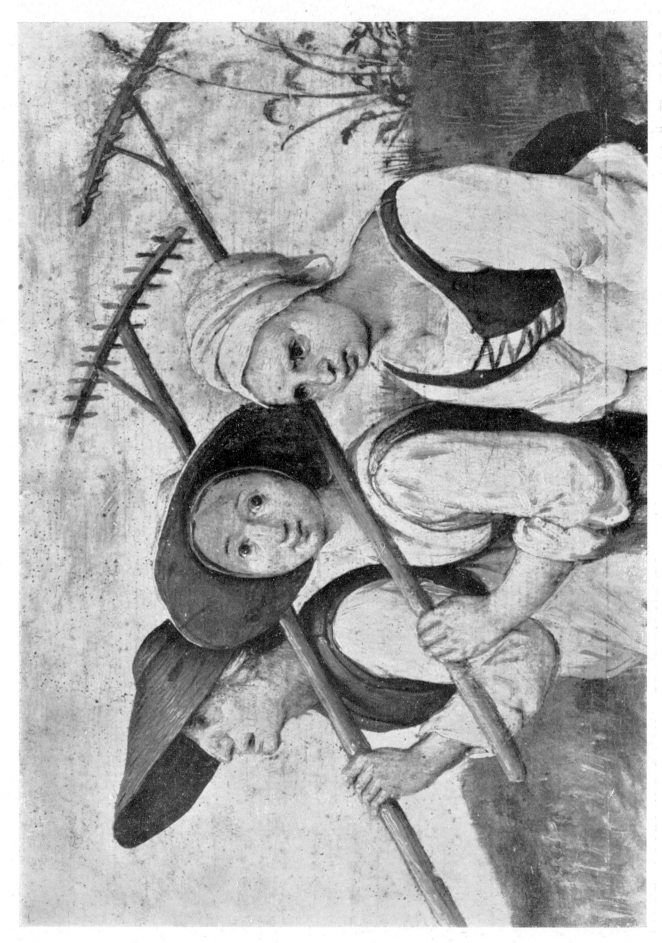

92. *Detail from Plate 91: Three Haymakers.*

93. Detail from Plate 91: *A Clearing in the Wood with two Women* (Left Side of Picture).

94. Detail from Plate 91: *Meadow and Woods* (near the left Border).

95. Detail from Plate 91: *Meadow in the Middle Distance on the right*.

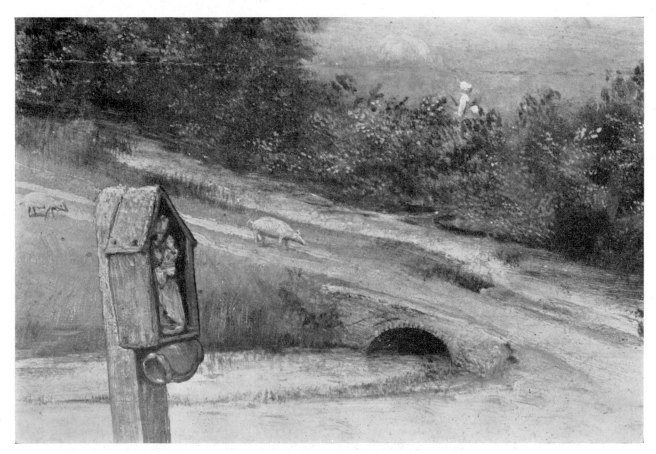

96. Detail from Plate 91: *Wayside Shrine with the Statue of the Virgin*.

98. Detail from Plate 91: *The Horses of the Hay Waggon.*

97. Detail from Plate 91: *Men loading Hay.*

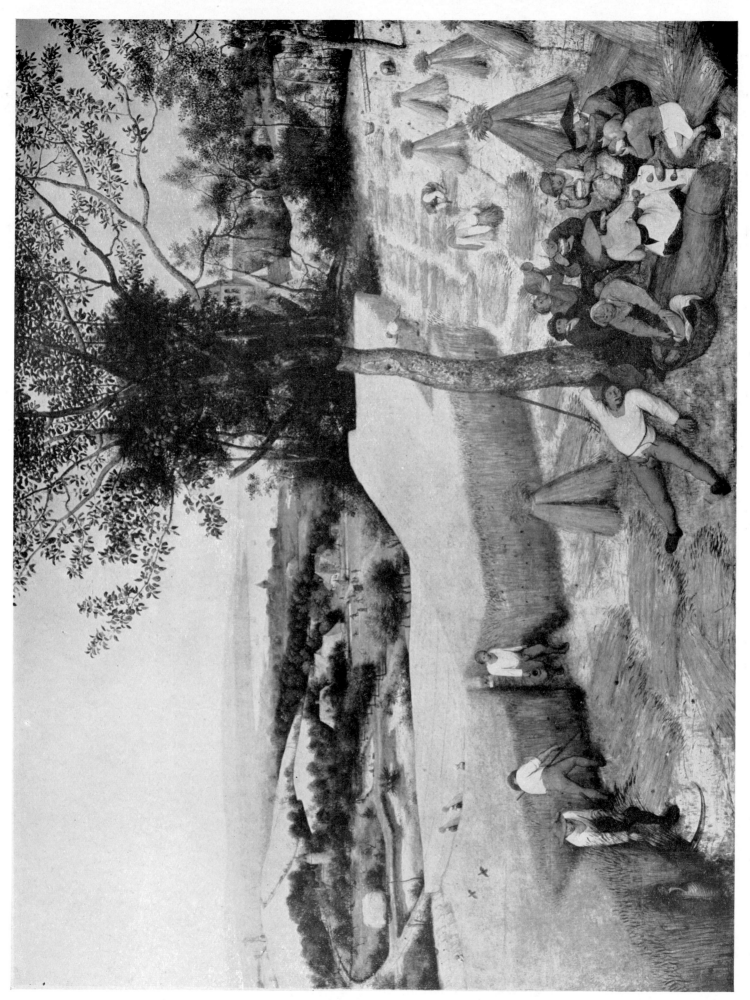

99. *The Corn Harvest (August).* 1565. New York, Metropolitan Museum of Art.

118 × 160.7 cm.

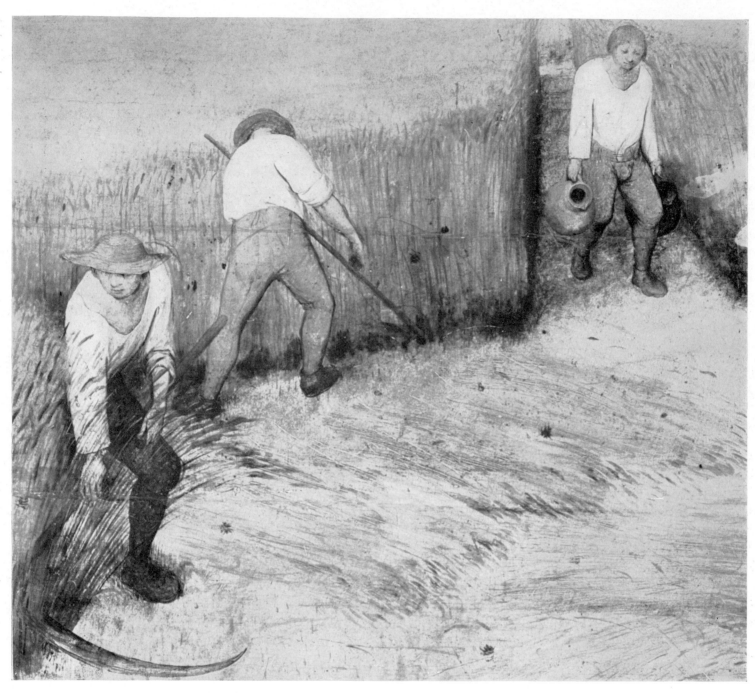

100. Detail from Plate 99: *Reaping*.

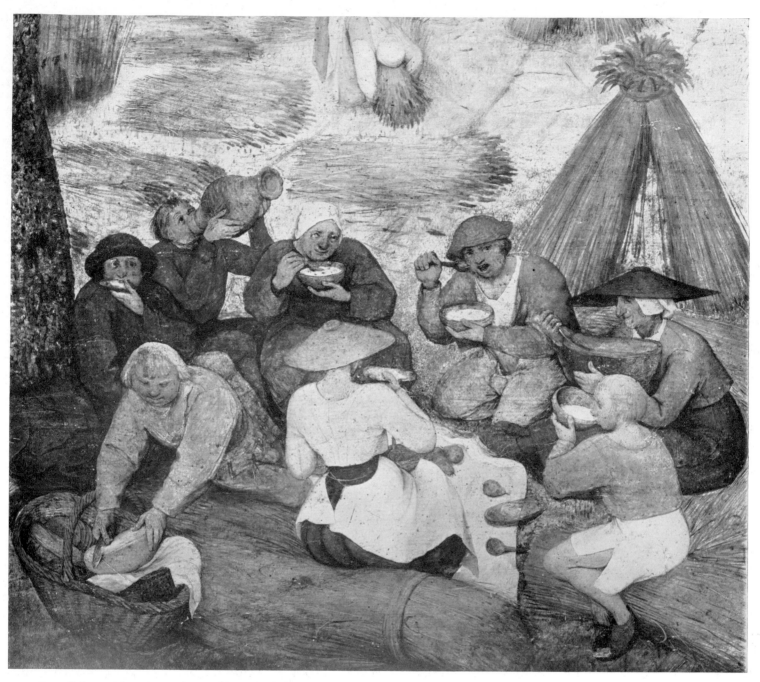

101. Detail from Plate 99: *The Midday Meal.*

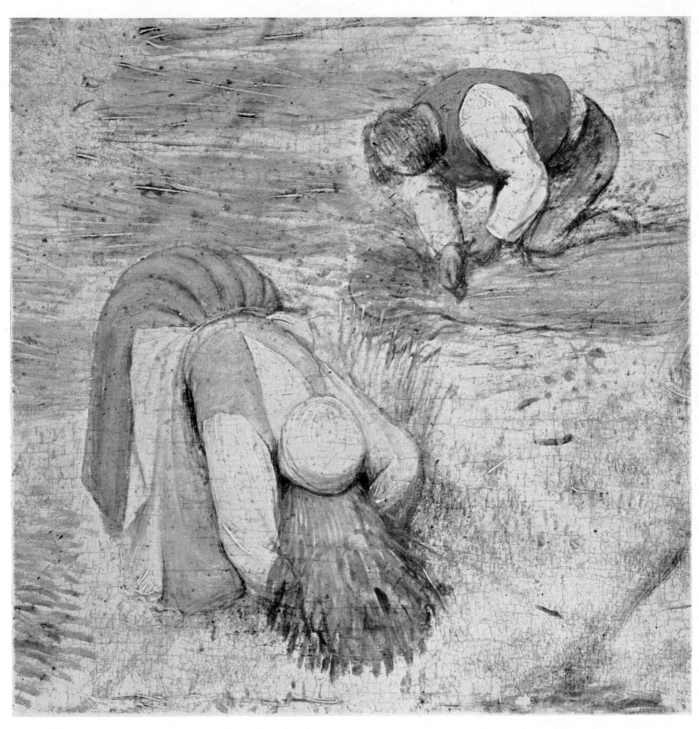

102. Detail from Plate 99: *Tying Corn Sheaves*.

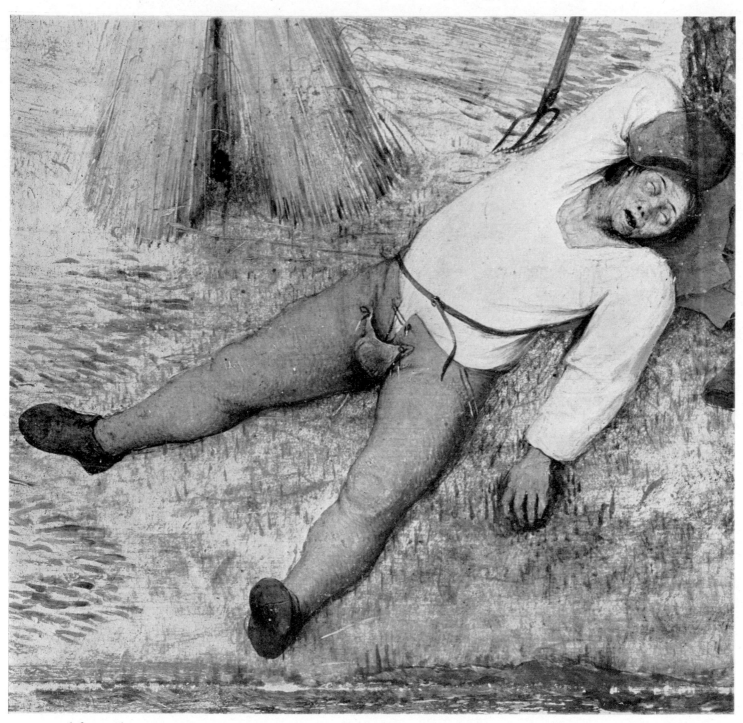

103. Detail from Plate 99: *A Reaper resting*.

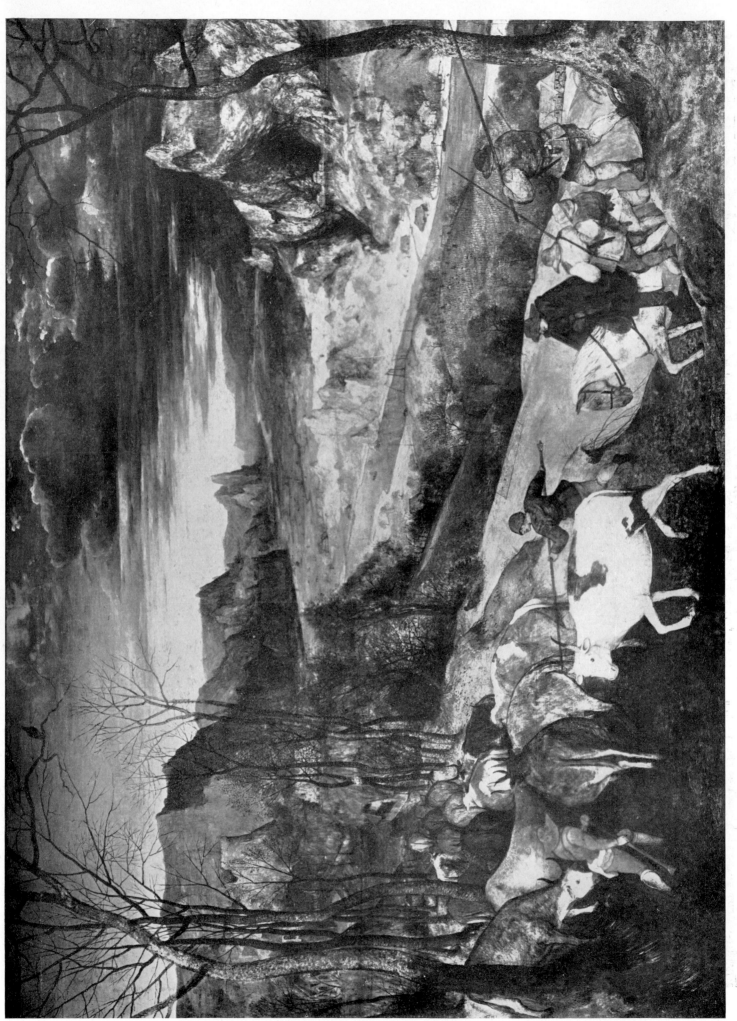

104. *The Return of the Herd (October or November?).* 1565. Vienna, Kunsthistorisches Museum. 117 × 159 cm.

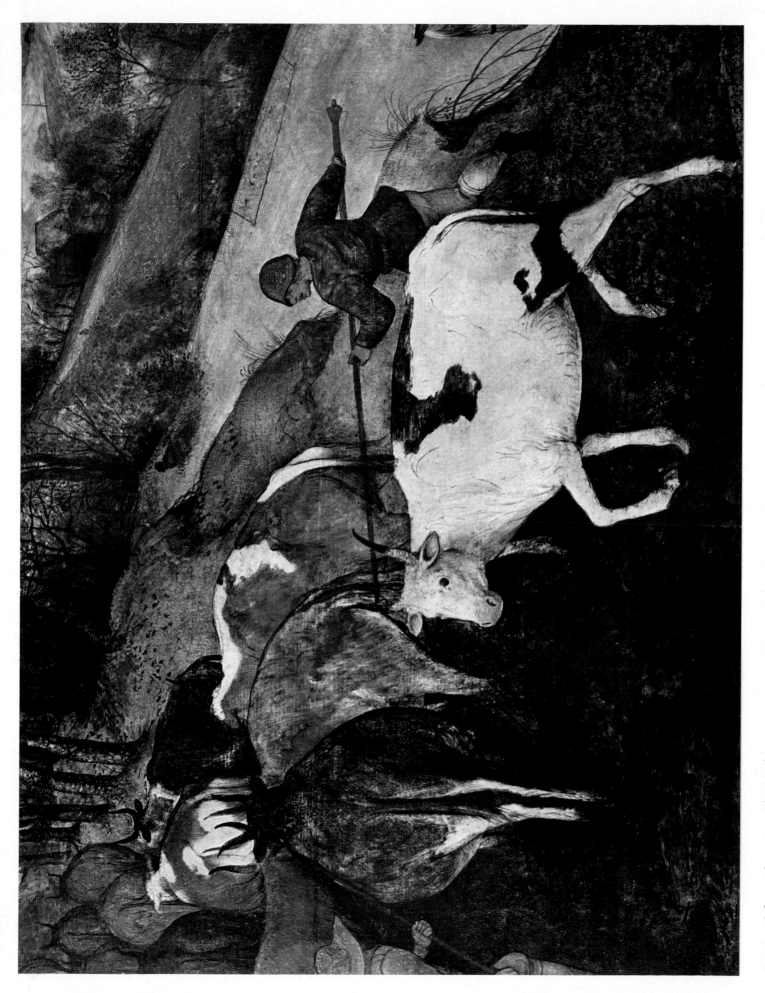

105. Detail from Plate 104: *The Herd.*

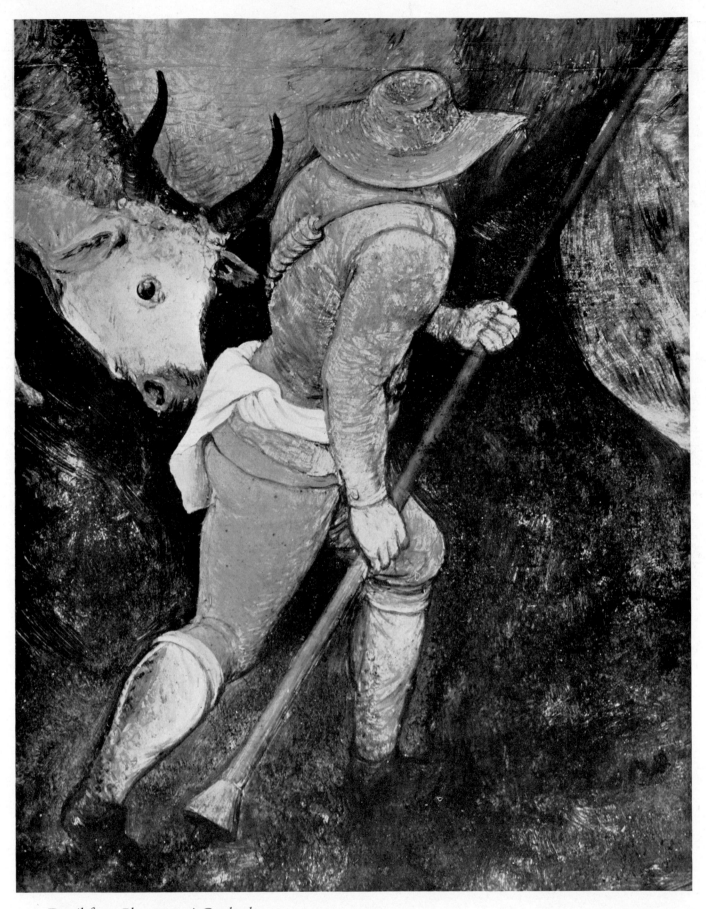

106. Detail from Plate 104: *A Cowherd*.

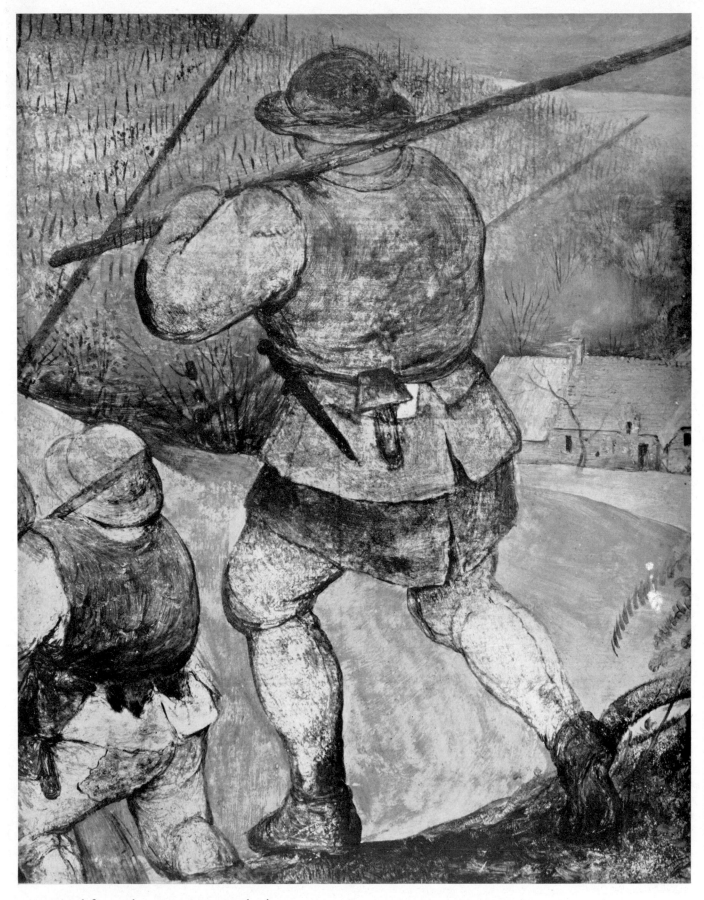

107. Detail from Plate 104: *Two Cowherds*.

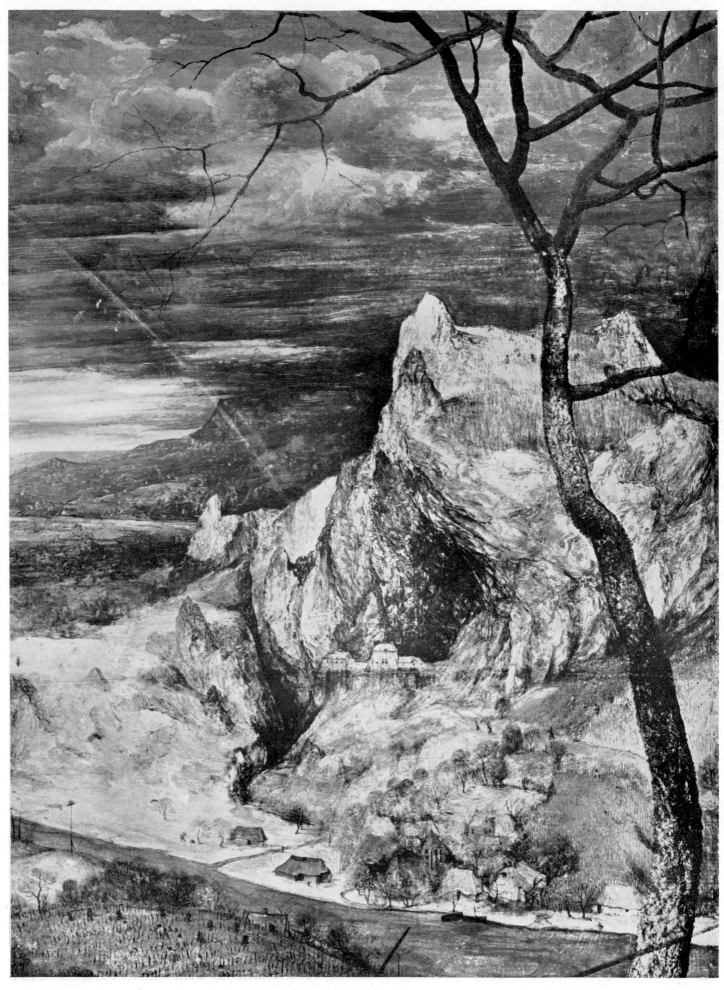

108. Detail from Plate 104: *Rocky Mountain, River and Vineyard.*

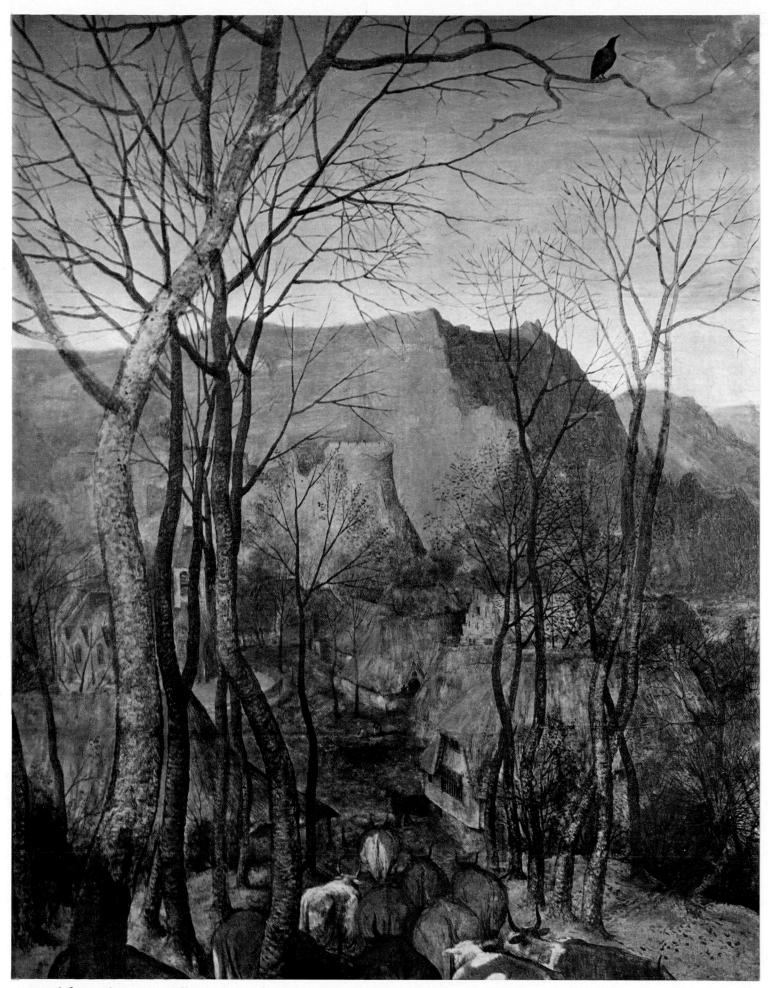

109. Detail from Plate 104: *Village Street and Ruin of a Castle*.

110. *The Massacre of the Innocents.* Vienna, Kunsthistorisches Museum. 116 × 160 cm.

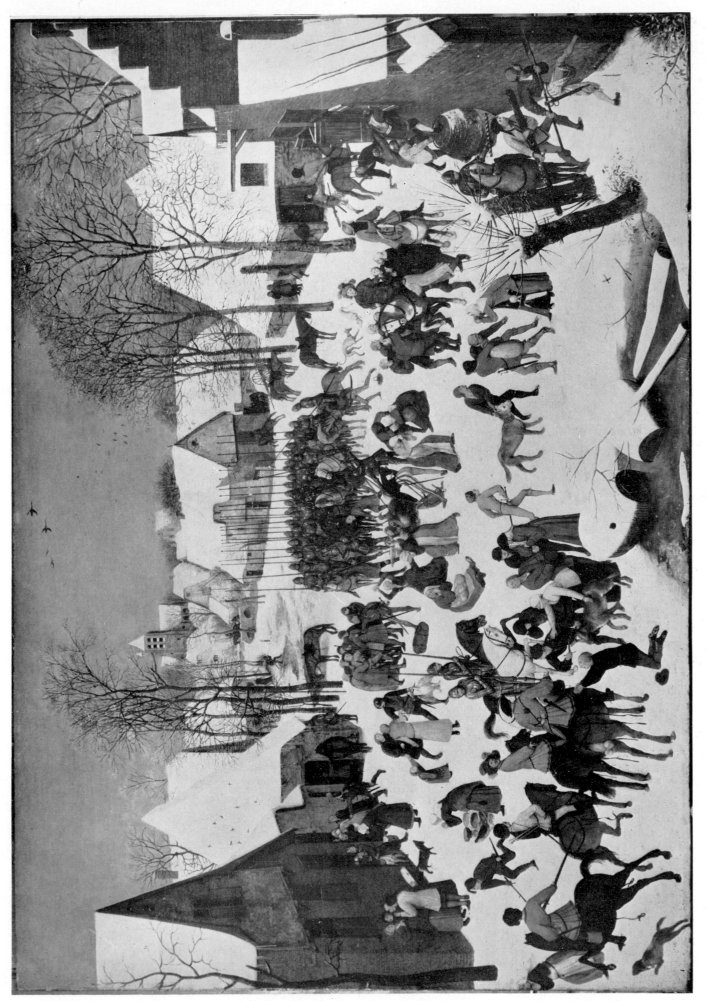

111. *The Massacre of the Innocents.* Hampton Court. Reproduced by gracious permission of H.M. The Queen.
109.2 × 154.9 cm.

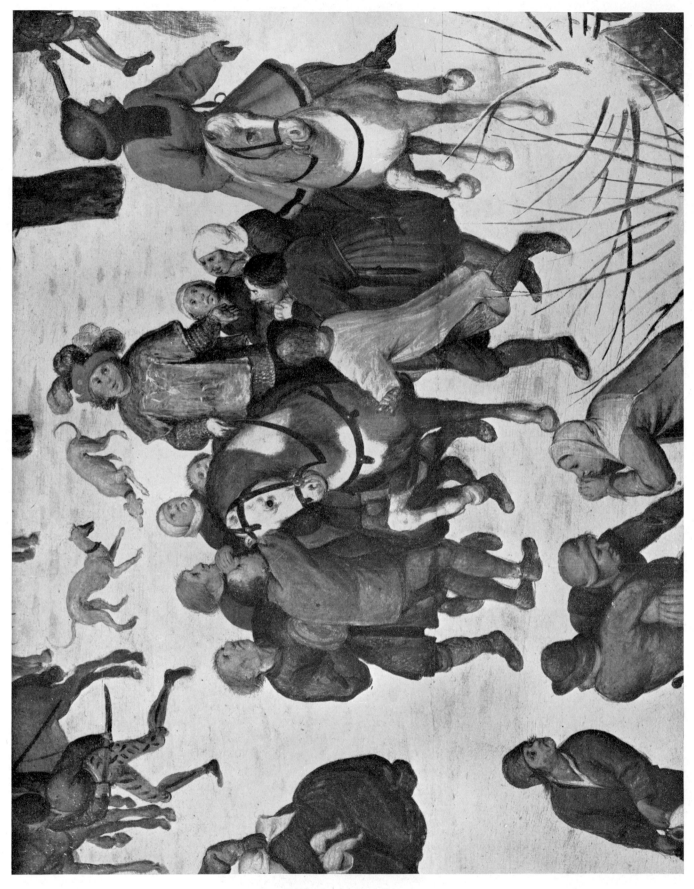

112. Detail from Plate 110: *Herald surrounded by Peasants praying for Mercy.*

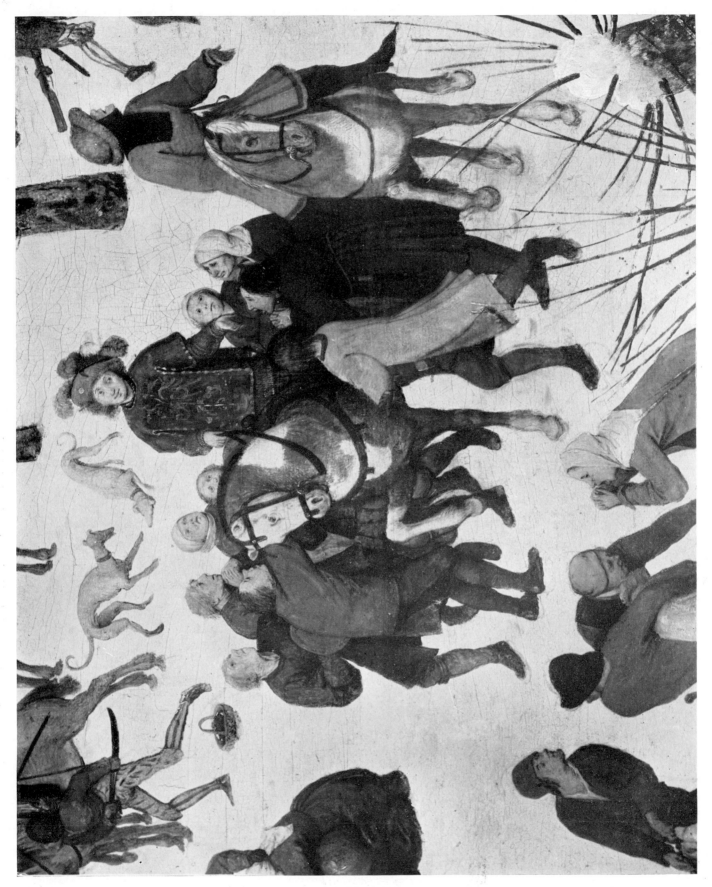

113. *Detail from Plate 111: Herald surrounded by Peasants praying for Mercy.*

114. *Winter Landscape with Skaters and a Bird-Trap.* 1565. Brussels, Dr. F. Delporte Collection. 38 × 56 cm.

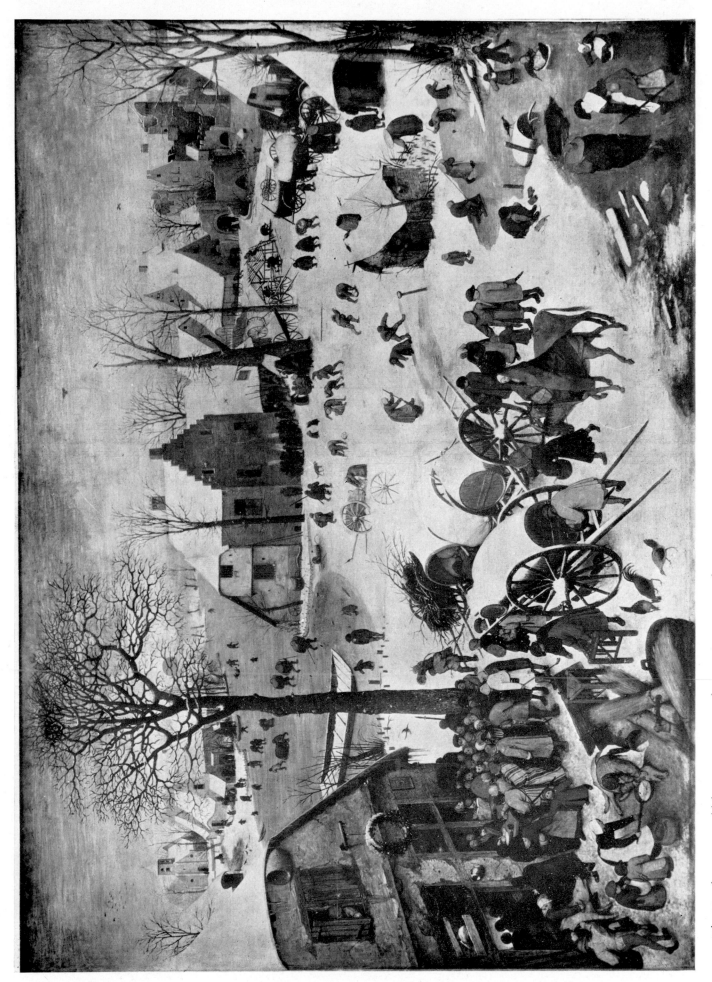

115. *The Numbering at Bethlehem.* 1566. Brussels, Musées Royaux des Beaux-Arts.

116 × 164.5 cm.

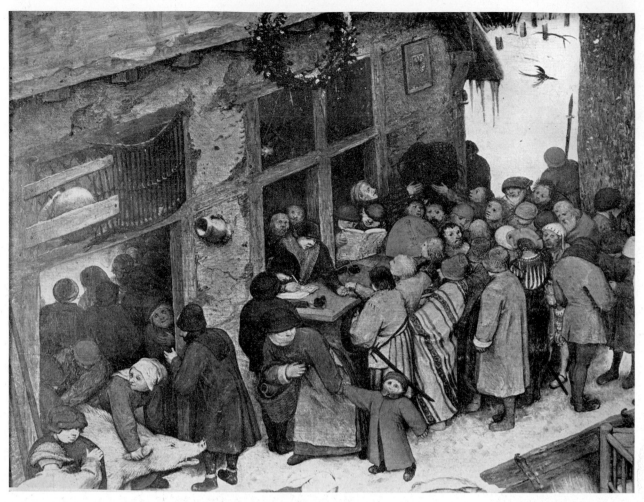

116. Detail from Plate 115: *The Clerk and the People*.

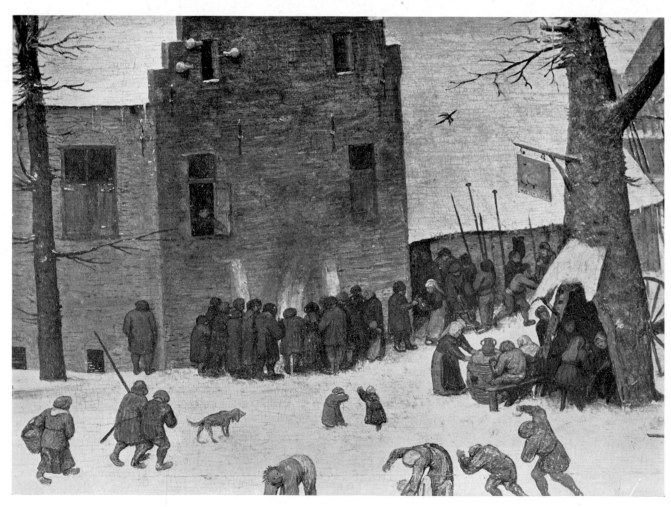

117. Detail from Plate 115: *People warming themselves by a Fire and Guests of the 'Tree' Inn, The Swan*.

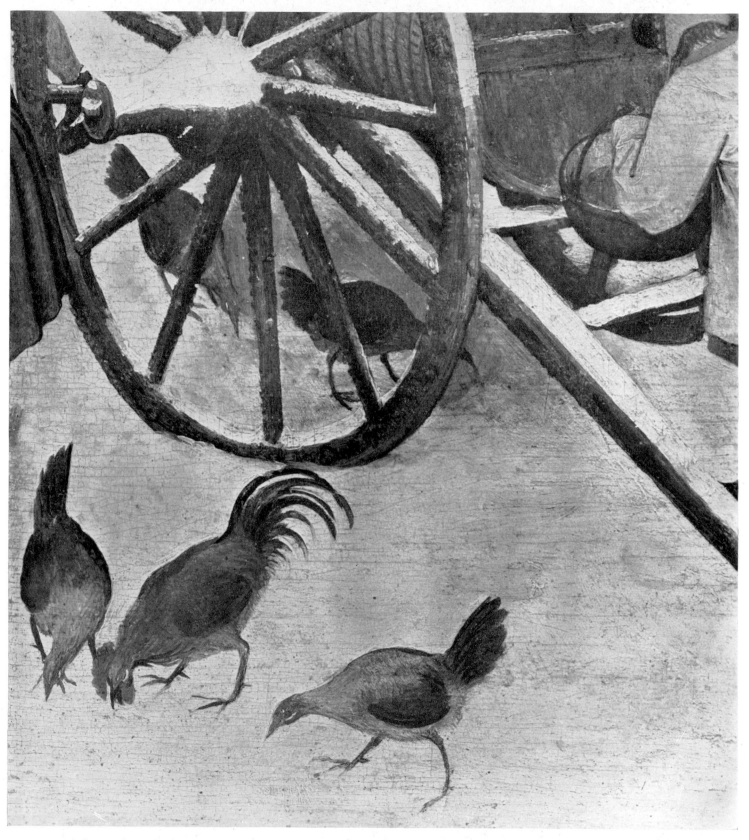

118. Detail from Plate 115: *Chickens near and beneath a Cart.*

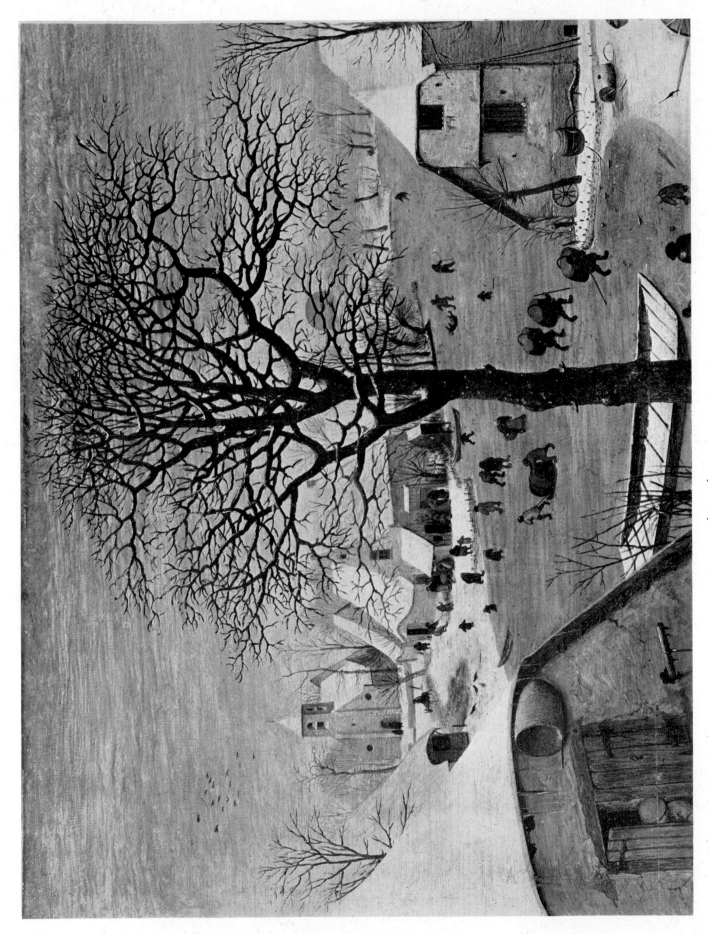

119. *Detail from Plate 115. The Sun setting over a Frozen River with People crossing.*

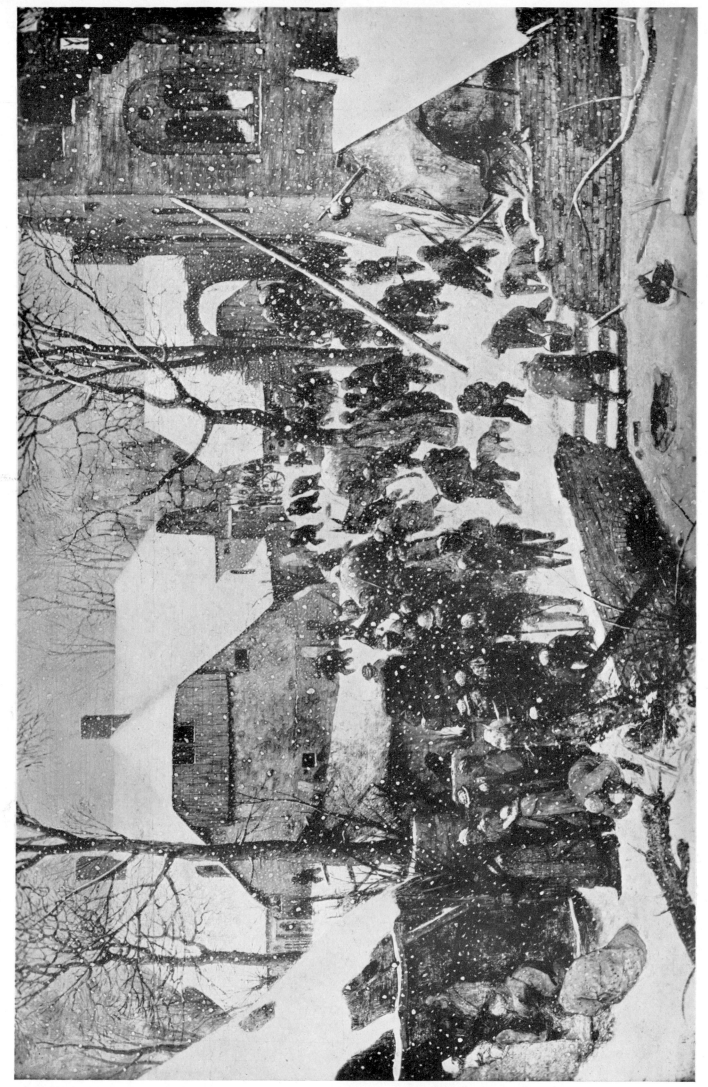

120. *The Adoration of the Kings in the Snow.* 1567. Winterthur, Dr. Oskar Reinhart Collection. 35 × 55 cm.

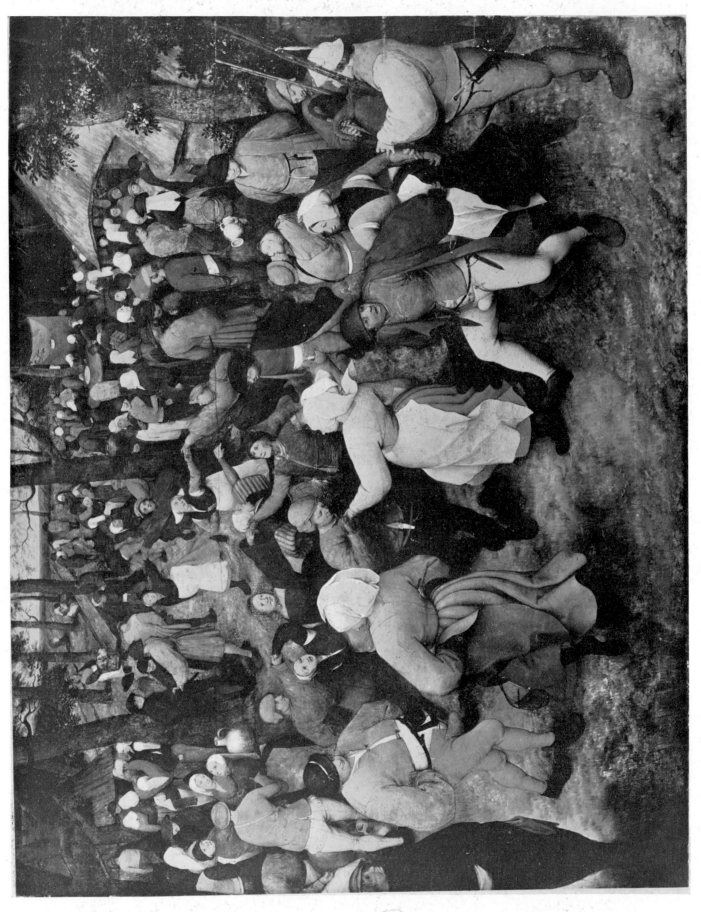

121. *The Wedding Dance in the Open Air.* 1566. Detroit, Institute of Arts.

119 × 157 cm.

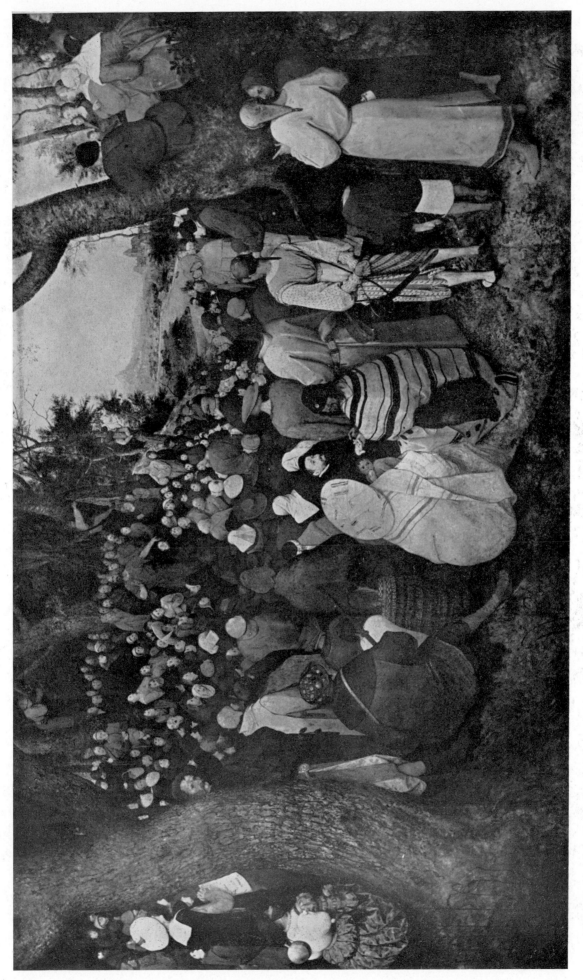

122. *The Sermon of St. John the Baptist.* 1566. Budapest, Museum of Arts.
95 × 160.5 cm.

123. Detail from Plate 122: *The listening Crowd.*

124. *Detail from Plate 122: A Gentleman having his Fortune told by a Gipsy; a Gipsy Woman with her Child.*

125. *The Conversion of St. Paul.* 1567. Vienna, Kunsthistorisches Museum.

108 × 156 cm.

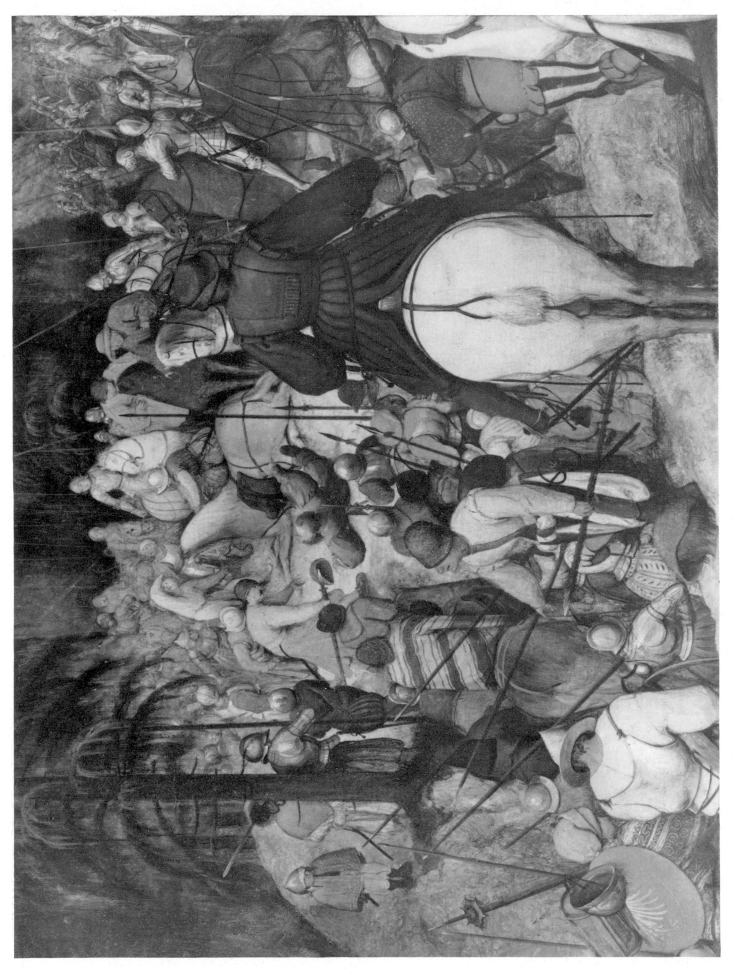

126. Detail from Plate 125: *St. Paul after his Fall, surrounded by his Escort.*

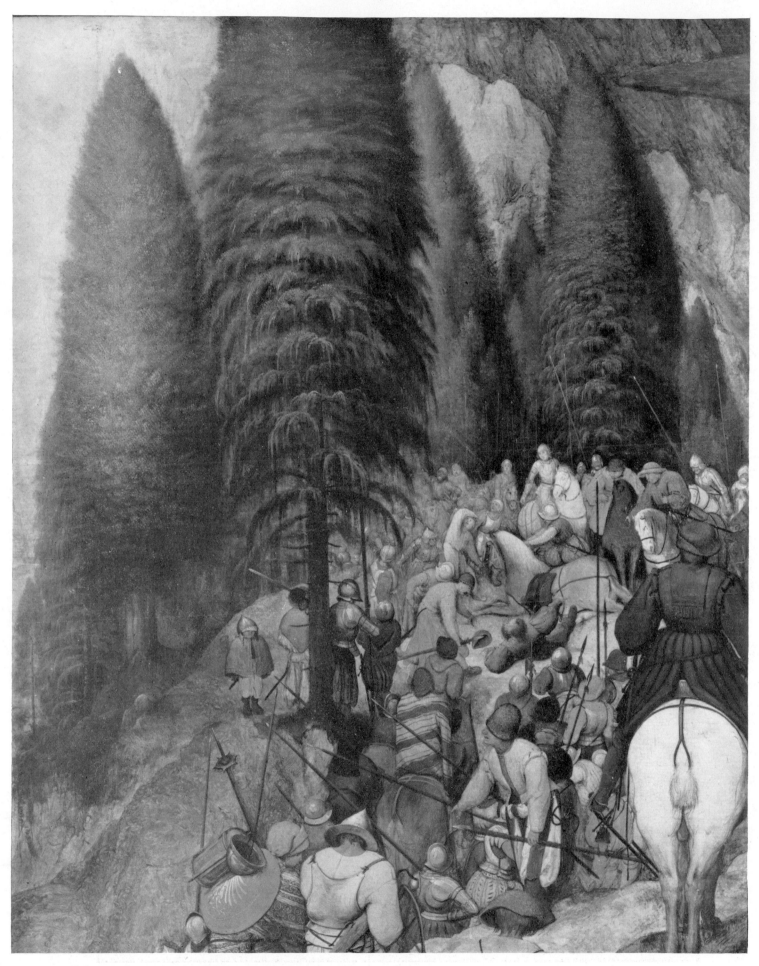

127. Detail from Plate 125: *High Pine Trees near St. Paul.*

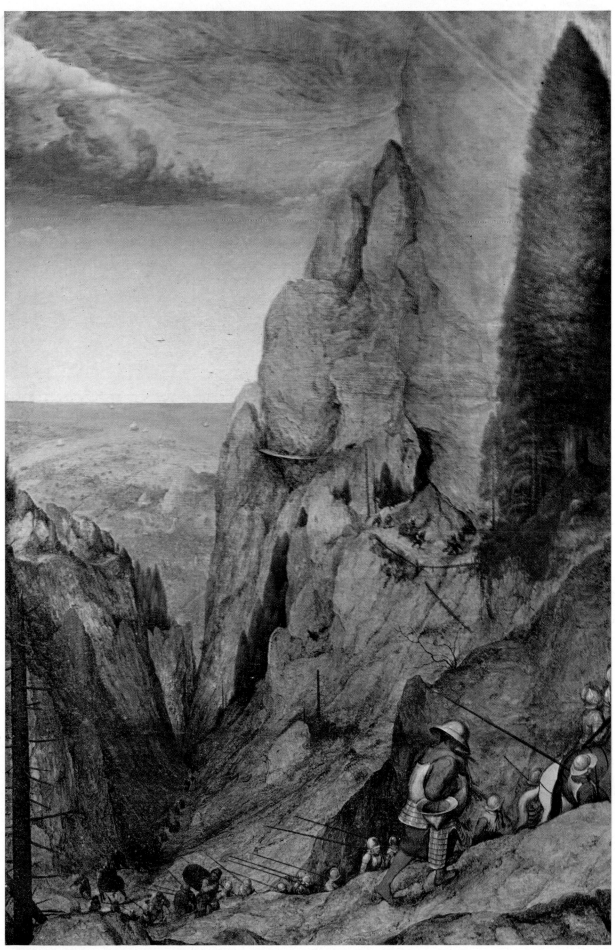

128. Detail from Plate 125: *Ravine*.

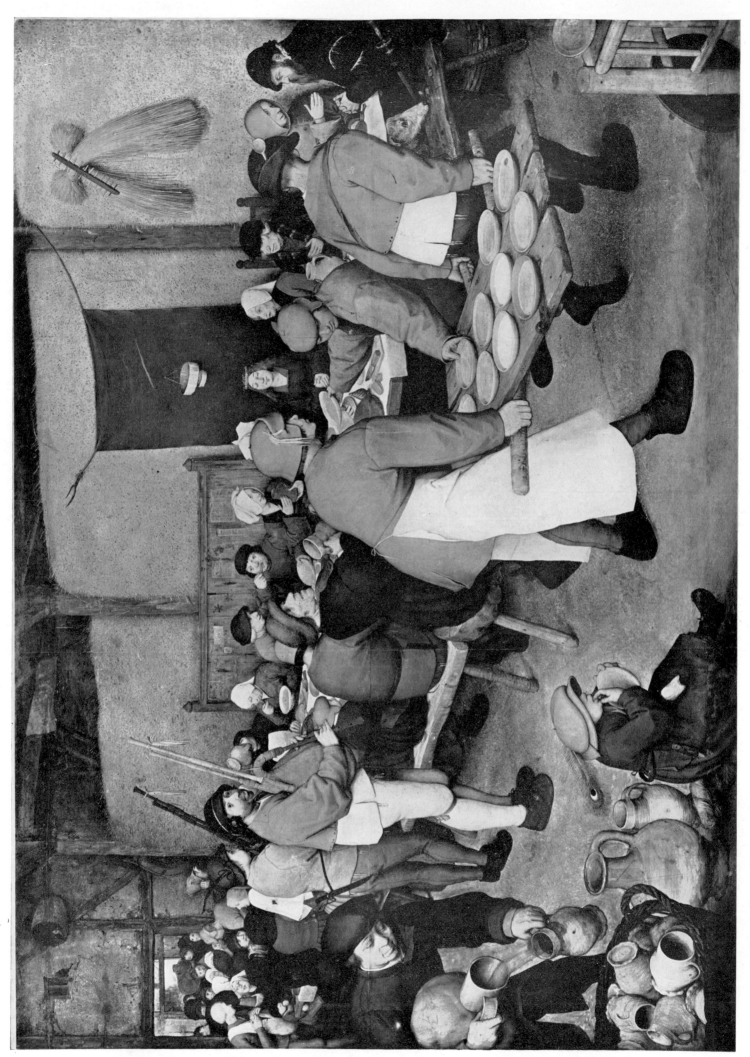

129. *Peasant Wedding (The Wedding Banquet)*. Vienna, Kunsthistorisches Museum. 114 × 163 cm.

130. Detail from Plate 129: *The Bride and the Mother.*

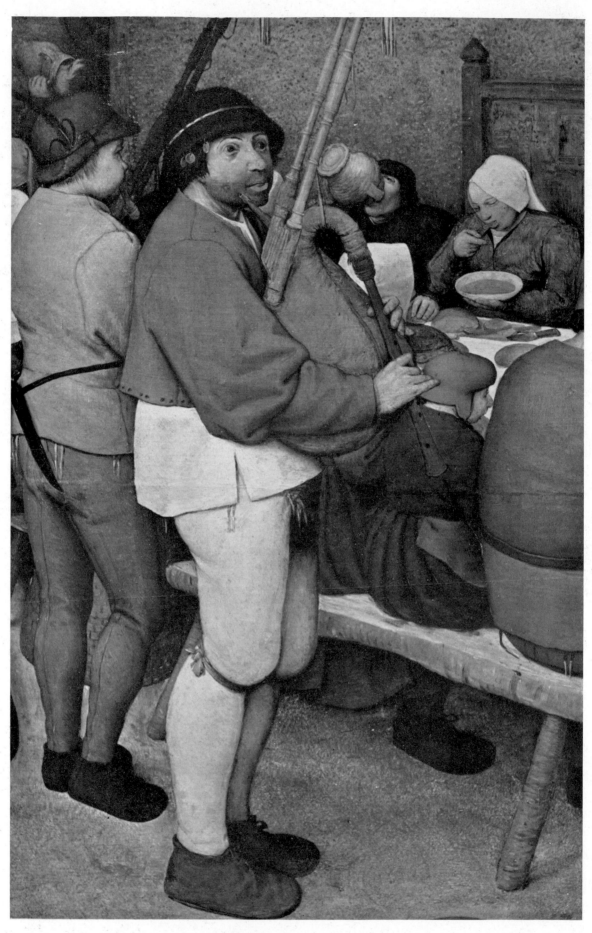

131. Detail from Plate 129: *Bagpipe Players*.

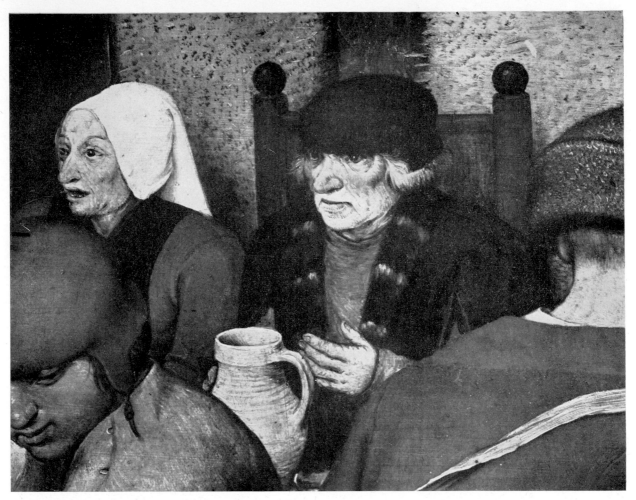

132. Detail from Plate 129: *The Parents*.

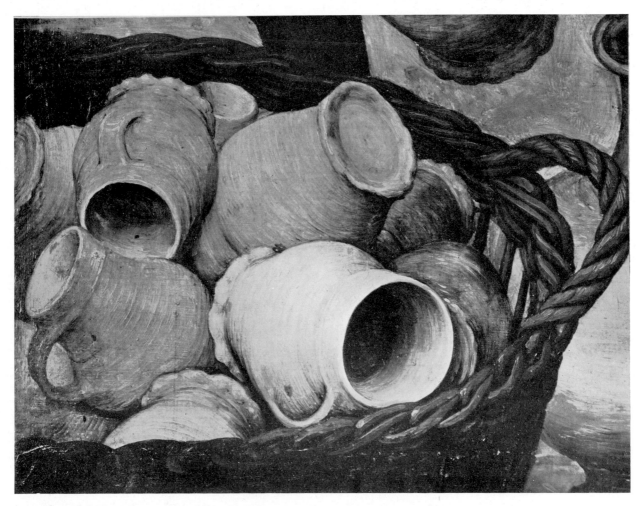

133. Detail from Plate 129: *Still Life of Jugs*.

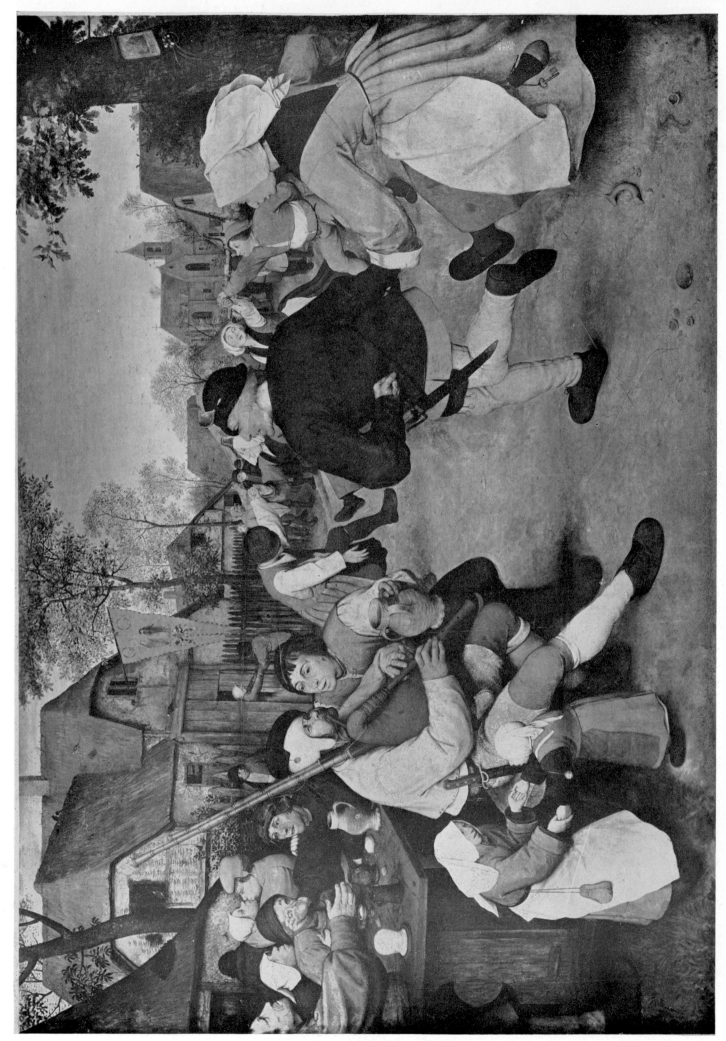

134. *The Peasant Dance*. Vienna, Kunsthistorisches Museum. 114 × 164 cm.

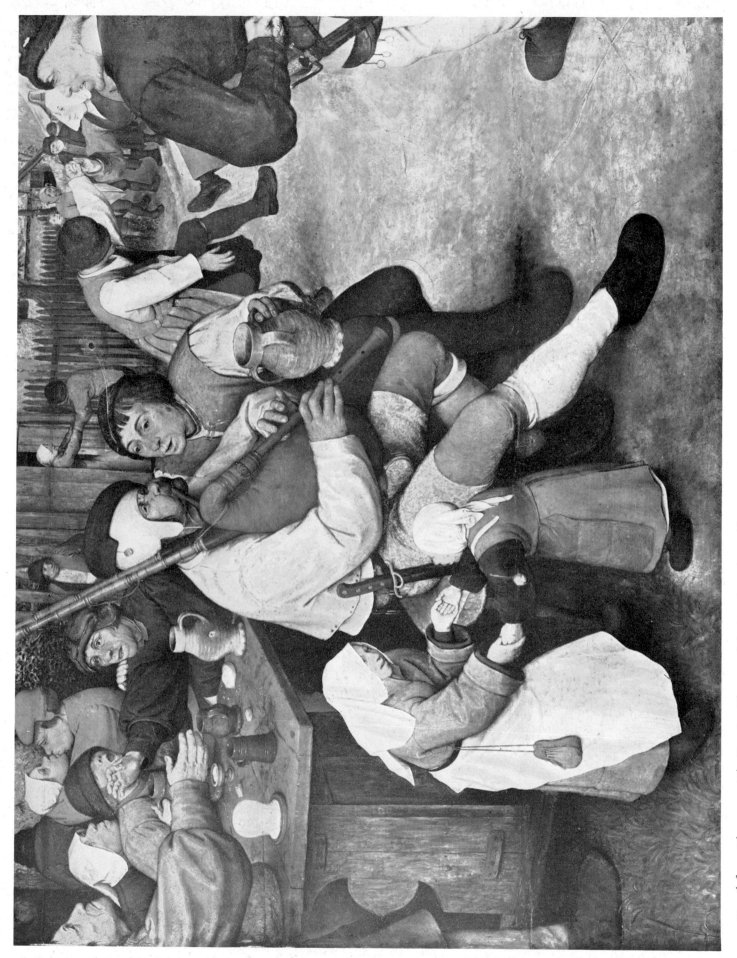

135. Detail from Plate 134: *The Bagpipe Player and the People at the Table.*

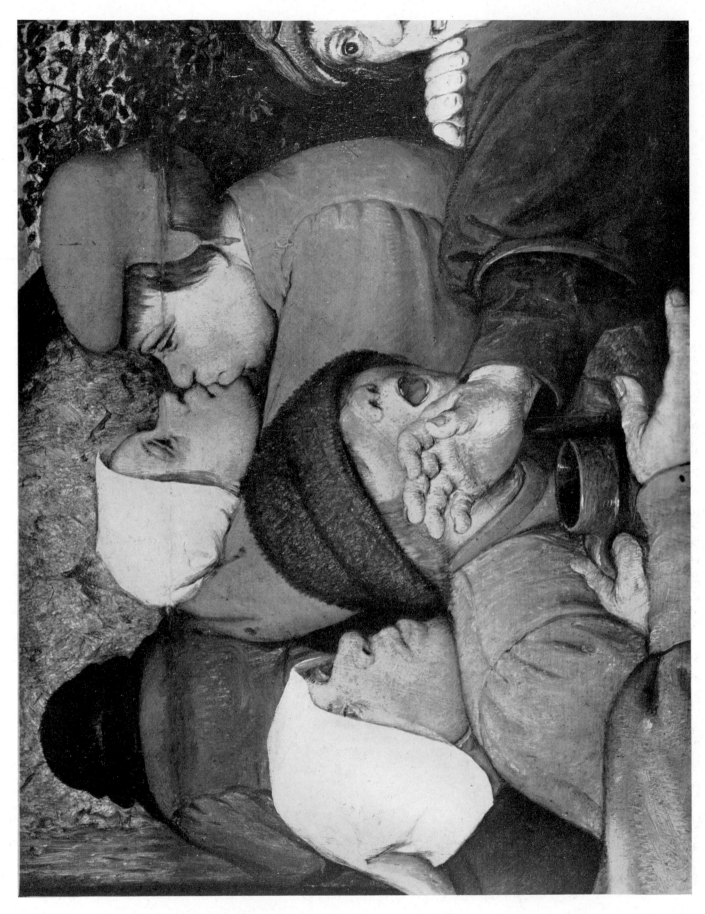

136. Detail from Plate 134: *Irate Drinkers and kissing Couple.*

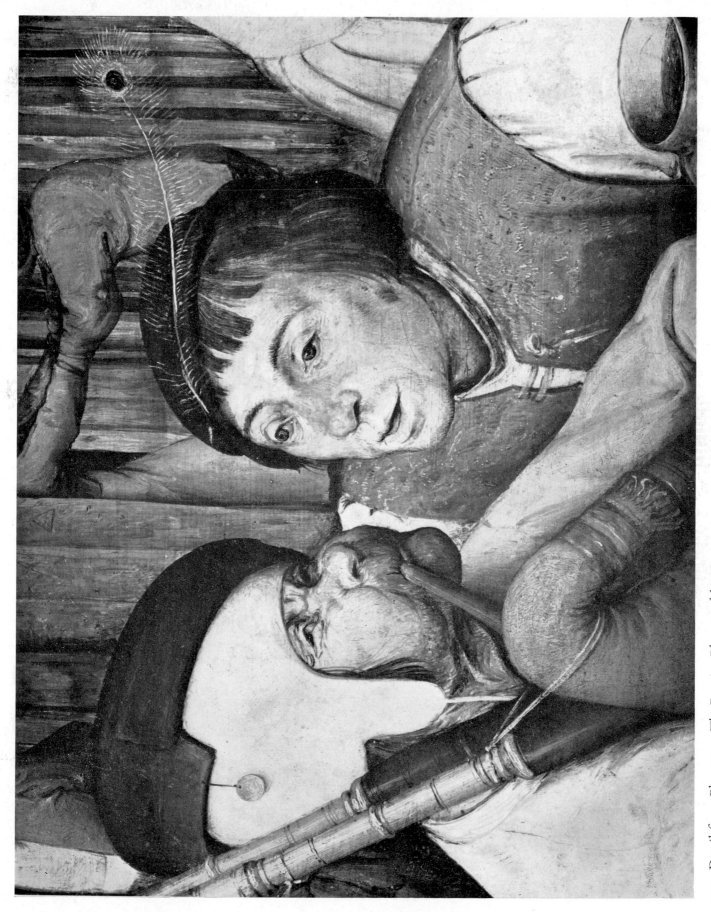

137. Detail from Plate 134: *The Bagpipe Player and his Companion.*

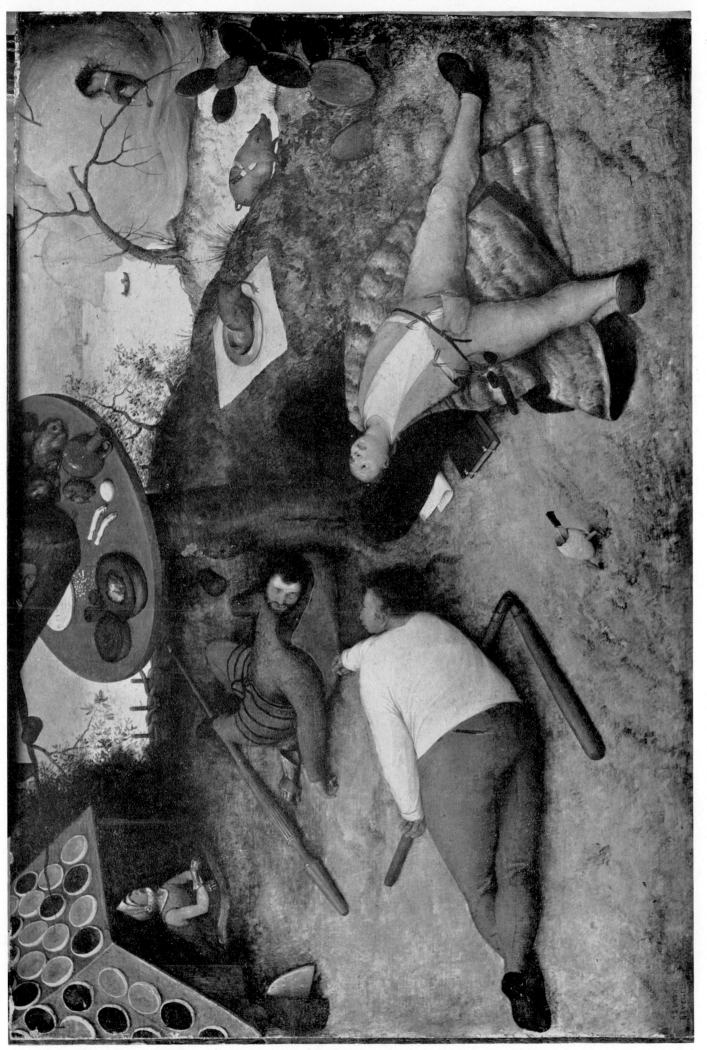

138. *The Land of Cockaigne.* 1567. Munich, Alte Pinakothek. 52×78 cm.

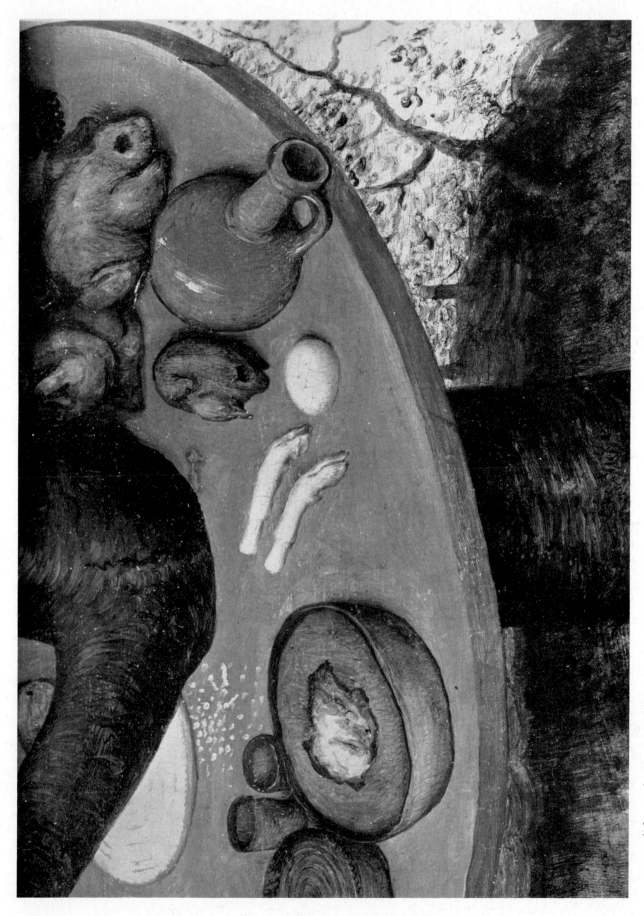

139. *Detail from Plate* 138: *Table with a Variety of Food.*

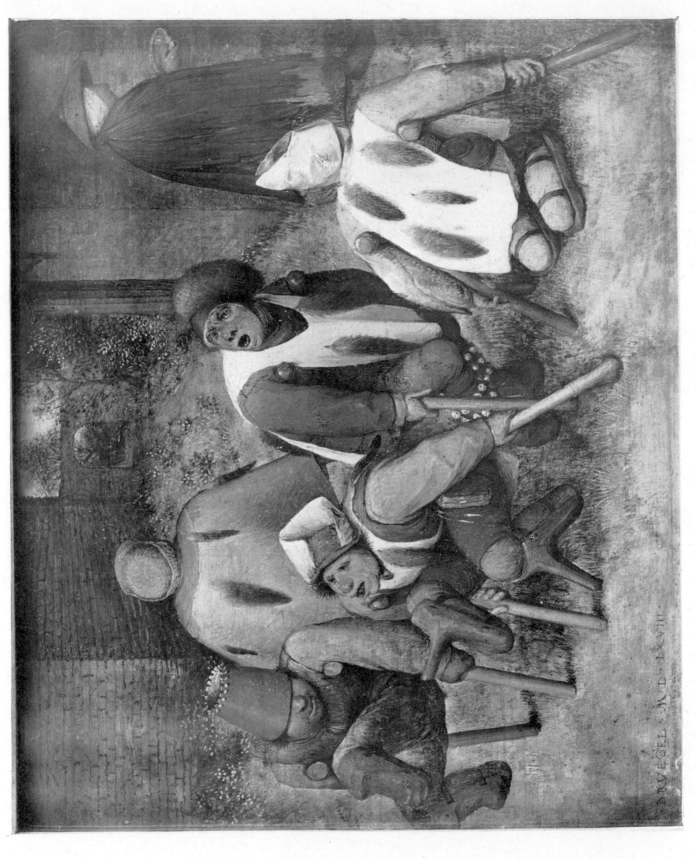

140. *The Cripples.* 1568. Paris, Louvre.

18 × 21.5 cm.

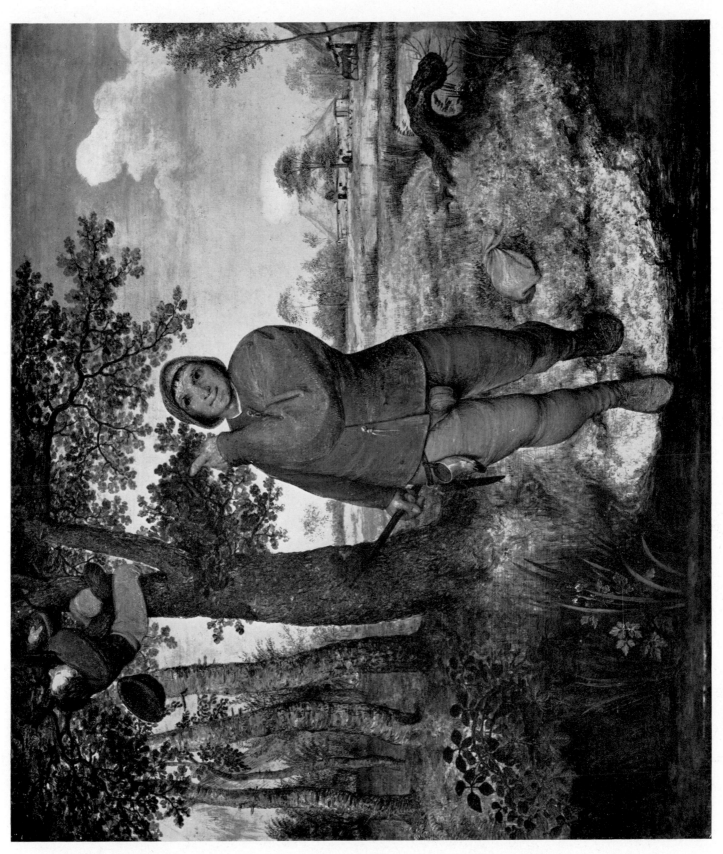

141. *The Peasant and the Birdnester.* 1568. Vienna, Kunsthistorisches Museum. 59 × 68 cm.

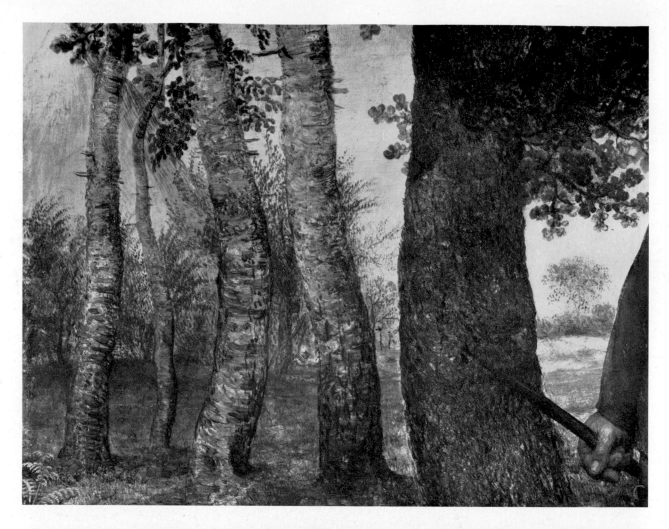

142–143. Details from Plate 141: *Birch Trees and Oak; Iris and Brambles*.

144. Detail from Plate 141: *Landscape with Farmhouses and in the Foreground a Willow.*

145. Detail from Plate 146: *Figure in a Glass Ball* (the 'Wicked World').

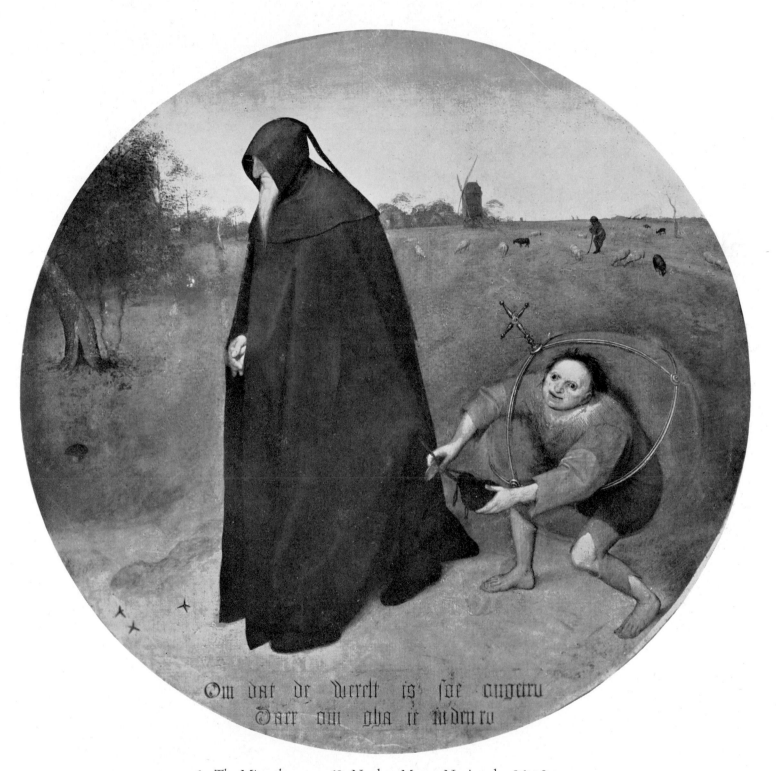

146. *The Misanthrope*. 1568. Naples, Museo Nazionale. 86×85 cm.

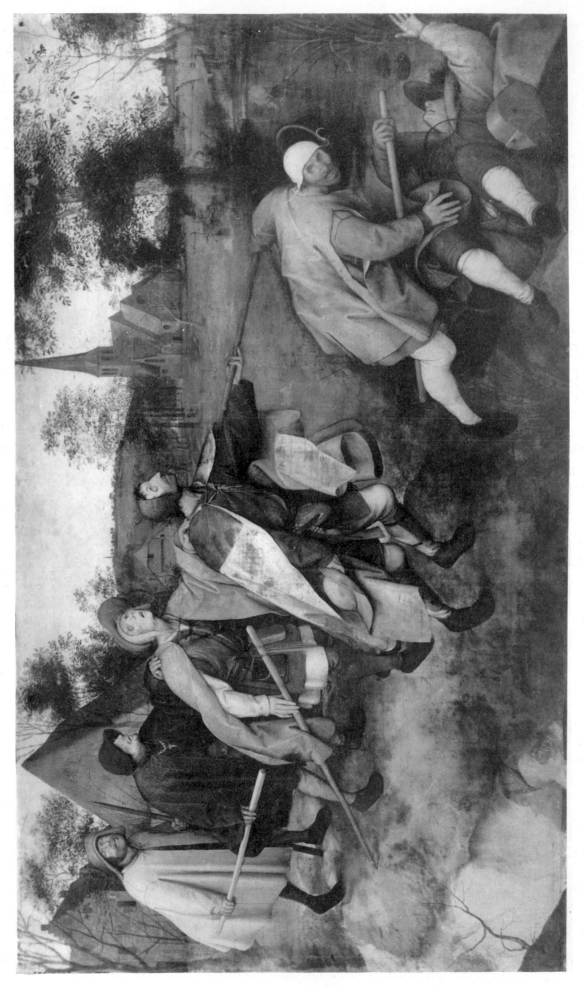

147. *The Parable of the Blind*. 1568. Naples, Museo Nazionale. 86 × 154 cm.

148. Detail from Plate 147: *The Third Blind Man and the Church*.

149. Detail from Plate 147: *The Second Blind Man, falling, and the Church.*

150. Detail from Plate 147: *The Fourth Blind Man*.

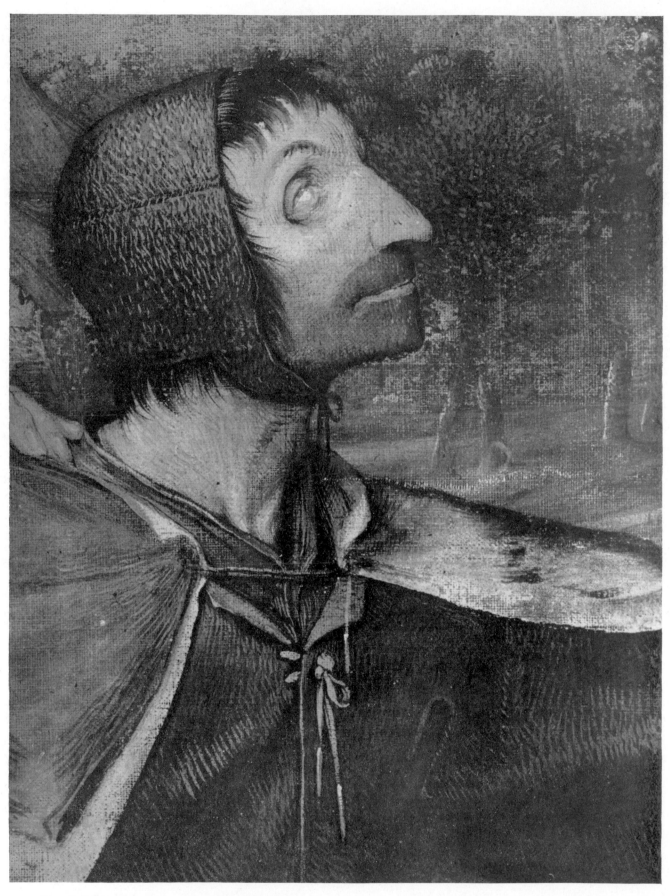

151. Detail from Plate 147: *The Third Blind Man.*

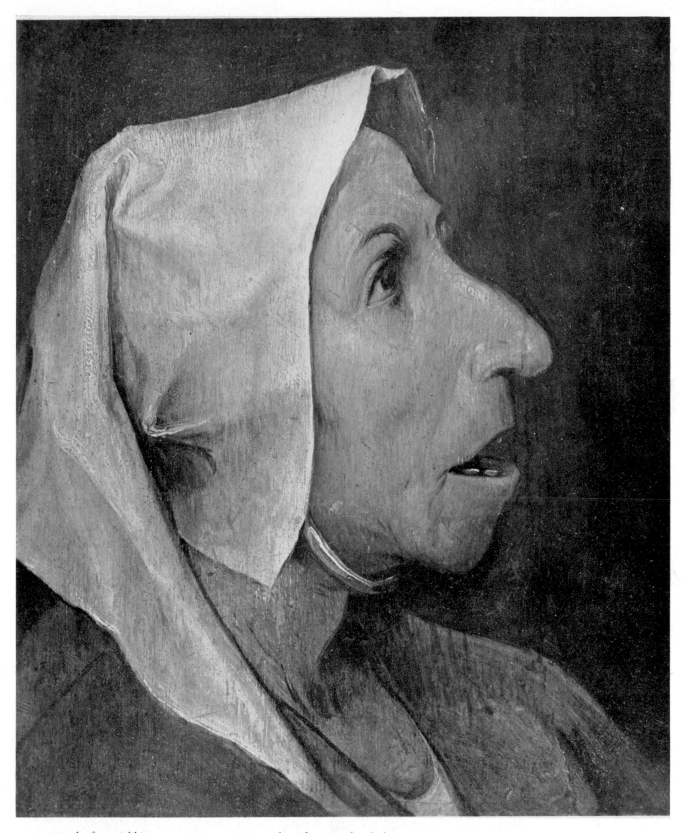

152. *Head of an Old Peasant Woman*. Munich, Alte Pinakothek.　　　　　　　　22 × 18 cm.

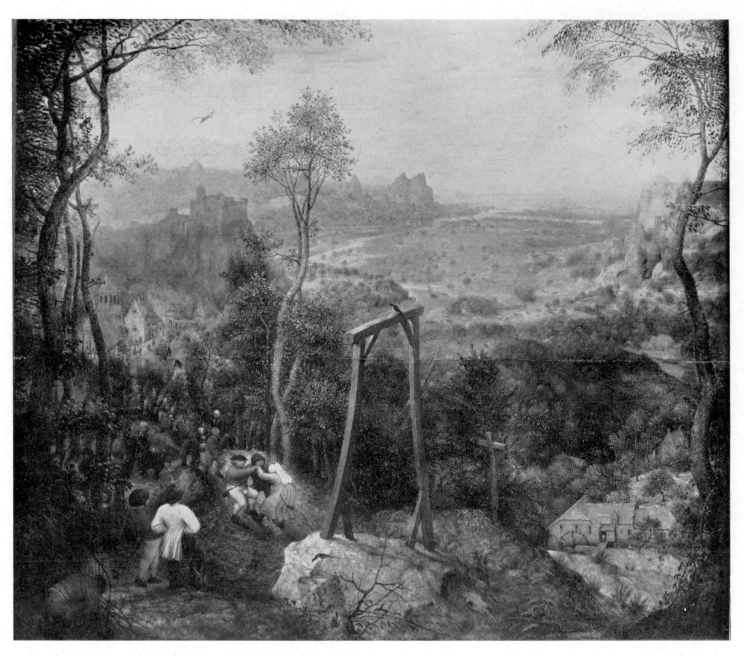

153. *The Magpie on the Gallows.* 1568. Darmstadt, Museum. 45.9 × 50.8 cm.

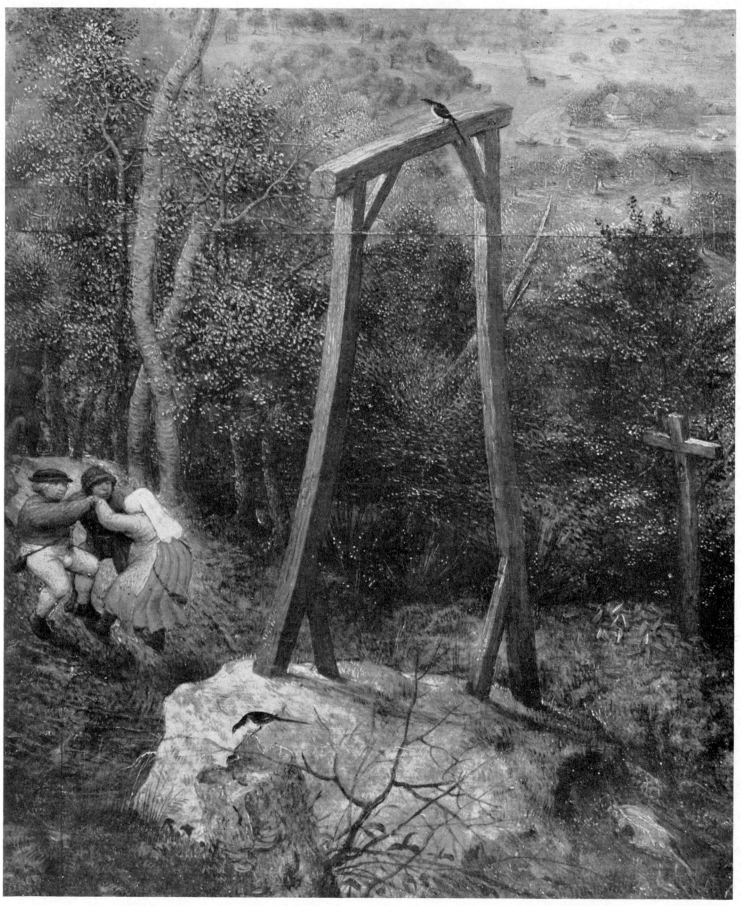

154. Detail from Plate 153: *Dancing Peasants, Gallows, Cross and two Magpies.*

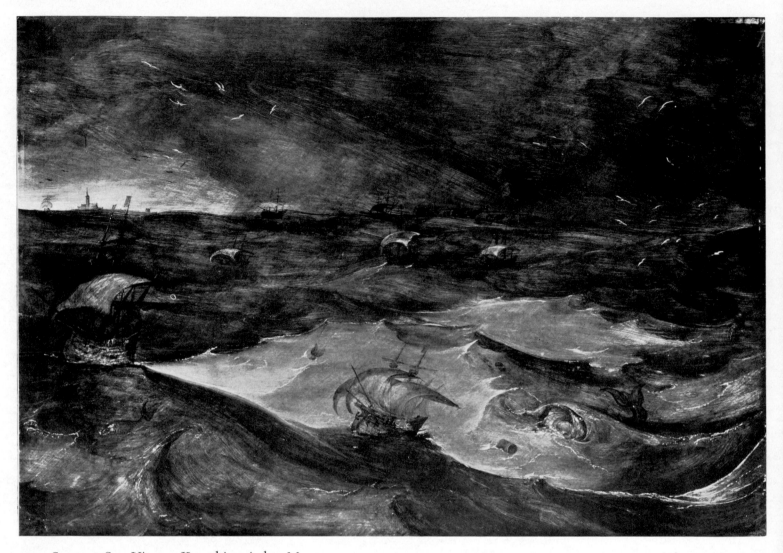

155. *Storm at Sea*. Vienna, Kunsthistorisches Museum. 70.3 × 97 cm.

NOTES ON THE PLATES

Acknowledgements

In the preparation of this book I have received valuable help in various ways from so many sides, from the authorities in charge of public galleries, of art historical institutes and libraries, from private collectors, colleagues and friends in this country and abroad, that it would be impossible to mention them all. I can only record my thanks to those who in one way or other have most efficiently helped to smooth my path. In Austria (Vienna) my special thanks are due to the Kunsthistorisches Museum, to Dr. E. Auer, Dr. F. Klauner, Professor F. Novotny; in Belgium to Professor R.-A. d'Hulst (Ghent), Mr. Georges Marlier (Brussels), Mr. L. Jacobs van Merlen (Antwerp), Professor W. Vanbeselaere (Antwerp), Mr. Carl van de Velde (Antwerp); in Denmark to Dr. J. Rubow (Copenhagen); in France (Paris) to Mr. F. Lugt and the late M. Edouard Michel; in Germany to Dr. H. Biehn (Darmstadt) and Dr. E. Wiese (Darmstadt); in Holland to the late Mr. D. G. van Beuningen (Vierhouten), to Professor J. G. van Gelder (Utrecht), Dr. H. Gerson (The Hague), Dr. S. J. Gudlaugsson (The Hague), Mr. C. Ebbinge Wubben (Rotterdam); in Sweden to Docent Dr. C. G. Stridbeck (Stockholm); in U.S.A. to Professor E. Haverkamp Begemann (New Haven), Mrs. S. van Berg (New York), Professor Ch. de Tolnay (Princeton); in South Africa to Professor D. Bax (Cape Town).

My debt of gratitude is greatest in this country. I would never have been able to write this book without the facilities accorded me by the Warburg Institute, the Courtauld Institute of Art, the Witt Library, the British Museum and the Victoria and Albert Museum. Here I have also to thank Dr. A. A. Barb, Professor Sir Anthony Blunt, Professor L. D. Ettlinger, Mrs. E. Frankfort, Professor E. H. Gombrich, Mr. S. Rees Jones, Professor O. Kurz, Mr. N. Maclaren, Mr. O. Millar, Dr. P. Murray, Mr. J. B. Trapp, Professor J. Wilde. But above all I wish here to express my gratitude to Dr. Count Antoine Seilern, who as collector, colleague and friend helped with photos, information and constant encouragement. I am most grateful to my publishers for the great interest they have shown in my work. To my deepest regret Dr. B. Horovitz, who suggested this book, is no longer alive to accept my thanks for his patience with the ever expanding work and for his understanding and generosity in the matter of illustrations and presentation generally. Here I would like also to pay my tribute to all those to whom I owe thanks and who have passed away since the first edition of this book was published: Professor L. Baldass, Mr. S. van Berg, Professor G. Bing, Dr. L. Burchard, Mr. D. M. van Buuren, Captain E. G. Spencer Churchill, Dr. L. Münz, and Sir Leonard Woolley. My last, though certainly not my least, thanks are due to Marguerite Kay and Benedict Nicolson for reading and improving the text.

NOTES ON THE PLATES

The plates illustrate all authentic paintings by Bruegel and a few disputed ones.

Bruegel's compositions contain a wealth of details which form complete pictures in themselves, and therefore it is more essential here than anywhere to isolate as many of them as possible. The details reproduced, a number of which were photographed especially for this book, were chosen in the first place, of course, for their specific relationship to the picture content, but also to demonstrate the range of Bruegel's invention and, so far as this is possible in reproductions, to emphasize the purely pictorial quality and the superb and varied painting technique of the master.

The dates suggested for the undated paintings and the new interpretations of some of the compositions will be discussed in the Catalogue Volume, where also the numbers of earlier catalogues and the opinions expressed there will be quoted and a more complete history of each picture will be given. In the following notes only the present and the first known owners or the earliest references are listed.

Unless otherwise stated, all paintings are on panel. In the measurements height precedes width.

1

LANDSCAPE WITH SAILING BOATS AND A BURNING TOWN

Private Collection.

$9\frac{5}{8} \times 13\frac{3}{4}$ in. (24.4 × 34.8 cm.). Neither signed nor dated.

Painted probably about 1552–53. This is probably the earliest known surviving painting by Bruegel. It was published for the first time in the first edition of this book. Another version of this composition which has come to my knowledge makes it necessary to re-examine the problem of Bruegel's authorship. This will have to be discussed in detail in the Catalogue Volume.

2

LANDSCAPE WITH CHRIST APPEARING TO THE APOSTLES AT THE SEA OF TIBERIAS

Private Collection.

$26\frac{1}{2} \times 39\frac{1}{2}$ in. (67 × 100 cm.). Signed and dated: P. BRVEGHEL 1553.

This is the earliest signed and dated painting by Bruegel known so far. It has only recently come to light again. Max J. Friedländer was the first to recognize it as an authentic work of the master. It was first published by Charles de Tolnay in *The Burlington Magazine*, XCVII, August 1955. The scene is based on the Gospel of St. John, ch. XXI, but the narrative is over-shadowed by the landscape. The very small figures are completely subordinated to it and relatively even smaller than in the engravings of the *Large Landscape Series* (Bastelaer, *Estampes*, Nos. 3–17), most of which were produced only after Bruegel's return from Italy. The picture is closely connected with the *Landscape with Sailing Boats* (Plate 1). In both pictures the composition is much more dependent on Patenier than in any other extant landscape painting by Bruegel.

3

LANDSCAPE WITH THE FALL OF ICARUS

New York and Brussels, D. M. van Buuren Collection.

$24\frac{3}{4} \times 35\frac{1}{2}$ in. (63 × 90 cm.). Neither signed nor dated. Acquired from Mme. J. Herbrand, Paris.

3a

LANDSCAPE WITH THE FALL OF ICARUS

Brussels, Musées Royaux des Beaux-Arts.

Transferred from panel to canvas; 29×44⅛ in. (73.5×112 cm.). Neither signed nor dated.
Purchased on the London art market (Sackville Gallery) in 1912.

Among Bruegel's paintings these are the only ones with a mythological subject. Though the motif as such of the Fall of Icarus appears also in two engravings after Bruegel's designs, there is no very close parallel to the composition in the whole of the master's extant oeuvre, and this increases the difficulty of establishing a definite date. Most scholars are in favour of an early date, but Vanbeselaere's arguments for a date around 1567–68 deserve serious consideration. The opinions as to the authenticity of both versions are greatly divided. On the one side the most extreme view is Glück's, who accepts both pictures as autograph, though with a preference for the van Buuren version, on the other side is Jedlicka's, who declares both paintings to be copies, adding that the smaller version is nearer to the lost original. A detailed discussion and comparison of the two compositions must be reserved for the Catalogue Volume.

4

THE ADORATION OF THE KINGS

Brussels, Musées Royaux des Beaux-Arts.

Canvas; 45½×64⅛ in. (115.5×163 cm.). Neither signed nor dated. Acquired from the Edouard Fétis Collection, Brussels, in 1909.

Painted probably about 1556. In very poor condition. This is the earliest painting by Bruegel in which the influence of Bosch can be detected, though the composition also owes a great deal to a tapestry cartoon of the same subject designed by an assistant of Raphael's.

5

LANDSCAPE WITH THE PARABLE OF THE SOWER

San Diego (California), Timken Art Gallery.

29⅛×40⅛ in. (74×102 cm.). Signed and dated: . . VEGHEL .557. Acquired from the F. Stuyck del Bruyère Collection, Antwerp, 1965.

Not in perfect condition. First mentioned by M. J. Friedländer (*Pantheon*, VII, 1931, p. 58). The subject is taken from Matthew, XIII, 3–8. On the river shore the crowd has gathered round the teaching Christ (Matthew, XIII, 2).

6-12

THE FIGHT BETWEEN CARNIVAL AND LENT

Vienna, Kunsthistorisches Museum.

46½×64¾ in. (118×164.5 cm.). Signed and dated: BRVEGEL 1559.

First mentioned by van Mander, without owner's name. By 1748 in the Weltliche Schatzkammer, Vienna. Several figures are now hidden under overpainting, among these a dead or dying man in the cart drawn by an old woman (Plate 9, top centre) and a man reduced to a skeleton, with a swollen belly and his legs covered by a white sheet (which has remained untouched by overpainting), in the right bottom corner. What for earlier artists had been a representation of an old play, popular in many countries, with only a few actors taking part, has become for Bruegel an occasion to depict in detail the Netherlandish Shrovetide customs and, more important, to paint a picture of human life generally with its gay and sombre sides, but with greater emphasis on the tragic aspects: poverty, blindness, incurable sickness, death, and on sin. The church is contrasted with the inn, the good deeds (the works of mercy) of the pious with the world's indulgence in sinful pleasures (dancing, performing useless comedies – in front of the inn on the left 'De vuile Bruid' ('The dirty Bride') (Plate 12) and in the background left 'Urson and Valentine', love making – the kissing couple in the window of the inn – gluttony, gambling) and with the neglect of the needy (nobody cares for the cripples on the left). Both carnival plays form also the subjects of woodcuts after Bruegel's designs (Bastelaer, *Estampes de Bruegel*, Nos. 215 and 216). The wood-block with Bruegel's original drawing for 'De vuile Bruid' (formerly wrongly described

as the 'Wedding of Mopsus and Nyssa') is preserved in the Metropolitan Museum of Art, New York.

13-14

THE NETHERLANDISH PROVERBS

Berlin–Dahlem, Staatliche Museen.

46×64⅛ in. (117×163 cm.). Signed and dated: BRVEGEL 1559.

First mentioned in the inventory of the Antwerp collector Peter Stevens, 1668. This is not the first pictorial representation of proverbs, but it is the first in which a whole 'proverb country' is created. The proverbs illustrated are mainly of two kinds: First those that show the absurdity of human behaviour, common sense upside-down, and the symbol for this is the world upside-down which greets us as a house-sign on the left. But as prudence is a virtue, folly can be a sin. And so the second type illustrates proverbial sayings characterizing wicked and sinful behaviour, as demonstrated in the central scenes of the woman 'hanging the blue coat round her husband' (i.e. making him a cuckold) and, above, of the man 'lighting two candles for the devil'. About one hundred proverbs have been identified. The most complete and convincing identifications were given by Wilhelm Fraenger (Der Bauern-Bruegel und das deutsche Sprichwort, Erlenbach – Zurich 1923), by Jan Grauls (De Spreekwoorden van Pieter Bruegel den Oude verklaard, Antwerp 1938) and by Gustav Glück (The Large Bruegel Book, Vienna 1952).

The proverbs seen in Plate 14 are, in addition to those mentioned in the caption of the plate: 'One shears the sheep, another the pig' or 'much ado and little wool, said the fool, and shore a pig'; 'one holds the distaff while the other spins', i.e. spreading evil gossip; 'he brings baskets of light out into the day-light'; 'the pig has been stuck through the belly', i.e. it is irrevocable, or 'he does not know how to kill a pig'; 'he throws roses to the swine'. (After Fraenger and Glück-Borms.)

15-19

CHILDREN'S GAMES

Vienna, Kunsthistorisches Museum.

46½×63⅜ in. (118×161 cm.). Signed and dated: BRVEGEL 1560.

Mentioned by van Mander, without owner's name. Acquired by Archduke Ernst of Austria in 1594. The subject is not unique, it appears in Flemish book illumination before Bruegel; but the treatment is unique. It has rightly been stressed that it was not Bruegel's intention to present a kind of encyclopaedia of children's games – although some eighty of them have been counted in the picture. It has also been said with some probability, that this may have been the first painting (infantia) for a series of the ages of man which Bruegel may have planned. Of perhaps even greater importance is the observation often made that the children look like adults rather than children. They are indeed absorbed in their games with the seriousness devoted by grown-ups to their own affairs, which – seen sub specie aeternitatis – have no greater importance. They can be compared to puppets (Plate 19, on the right) who do not act from their own volition. The games have been carefully listed by Glück (The Large Bruegel Book), by Victor de Meyere (De Kinderspelen van Pieter Bruegel den Oude verklaard, Antwerp 1941) and by Jeannette Hills (Das Kinderspielbild von Pieter Bruegel d. Ä., Vienna 1957).

20-29

THE TRIUMPH OF DEATH

Madrid, Prado.

46×63¾ in. (117×162 cm.). Neither signed nor dated. Painted probably around 1562. Van Mander's description of a painting 'in which expedients of every kind are tried out against death' probably refers to this picture, which is possibly identical with a 'Triumph of Death' listed in the inventory of Philips van Valckenisse, Antwerp, in 1614.

It has been rightly observed that two iconographical traditions are here combined: the Italian idea of the Triumph of Death and the Northern conception (e.g. Holbein) of the Dance of Death (Tolnay, Bruegel, 1935, p. 31). But Bruegel further enriched this combination by including the motif of the army of the dead (death for him means many dead men and: everybody gets the death he deserves) fighting against the living (in the centre and Plates 26 and 27). He invented as the appropriate and convincing setting for the frightening scenes the barren landscape of Death, the counterpart of and related to the landscape

of Hell (*cf.* Plate 36). In accordance with Christian doctrine death is for Bruegel the wages of sin and thus the men and women are not only representatives of various human occupations and stations in life, as in the Dance of Death, but of certain sins, among which covetousness, greed, the placing of worldly possessions above salvation, above faith in God, seems to be the dominant one. A toad-like monster almost exactly in the centre of the composition (next to Death on his horse, Plate 29, in the top right corner) emphasizes this idea. Moreover barrels filled with gold are placed next to the Emperor and the Cardinal (Plates 20 and 21), the pilgrim's purse is most conspicuously shown (Plate 23) – an attack on the outward show of piety as we meet it again in the *Procession to Calvary* (see the comment on Plate 66). Anger, gluttony (and gambling), lust are the sins exposed in the foreground on the right (Plate 25), common criminals and suicides are shown as the victims of death in the background (Plate 29). The sinner, whatever his colour or creed (Plate 29) cannot escape death – and damnation. It is the idea of the Last Judgment closely connected with death which for Bruegel, the Christian, makes physical death so frightening.

30-31

THE RESURRECTION OF CHRIST

Rotterdam, Museum Boymans-Van Beuningen. Brush and pen drawing in grisaille on paper attached to a panel; 17×12⅛ in. (43.1×30.7 cm.). Inscribed by a later hand over an earlier signature now lost: B R V EVEGEL. Not dated.

Probable date *c.* 1562. Earliest identified owner A. Grahl (d. 1868), Dresden. In *Bulletin, Museum Boymans, Rotterdam* (v, 1954, pp. 54 ff.) the present writer has tried to re-establish the authenticity of this grisaille drawing, which had been disputed, and to show that it is one of the three original grisailles painted by Bruegel. The existence of these grisailles had been suspected on the evidence of copies. Whereas the other two grisailles are oil paintings on panel (see Plates 77 and 78), this is the only one in a different technique. Unlike Bruegel's other drawings, which are all done with the pen only, it is done like the paintings mainly with the brush (to which only little pen work is added) and seems indeed to have

taken the place of a painting. At an early date it was attached to a panel and framed like a picture, for in the engraving after it, published by Hieronymus Cock (Bastelaer, *Estampes*, No. 114), the frame is also reproduced. For this reason and on account of its close connection in content with the paintings around 1562 it has here been included among the paintings. The Resurrection of the Saviour – expressing for the Christian the certainty of his own resurrection and salvation – is clearly conceived as a spiritual companion or counterpart to the *Triumph of Death*. What in particular the Resurrection of Christ may have meant to Bruegel will be discussed in the Catalogue Volume. One thing seems certain: All three grisailles have something of a personal or private character within Bruegel's oeuvre: The *Death of the Virgin* (Plate 77) was painted for a close friend Abraham Ortelius, *Christ and the Woman taken in Adultery* (Plate 78) was kept in Bruegel's family after his death, and the *Resurrection* may well have been produced for presentation to a dear friend. Tempting though this is, it would be too bold, I think, to identify this friend with Hans Franckert.

32-35

THE FALL OF THE REBEL ANGELS

Brussels, Musées Royaux des Beaux-Arts. 46×63¾ in. (117×162 cm.). Signed and dated: M.D.LXII BRVEGEL. Purchased from F. Stappaerts, Brussels, in 1846.

In the years around 1562 Bruegel's mind was filled with thoughts of the Last Things, of Death and Resurrection, of Judgment and Hell. Here, too, the Fall of the Rebel Angels finds its place. It expresses an idea with which Bruegel was obsessed throughout his life: the conflict between virtue and sin. The Archangel Michael and his companions are shown fighting against the sins – the fallen angels have been transformed into monsters which represent the various sins – for all sins are closely related (and this is an idea expressed over and again in Bruegel's compositions) – although the overriding sin of Lucifer and his followers is, of course, pride. Of all earlier representations of the Fall of the Rebel Angels the one by Bosch in the altarpiece of the Last Judgment (Vienna, Akademiegalerie) comes nearest to Bruegel's and was

one of the sources of his inspiration. For a more detailed interpretation of the content see John B. Knipping, *Pieter Bruegel de Oude: De Val der opstandige Engelen*, Leyden 1949.

36–44
THE 'DULLE GRIET' (MAD MEG)

Antwerp, Musée Mayer van den Bergh.

$45\frac{1}{4} \times 63\frac{3}{8}$ in. (115×161 cm.). Very little has remained of signature and date, all I can read is MDLXI. and Glück's interpretation of the remains as MDLXII appears to me more plausible than any other.

According to van Mander the painting was in the collection of Rudolph II. In subject-matter there is a close connection with the compositions reproduced in Plates 20–35, which fact also supports the date 1562. Various interpretations have been suggested. In my view it is the sin of covetousness which is here castigated. Dulle Griet is the personification of this sin: a large figure in the centre who dominates the composition as do the symbolic figures of the sins and virtues in the series of drawings dedicated to the Seven Deadly Sins and the Seven Virtues, which Bruegel had designed a few years previously. But she is less abstract and more active than her predecessors. To gain her loot she would even storm Hell, and the women in whose hearts this sin lives are certainly not afraid of fighting the devils (Plate 40). To save Hell from them a tempter (a figure with the face of a man and the clothes of a woman) throws down to them the money which fills his body and tries to entice them also with the lure and blandishment of other sins (among them gluttony) offered to them in a glass ball, the symbol of vanity (Plate 38). (*Cf.* Liselotte Möller, in *Jahrbuch der Hamburger Kunstsammlungen*, II, 1952, pp. 157 ff., and in particular, p. 167.) Hell is peopled with all sins and their victims. The head of Satan (Plate 43) is a more convincing and realistic version of the old medieval type of the mouth of Hell, improved upon by ingeniously invented details. This is Bruegel's last painting in which sins are represented by fantastic monsters – and only once in later years does he again add to the real world by the fantastic rendering of the abstract idea of the maliciousness of the world (in the *Misanthrope*, Plate 146) – but it is not the last work in which he castigates sin.

45
TWO MONKEYS

Berlin-Dahlem, Staatliche Museen.

$7\frac{7}{8} \times 9$ in. (20×23 cm.). Signed and dated: BRVEGEL MDLXII.

First mentioned in the inventory of the Antwerp collector Peter Stevens, 1668. Though no completely satisfactory interpretation of this painting has yet been given, the expression of the captive animals, their skilfully contrasted attitudes and positions and the inclusion of the distant view of Antwerp suggest that more than just a realistic animal study was intended. The fact that the ape could be interpreted as a symbol for many different and even conflicting notions (*cf.* H. W. Janson, *Apes and Ape Lore in the Middle Ages and the Renaissance*, London 1952) makes it all the more difficult to arrive at a correct solution.

46–47
THE SUICIDE OF SAUL

Vienna, Kunsthistorisches Museum.

$13\frac{1}{4} \times 21\frac{5}{8}$ in. (33.5×55 cm.). (A strip at the top, 4 cm. high, and another at the bottom, 1 cm. high, are later additions.) Inscribed and signed at the bottom: SAVL.XXXI CAPIT. BRVEGEL.M.CCCCC.LXII.

The date has sometimes been read differently, but today this reading is accepted by most critics. The inscription clearly indicates that the picture represents the suicide of Saul after his defeat by the Philistines on Mount Gilboa (I, Samuel, 31). Next to the *Tower of Babel*, this is the earliest extant painting by Bruegel of an Old Testament subject. As in most of his biblical compositions the scene is visualized as a contemporary, or near-contemporary event. (There is, moreover, a surprising resemblance to battle scenes as depicted in the first half of the century by artists such as Altdorfer in his *Battle of Issus* (1529).) The subject is exceptional in painting, though not infrequent in illustrated bibles. The explanation for the surprising choice of subject may lie in the fact that Saul's suicide was interpreted as punished pride. In Dante's *Divina Commedia* (*Purgatorio*, xii, 25 ff.), Lucifer, Nimrod who built the Tower of Babel, and Saul are among the examples of punished pride.

48-49
VIEW OF NAPLES

Rome, Galleria Doria

$15\frac{5}{8} \times 27\frac{3}{8}$ in. 39.8×69.5 cm.). Neither signed nor dated.

Painted probably about 1562–63. All critics except F. Winkler (*Die Altniederländische Malerei*, Berlin 1924, p. 345), with whom I agree, see in this mature composition an early work of the master. First mentioned by S. Tonci (*Descrizione ragionata della Galleria Doria*, Rome 1794, p. 291) among the paintings of the Galleria Doria. This is the only painting of a definite locality by Bruegel that has come down to us, although a few more (a *View of Lyons in France*, a *View of the St. Gotthard*) are listed in old inventories. The painting was done from memory, certainly with the help of drawings made on the spot in 1552. We find the same procedure in the large engraving of the *Straits of Messina*, of 1561 (Bastelaer, *Estampes*, No. 96), and here one of the early drawings utilized in it – the *View of Reggio* in the Museum Boymans – is still preserved. It has been noticed that Bruegel transformed the actual rectangular harbour jetty into a circular one (Tolnai, *Jahrbuch der Kunsthistorischen Sammlungen*, N.F. VIII, Vienna 1934, p. 106). He certainly did so for compositional reasons, not because he had forgotten the shape of the jetty. Bruegel had a great love for the sea and a very great interest in ships. His earliest extant paintings (Plates 1 and 2) show them, they dominate the *View of the Straits of Messina*, of 1561, he designed a whole series of ships for engravings, and in the last painting attributed to him, the *Storm at Sea* (Plate 155), they appear again, this time tossed by and at the mercy of the waves. All the landmarks of Naples have here been portrayed by Bruegel, from left to right: the Castel dell' Ovo, the island tower of St. Vincent (now destroyed), the Castel Nuovo and on the hill the Castel Sant'Elmo. The tower of St. Vincent seems to have been the inspiration for the island tower in the *Triumph of Death* (Plates 26 and 27). In the foreground, according to F. Smekens, in *Jaarboek 1961 Koninklijk Museum voor Schoone Kunsten, Antwerpen*, pp. 27 ff., a sea battle is in progress. He suggests that an episode in the war between the Turks and the Imperial forces, the defence of Naples against a Turkish attack, is represented.

50, 52-54, 56
THE TOWER OF BABEL

Vienna, Kunsthistorisches Museum.

$44\frac{7}{8} \times 61$ in. (114×155 cm.). Signed and dated: BRVEGEL. FE. M.CCCCC.LXIII.

This is probably the picture referred to as in the collection of Niclaes Jonghelinck in Antwerp in February 1566, and certainly the larger one of the two paintings owned, according to van Mander, by Rudolph II.

51, 55, 57-59
THE TOWER OF BABEL

Rotterdam, Museum Boymans-van Beuningen.

$23\frac{5}{8} \times 29\frac{3}{8}$ in. (60×74.5 cm.). Neither signed nor dated.

Friedländer dates the smaller picture also *c.* 1563 other critics have assigned it either to a very early or a very late period in Bruegel's life. (The 'impressionist' technique which is sometimes thought to be only a very late achievement in Bruegel's career, is certainly fully developed by 1563, as Plate 62 shows, which should be compared with Plate 59.) This is obviously the second *Tower of Babel*, the smaller version, which was owned by Rudolph II. As we know from the inventory of Clovio, Bruegel had also painted a very small version, on ivory, now lost. The mood is not the same in the two extant versions and there are also other differences in the conception of the subject. The Vienna version is more in keeping with tradition, as the visit of Nimrod to the building is included; in the other version this feature is lacking. The tower has here been placed nearer to us and as a result of this device and of the darkness of the heavy clouds and the deep shadow on the right the tower has become much more sombre and threatening. In both paintings the impression of immense size of the building is conveyed by similar means: in the first place the building looks like a mountain disappearing into the clouds, and in addition, the innumerable tiny ant-like people working on the building and in the surrounding countryside give us a yardstick by which to measure the tower. Bruegel's engineering spirit and his expert knowledge of building operations have often been admired (*cf.* Plates 54–56).

While the story of the Tower of Babel was obviously understood by Bruegel as an example of pride punished (*cf.* the notes on Plates 46 and 47) and this may explain his intense interest in the subject, the related notion of the vanity of all human endeavour too played its part in Bruegel's reading of the Bible story. Bruegel's tower reminded several observers of the Colosseum in Rome, and no doubt the Vienna *Tower of Babel* is, at least in part, modelled on the Colosseum and other Roman ruins, which Bruegel had not only seen some ten years before he painted his picture, but which he could contemplate at ease in Hieronymus Cock's engravings, some of which he seems to have used in both versions with only slight alterations. By likening the Babylonian structure to the ruins of Rome Bruegel made his idea clear to his contemporaries, for whom ruins, and in particular the ruins of the 'Eternal City', the remains of what the Caesars had built 'for Eternity', were a symbol of the vanity and transience of man's work. We find such an attitude to the ruins of Antiquity, for instance in Joachim du Bellay's *Romae descriptio* or in his *Lez Antiquitez de Rome* (1558). (*Cf.* Carl Fehrman, *Diktaren och döden* (The Poet and Death), Stockholm 1952, pp. 146 ff., to which Dr. C. G. Stridbeck has kindly called my attention.)

60-62

THE FLIGHT INTO EGYPT

London, Count Antoine Seilern Collection.
$14\frac{5}{8} \times 21\frac{7}{8}$ in. (37.2 × 55.5 cm.). Signed and dated: BRVEGEL MDLXIII (the last two figures only partly legible).

First mentioned in the inventory of the heirs of Cardinal Antoine Perrenot de Granvelle, Besançon, 1607. The *Flight into Egypt*, a popular subject in Flemish painting and in particular in the School of Patenier, appears in Bruegel's oeuvre first in an engraving (Bastelaer, *Estampes*, No. 15), then in a drawing, now in Berlin, and last in this painting. On the whole the sixteenth century preferred to show the Holy Family resting during the flight (*Il Riposo*) rather than travelling. Bruegel's two earlier compositions belong to the *Riposo* type, though he is most inventive and independent in his transformation of the old motifs. In view of his ever increasing interest in movement we can understand that in the

painting he gave up the resting type. The impression of movement is very strongly conveyed by the posture and attitude of St. Joseph and by the parallel forward bend in the same direction given to the willow with the falling idol. This symbol for the defeat of Paganism by the coming of Christ, which is derived from the Apocryphal Gospels, appears frequently in Flemish painting and in the special form adopted by Bruegel it occurs in several works of the Patenier School. While for the modern beholder this is in the first place a landscape – one of the most beautiful and delicate painted by Bruegel and in such parts as the trees in the centre and the countryside behind them (Plate 61) anticipating Rubens – and while in relation to the landscape the actual size of the figures is very small, they gain prominence by their place in the foreground and by a purely colouristic device: the red in the Virgin's garment, the only strong colour in the picture. In the rocks and mountains on the left Bruegel used and freely transformed studies he had made during his journeys through the Alps and which had also inspired several engravings of the *Large Landscape Series* published by Cock.

63-74

THE PROCESSION TO CALVARY

Vienna, Kunsthistorisches Museum.
$48\frac{3}{4} \times 66\frac{7}{8}$ in. (124 × 170 cm.). Signed and dated: BRVEGEL MD.LXIIII.

This is obviously the painting which is mentioned among the sixteen paintings by Bruegel owned by Niclaes Jonghelinck in Antwerp in February 1566. It may even have been painted for this rich Mæcenas. It is the largest painting by Bruegel and shows the most elaborate treatment of detail. At the same time it has a freshness which is rare even for Bruegel. This is one of the two paintings for which preparatory figure studies survive (in the Museum Boymans, Rotterdam), as Tolnay was the first to observe: for the man seen in profile in the centre of Plate 71 and for the fat man on the left in Plate 72. (The other is the Vienna winter landscape, Plate 79; see note on that painting.) While the main features of the composition – the long procession and the accompanying crowd – are derived from works by Bruegel's immediate predecessors or contemporaries, such as the so-called Brunswick Monogrammist

(who has been identified with Jan van Amstel) or Pieter Aertsen, amongst several others, most of the details are Bruegel's own inventions and they serve a rather different interpretation of the event which has a topicality not understood in this way by the earlier artists. It has often been remarked that Bruegel has here given a picture of the preparations for an execution, such as he must have seen in his own time, with the typical reactions of the public to such a spectacle. What lends it poignancy is the fact that the object of idle curiosity or indifference is Christ. (That it needs a certain effort to detect the figure of Christ in the throng has therefore a deeper meaning – and such a device also conforms to Mannerist principles of composition.) The painting thus becomes a condemnation – this is particularly clear in the episode which attracts the attention of many of the onlookers (Plate 66): Simon of Cyrene, seized by the soldiers in order to help Christ carry the Cross, does not want to perform this act of mercy; he struggles with the soldiers and is supported in this struggle by his wife to whose bodice a rosary with a cross – a sign of her outward piety – is attached! (Noticing this incident Ludwig Baldass states: One could not condemn hypocritical Christianity more clearly; see *L'Umanesimo e il Demoniaco, Atti del II° Congresso internazionale di Studi Umanistici*, Rome 1953, p. 174.) The Virgin Mary and the holy figures around her are contrasted with and separated from the rest of the people; they seem to belong to a different, a timeless sphere, not to the contemporary world.

75-76
THE ADORATION OF THE KINGS

London, National Gallery.

$43\frac{3}{4} \times 32\frac{3}{4}$ in. (111×83.5 cm.). Signed and dated: BRVEGEL M.D.LXIIII. (There is a vertical crack in the panel between the L and the X of the date and this X and the following four figures lack the beautiful calligraphic character of Bruegel's script; the L seems to be drawn over the original figure.)

This painting is probably identical with an *Adoration* mentioned in the inventory of Archduke Ernst, 1594, and again in an inventory of the Imperial collection in Vienna, 1619. It is the first painting by Bruegel built up almost exclusively of large figures. The concentration of the figure composition is matched by the intensity and range of expressions studied in the various reactions of the bystanders to the great event. Though the individualization of the features and their lack of ideal beauty in the Italian sense bear witness to a different conception of man, the figure composition as such is closely related to Italian art, as Hulin de Loo was the first to notice. This *Adoration* and the *Resurrection* (Plate 30) are the only upright paintings by Bruegel.

77
THE DEATH OF THE VIRGIN

Banbury, Upton House, National Trust.

Grisaille painting; $14\frac{1}{2} \times 22$ in. (36×55 cm.). Signed: BRVEGEL, traces of date illegible.

Painted, probably about 1564, for Bruegel's friend Abraham Ortelius, who had an engraving made after it by Philip Galle for presentation to other friends in 1574. As in the *Resurrection* (Plate 30) Bruegel has here again expressed his confident belief in the resurrection and salvation of the just. This is clear from the – rather unusual – way in which he has represented the death of the Virgin with a vast throng of mourners. His inspiration was the *Golden Legend* by Jacobus de Voragine, who speaks of the patriarchs, martyrs, confessors and holy virgins being present when the Virgin was again united with her Son, and praising her in these words: 'This is she that never touched the bed of marriage in delight, and she shall have fruit in the refection of holy souls.' According to Jacobus de Voragine this account of the Virgin's death was given in an apocryphal book of St. John the Evangelist (*cf.* F. S. Ellis (ed.), *The Golden Legend or Lives of the Saints as Englished by William Caxton*, London 1900, IV, pp. 324 ff.) As the man who was aware of the miraculous event and had recorded it, St. John is shown isolated in the picture with his eyes closed, apparently asleep. But with his inner eye – as in a dream – he sees the miracle – and in Bruegel's mysterious treatment of light anticipating Rembrandt it becomes truly a miracle.

78
CHRIST AND THE WOMAN TAKEN IN ADULTERY

London, Count Antoine Seilern Collection.

Grisaille painting; $9\frac{1}{2} \times 13\frac{1}{2}$ in. (24.1×34 cm.). Signed and dated: BRVEGEL M.D.LXV.

This picture, which has only recently come to light and was published by the present writer in *The Burlington Magazine* (XCIV, 1952, pp. 218 ff.), remained in the master's family until the death of Jan Brueghel (d. January 12, 1625), who bequeathed it to Cardinal Federigo Borromeo, Archbishop of Milan. In 1579 it was reproduced in an engraving of exactly the size of the original by Pierre Perret (Bastelaer, *Estampes*, No. 111). All along the edge of the picture fine pricks made by the points of compasses recur at regular intervals. They are the work of the engraver and, according to a suggestion of Professor Johannes Wilde, they had to serve as starting points for a network of lines on the tracing paper used by the engraver when preparing the print. They helped to keep the tracing paper in position.

In the article mentioned above I tried to deduce both from the obvious meaning of the biblical story, which is told in John, VIII, 3–11, and by drawing upon Ortelius' letters that this grisaille has to be understood as a plea for toleration in the religious strife of Bruegel's time. Like the *Adoration of the Kings* of the preceding year (Plates 75 and 76) this composition is built up of figures only, without any trace of landscape. Although the iconographical scheme follows the Flemish tradition (we find the closest parallel to it, as Dr. C. G. Stridbeck has recently shown, in a painting attributed to Pieter Coeck in the Ghent museum), the figure composition – and its monumentality – are the results of Bruegel's study and understanding of Raphael's tapestry cartoons with the *Acts of the Apostles* (now in the Victoria and Albert Museum, London) which in Bruegel's time were in Brussels, and among which the *Healing of the Lame Man* seems to have been the direct prototype.

79–109
THE SERIES OF THE MONTHS

79–84
THE HUNTERS IN THE SNOW (JANUARY)

Vienna, Kunsthistorisches Museum.
$46 \times 63\frac{3}{4}$ in. (117×162 cm.). Signed and dated: BRVEGEL. M.D.LXV.

85–90
THE GLOOMY DAY (FEBRUARY)

Vienna, Kunsthistorisches Museum.
$46\frac{1}{2} \times 64\frac{1}{8}$ in. (118×163 cm.). Signed and dated: BRVEGEL MDLXV.

91–98
HAY MAKING (JULY)

Prague, National Gallery.
$46 \times 63\frac{3}{8}$ in. (117×161 cm.). Neither signature nor date are visible now, but as this painting is one of a series all the other parts of which are dated 1565, the same date can safely be assigned to it.

99–103
THE CORN HARVEST (AUGUST)

New York, Metropolitan Museum of Art.
$46\frac{1}{2} \times 63\frac{1}{4}$ in. (118×160.7 cm.). Signed BRVEGEL. Of the date only the last figures ... LXV are clearly legible.

104–109
THE RETURN OF THE HERD (OCTOBER OR NOVEMBER?)

Vienna, Kunsthistorisches Museum.
$46 \times 62\frac{5}{8}$ in. (117×159 cm.). Signed and dated: BRVEGEL MDLXV.

These five paintings form part of a now incomplete series of the *Months*. As early as February 1566 the whole series was owned by Niclaes Jonghelinck. It was probably commissioned by him as part of the large-scale scheme of decoration for his palatial house in Antwerp, in which also the most renowned Antwerp artist of the day, Frans Floris, was engaged. There is some controversy about the original number of panels which constituted the series: twelve, the more usual number, has been suggested as well as six which, though less common than twelve, was sometimes also chosen to represent the Months, in which case two were allotted to one picture. From the document of February 1566, in which the series of the Months is mentioned for the first time, we learn that Jonghelinck possessed 'sixteen paintings

by Bruegel, among which are the *Tower of Babel*, a *Procession to Calvary*, the *Twelve Months*'. If there were only six pictures of the *Months*, one would have to assume that in addition to the specified pictures there were eight more by Bruegel the titles of which were omitted, which seems unlikely, seeing that in this document the paintings by Frans Floris were carefully listed with their titles. It has been further suggested that 'six paintings representing the twelve months', which, according to the book of expenses kept by Blasius Hütter, the private secretary of Archduke Ernst in the Netherlands, the Archduke received as a gift from the city of Antwerp on July 5, 1594, were the paintings of the *Months* by Bruegel. While no artist's name is given in Hütter's book of expenses nor in the inventory of the Archduke's estate, for photographs of which I am greatly indebted to Professor J. G. van Gelder, another copy of the inventory has been published by Marcel de Maeyer in which the name of Bruegel is given for these and some other paintings in the Archduke's collection. De Maeyer has also discovered a later inventory of pictures belonging to the Brussels court (to be dated between 1665 and 1692) in which six paintings by Bruegel representing the twelve months are listed again (M. de Maeyer, *Albrecht en Isabella en de Schilderkunst*, Brussels 1955, pp. 259 and 455 f.). On the other hand five pictures from the series of the *Months* appear in Vienna in 1657 (i.e. before the second Brussels inventory) in the collection of Archduke Leopold Wilhelm who, before removing his collection to Vienna, had been Governor of the Netherlands until 1656, and they are obviously those which came by bequest to the Imperial collection in Vienna and are still preserved, although only three of them have remained in Vienna. The discovery of the later Brussels inventory thus raises new problems rather than solving the old ones.

The first to put forward the thesis that the series consisted only of six paintings was Tolnay (*Jahrbuch der Kunsthistorischen Sammlungen*, N.F. VIII, Vienna, 1934) – a thesis accepted by some later critics. The complicated question can be dealt with at adequate length only in the Catalogue Volume; here it must suffice to state that Tolnay based his theory on comparisons with earlier representations of the Months but, in my view, further extensive examinations of comparative material are needed. My studies of the iconography of the *Months* in Flemish and German art have led me to the conclusion that it is not necessary to assign the motifs shown in one picture to two Months. On the basis of the material known to me I suggest that the painting of the *Hunters in the Snow* is meant for January, the *Gloomy Day* for February, the *Hay Making* for July and the *Corn Harvest* for August. Only the meaning of the remaining picture is not quite certain, as the main motif, the return of the herd, is unusual before Bruegel. But it appears in the *November* picture, inscribed with the name of the month, in the series of the *Months* by Martin van Valckenborch in Vienna, a series which is in many respects indebted to Bruegel. Nevertheless an identification with October, also suggested by Auner, cannot be excluded.

Generally speaking, Bruegel is never satisfied with showing only *one* characteristic of a month or *one* typical occupation. But above all it is the landscape more than any single motif which conveys the idea, the atmosphere of a special phase of the year. In fact it is Nature herself, her growth, fullness, decay and rebirth, to which the doings of men and animals are subordinated – and this is the essentially new feature when compared with the earlier treatment of the *Months* – which is the true subject of these pictures. In each the scenes are closely knit together in complete unity of time, place and action. The paintings, which were probably hung above the panelling, as was the fashion of the time, formed a kind of frieze, with the continuous landscape background connecting each picture with its neighbour, as can still be seen in the remaining fragments of the 'frieze'. On compositional grounds the *Hunters in the Snow* would appear to be the first member of the frieze, and this fact also confirms the interpretation of this composition as a representation of January.

The whole set was probably painted in the short span of one year and to do this was only possible for an artist who was a complete master of his technique. The technique in fact here shows a spontaneity, a rapid, sometimes almost shorthand method quite different from the elaborate execution of earlier works. The underpainting is sometimes left visible, used as a colour effect, and the paint is often applied only quite thinly or with an almost dry brush. The extraordinary results of this technique, which Rubens was later further to develop following

Bruegel's lead, can best be studied in the *Return of the Herd* (Plates 105–107). Only for the *Hunters in the Snow* (Plate 79) a preparatory drawing is known. It is a study for one of the hunters, preserved in the University Library of Uppsala (see F. Grossmann, in *The Burlington Magazine*, CI, 1959, p. 346, Fig. 48).

Only few of the details reproduced in this book call for an explanation.

Plate 84: Pig slaughter was often used to illustrate the winter months. Bruegel has here replaced the scene of the killing and bleeding (*cf.* Plates 115 and 116) by the rarer scene of the singeing of the pig, a motif that was then taken up by his followers.

Plate 89: The pollarding of the willows is mostly shown in representations of February.

Plate 90: February is the Carnival season. A child with a similar carnival paper crown appears among the followers of Carnival (Plate 8 near the left edge). The most detailed and careful study of various aspects of Bruegel's *Months* published so far is Fritz Novotny's *Die Monatsbilder Pieter Bruegels d. Ä.* (Vienna 1948).

110 and 112

THE MASSACRE OF THE INNOCENTS

Vienna, Kunsthistorisches Museum.

45⅝ × 63 in. (116 × 160 cm.). Inscribed BRVEG. Not dated.

111 and 113

THE MASSACRE OF THE INNOCENTS

Hampton Court, H.M. the Queen.

43 × 61 in. (109.2 × 154.9 cm.). Neither signed nor dated.

The most probable date for both versions appears to me to be the years around 1565–67 at which time Bruegel was particularly interested in the painting of winter scenes, though I am inclined to place it in the earlier part of this period. Van Mander mentions a *Massacre of the Innocents* in the collection of Rudolph II. The Hampton Court version can be traced back to Queen Christina of Sweden and from her to the Imperial collection in Prague, a great part of which fell into Swedish hands in 1648. On the other hand a *Massacre of the Innocents* by Bruegel is listed in two

inventories of the Imperial collections in Vienna between 1610 and 1619. Unless this latter painting was later transferred to Prague, the Vienna inventory entries may well refer to the version now in the Kunsthistorisches Museum. Neither version is in a satisfactory condition.

Modern critics on the whole have not treated the Vienna version too kindly and X-ray photographs, for which I am indebted to Dr. F. Klauner and Dr. E. Auer of the Kunsthistorisches Museum, reveal definitely that Bruegel can have had no great share in the execution, though certain parts, especially those showing *pentimenti*, permit the conclusion that the picture was painted in Bruegel's workshop and partly retouched by him. On the other hand, the Hampton Court version, which up to now has not been seriously taken into consideration as an original work by Bruegel, was certainly painted by him, as the technique, also revealed by X-ray examination (kindly authorized by Professor Sir Anthony Blunt and conducted by Mr. S. Rees Jones at the Courtauld Institute of Art), makes abundantly clear. But it has suffered damage to an even greater extent than the Vienna version. There are not only seventeenth-century overpaintings by which the children are hidden and the meaning of the picture is altered, but – and this is much more serious – in many places the original paint has completely disappeared and the gaps have been clumsily filled in by some early restorers. A comparison of the same details (Plates 111 and 113) shows the superiority of the Hampton Court version in its original parts, as for instance in the head appearing to the right of the herald's hand. The eyes drawn as perfect circles are typical of Bruegel's manner and should be compared with Plate 123, where this characteristic can be studied very well.

As in the *Procession to Calvary*, Bruegel has here represented the biblical scene as a contemporary event, a punitive expedition to a Flemish village, thus endowing it with an extreme intensity and poignancy. Comte Charles Terlinden (in *Revue Belge d'Archéologie et d'Histoire de l'Art*, III, 1942, p. 250) is right, I think, in rejecting a political meaning – the condemnation of the Spanish soldiers in the Netherlands – for Bruegel's realistic scene (since there were no Spanish soldiers in the Netherlands, between September 1560 and August 1567), though of course, it is based on actual observation.

114

WINTER LANDSCAPE WITH SKATERS AND A BIRD-TRAP

Brussels, Dr. F. Delporte Collection.

15 × 22 in. (38 × 56 cm.). Signed and dated: BRVEGEL. M.D.LXV.

First mentioned by Paul Lambotte (in *Apollo*, January 1927) and Max J. Friedländer (in *Cicerone*, XIX, 1927, p. 216). This is one of the compositions by Bruegel that was most frequently copied and it is not clear which versions are referred to in old inventory entries. Of all the versions I have seen this is the best and probably the original, although some doubts have been occasionally expressed about its authenticity. While in the Vienna *January* picture Bruegel evoked the impression of a clear winter day of sharp and biting frost, with the misty atmosphere of this landscape he presents another aspect of winter. This little cabinet picture is a precursor of seventeenth-century Dutch winter landscapes, though it certainly is not meant as a pure landscape or genre painting. With the bird-trap juxtaposed to the skaters, one feels, some deeper meaning is intended. What this meaning is has so far remained unexplained.

115-119

THE NUMBERING AT BETHLEHEM

Brussels, Musées Royaux des Beaux-Arts.

45⅝ × 64¾ in. (116 × 164.5 cm.). Signed and dated: BRVEGEL 1566.

Acquired by the Museum at the sale of the Edmond Huybrechts Collection, Antwerp, in 1902. At an earlier date it had been in the van Colen de Bouchout Collection, also in Antwerp. The numbering or taxing at Bethlehem and Joseph's and Mary's arrival there is told in Luke, II, 1–5. While their coming to Bethlehem and the arrival at the inn appears in Flemish art before Bruegel (for instance in panels by or attributed to Cornelis Massys in Berlin and New York), the scene of the taxation is not usual before Bruegel. The biblical subject is again shown as a contemporary event. The ruins of the castle in the background, certainly placed there for their symbolical meaning, are inspired by the towers and gates of Amsterdam that Bruegel had drawn in 1562. Here

winter is again seen differently. All motifs are based on careful observation, but they are endowed with a poetic quality transcending realism, as in the almost Japanese-like vision of the setting of the red winter sun seen through the pattern of the bare branches of a tree (Plate 119), or in the group of chickens near the cart (Plate 118).

120

THE ADORATION OF THE KINGS IN THE SNOW

Winterthur, Dr. Oskar Reinhart Collection.

13¾ × 21⅝ in. (35 × 55 cm.). Signed and dated: M.D. LXVII BRVEGEL. (The figures of the date are not perfectly preserved; this has led to different readings, but MDLXVII, Glück's reading, is probably correct.)

Listed in the inventory of Everard Jabach's estate, Paris 1696. This is Bruegel's last attempt at creating a new type of winter picture and a new type of the *Adoration of the Kings*. Although snow showers were painted before Bruegel in the calendar illustrations of Flemish illuminated Books of Hours (which were among his main sources of inspiration), they were never connected with the *Adoration of the Kings*. In this way Bruegel made the biblical event, which in the Christian year is connected with January 6, as 'real' and life-like as possible.

121

THE WEDDING DANCE IN THE OPEN AIR

Detroit, Institute of Arts.

47 × 62 in. (119 × 157 cm.). Without signature; dated: M.D.LXVI.

Purchased from the English art market in 1930. The picture was cleaned in 1942. Judging by new photographs and by the opinions of scholars who have seen the picture since the cleaning, former doubts about its authenticity no longer appear justified. This is the earliest extant painting of a Peasant Dance we have by Bruegel, but there are good reasons for believing that it was preceded by others of its kind. The various types of *Peasant Weddings* Bruegel painted will be discussed in the Catalogue Volume. Dancing, and with it the music of bagpipes, appears mostly as something sinful in Bruegel's works (*cf. Carnival and Lent*, Plates 6–12, or the engraving with the *Parable of the*

Wise and Foolish Virgins (Bastelaer, *Estampes*, No. 123), where the foolish – sinful – virgins are shown dancing and playing the bagpipe). An examination of further details confirms the view that Bruegel has given here a picture of the sin of lust, for which the wedding, so Bruegel tells us, has become a pretext, instead of recalling the holy sacrament of matrimony. The difference between this late composition and the early works is that Bruegel no longer shows sin, or the punishment of sin, in an abstract manner, but so to speak in its everyday clothes. The 'reality' of the dance – the movement and rhythm of which pervade the whole composition – is most convincing. It is therefore not surprising that this and Bruegel's other peasant pieces have been misinterpreted as simple genre scenes without deeper significance.

122-124

THE SERMON OF ST. JOHN THE BAPTIST

Budapest, Museum of Fine Arts.

$37\frac{3}{8} \times 63\frac{1}{4}$ in. (95 × 160 cm.). Signed and dated: BRVEGEL.M.D.LXVI. Formerly owned by the Count Batthyány family. The picture is first recorded in the collection of the Infanta Isabella at Brussels, in an inventory drawn up, after her death, between 1633 and 1650.

The subject is not rare in Flemish painting, but Bruegel stressed certain features and even introduced new ones into it which endow it with a specific meaning. The Baptist is clearly indicated as the one who only prepares the way for a greater one to come, for Christ: Christ is present at the sermon and St. John points at Him. The majority are listening with rapt attention (and here Bruegel assembles a collection of expressive heads comparable or even superior to those in the London *Adoration*, Plates 75 and 76), and with these listeners Bruegel contrasts a gentleman who pays no attention to the sermon and has his fortune told by a gipsy. Gustav Glück assumed that Bruegel's painting was inspired by the well-attended open-air sermons in the Reformed communities. I think that this assumption is correct, and in the Catalogue Volume an attempt will be made to prove this. Anticipating the results of a more detailed examination, we can here only state that the connection with the meetings of the Reformed com-

munities seems to throw some light on the fortune-telling scene placed so conspicuously in the foreground. Having one's fortune told was condemned by Calvin and expressly forbidden to his followers. The attitude of the gentleman – and as an exception Bruegel has introduced a portrait into a biblical scene – is perhaps meant to express this man's hostility to such meetings, a rejection of Calvinism. It should, however, be added that fortune-telling was generally prohibited in the Netherlands in the sixteenth century.

125-128

THE CONVERSION OF ST. PAUL

Vienna, Kunsthistorisches Museum.

$42\frac{1}{2} \times 61\frac{3}{8}$ in. (108 × 156 cm.). Signed and dated: BRVEGEL. M.D.LXVII. Bought by Archduke Ernst of Austria, Governor of the Netherlands, on October 13, 1594. Later mentioned by van Mander as in the collection of Rudolph II.

The subject, frequent in Italian art and also to be found in Flemish painting before Bruegel, is taken from the Acts of the Apostles, IX, 3. Unusual is the mountain setting that Bruegel has chosen for the story. He has shifted the main scene, the fall of St. Paul, into the background, leading us skilfully to the saint from the ravine on the left through the whole picture and thus conveying the characteristic sensation of moving through the mountains, in a way no artist had done before him. St. Paul has been likened to the Duke of Alba, the persecutor of the Netherlands. I do not think that such a political interpretation is justified. I believe the picture is rather to be understood as an exhortation to follow God, to be converted to true faith although the connection of the subject with Superbia (pride) in medieval iconography may well have been known to Bruegel.

129-133

PEASANT WEDDING (THE WEDDING BANQUET)

Vienna, Kunsthistorisches Museum.

$44\frac{7}{8} \times 64\frac{1}{8}$ in. (114 × 163 cm.). At the bottom a strip of 5.5 cm. height is a later addition and probably replaces the earlier bottom portion of the picture now lost. Neither signed nor dated.

The lost bottom strip may have contained signature and date. Various dates have been suggested. I consider, c. 1567, before the tragic works of 1568, to be the most probable one. The picture is unmistakably described in the inventory of Archduke Leopold Wilhelm, 1659. A *Peasant Wedding* by Bruegel was acquired by Archduke Ernst on July 16, 1594. Van Mander mentions a *Peasant Wedding* in the collection of Herman Pilgrims in Amsterdam. Which of these two later passed to Leopold Wilhelm and finally to the Vienna collection cannot be decided at present.

If one accepts the interpretation here suggested for the Detroit *Wedding Dance*, then one must agree that this peasant banquet is meant as a picture of gluttony. The strong accent of the man pouring out wine in the foreground, the still life of wine jugs, the greedy child, these motifs sound the '*leitmotiv*' which can be followed through the whole composition.

134-137
THE PEASANT DANCE

Vienna, Kunsthistorisches Museum.

$44\frac{7}{8} \times 64\frac{5}{8}$ in. (114×164 cm.). Signed: BRVEGEL. Not dated, obviously painted about the same time as the *Peasant Wedding* (Plate 129). Perhaps to be identified with a painting listed in an inventory of the Imperial collection in Vienna c. 1612–18.

We find here a further development of the tendencies observed in the Detroit *Wedding Dance*. But now it is not only the sin of lust which Bruegel portrays: anger and gluttony appear combined with it (at the table, Plate 136). The man next to the bagpipe player wears on his hat the peacock feather of vain pride (Plate 137). The occasion for all this sinful behaviour is a kermesse, to celebrate some saint's day! The church appears in the background, but all figures are shown with their backs to it. Moreover they do not pay the slightest attention to the picture of the Madonna which looks down on the sinners from the tree on the right.

138-139
THE LAND OF COCKAIGNE

Munich, Alte Pinakothek.

$20\frac{1}{2} \times 30\frac{3}{4}$ in. (52×78 cm.). Signed and dated: M.DLXVII. BRVEGEL.

First mentioned in an inventory of the Imperial Collection in Prague, 1621. This picture of the fairy-tale land of Cockaigne is obviously intended as a condemnation of the sins of gluttony and sloth, as is also indicated by the Dutch name *Luilekkerland* for the Land of Cockaigne (*lui* for lazy, *lekker* for gluttonous).

140
THE CRIPPLES

Paris, Musée du Louvre.

$7\frac{1}{8} \times 8\frac{1}{2}$ in. (18×21.5 cm.). Signed and dated: BRVEGEL M.D. LXVIII.

On the back of the panel several old inscriptions including two Latin distichs in praise of Bruegel (for details about the inscriptions see Edouard Michel, *Musée National du Louvre. Catalogue raisonné ... des Peintures Flamandes du XVe et du XVIe Siècle*, Paris 1953, p. 42). Perhaps identical with a picture sold by the Amsterdam Orphans Chamber on March 5, 1607. Similar pictures are listed in the inventories of Herman de Neyt, Antwerp 1642, and of Queen Christina of Sweden, 1652 (the latter without an indication of the artist and described as coming from Prague). But all these identifications are uncertain. Presented to the Louvre by Paul Mantz in 1892.

It has been shown by S. J. Gudlaugsson (in *Kunsthistorische Mededelingen van het Rÿksbureau voor Kunsthistorische Documentatie*, II, The Hague, 1947, pp. 32 ff.) that these cripples are lepers whose distinctive emblems worn at the Lepers' Processions on the Monday after Twelfth Night and during the Carnival season were the fox tails (*cf.* also Plate 6, left centre). What meaning exactly, beyond the general idea that physical defects express moral defects, Bruegel intended to convey with his lepers' assembly is not quite clear. None of the earlier interpretations, suggested before the true significance of the fox tails was discovered, is satisfactory.

141-144
THE PEASANT AND THE BIRD NESTER

Vienna, Kunsthistorisches Museum.

$23\frac{1}{4} \times 26\frac{3}{4}$ in. (59×68 cm.). Signature and date: BRVEGEL MD.LXVIII, written in gold, are renewed.

First mentioned in the inventory of Archduke Leopold Wilhelm, 1659. This picture has been interpreted by Hulin de Loo as an illustration of the Netherlandish proverb: 'He who knows where the nest is, has the knowledge, he who robs it has the nest.' Kjell Boström (in *Konsthistorisk Tidskrift*, XVIII, 1949, pp. 77 ff.) has expanded this interpretation into a detailed analysis of the figures and the landscape and has shown that Bruegel has here given expression to his pessimistic view of human nature and contrasted the active and wicked thief with the passive man who is virtuous in spite of adversity. In support of his interpretation Boström points to the symbolic significance of the plants and trees discovered in contemporary sources. The iris is, according to Boström, the symbol of a man strengthened by persecution and the bramble hints at the overcoming of temptations (Plate 143). These symbols refer to the peasant; the deformed willow tree (Plate 144), a symbol of useless human beings, indicates the thief. While agreeing in principle with Boström, I think that some modifications may be necessary.

Its extremely rich and varied technique, its composition, the perfect combination of linear pattern and spatial design, the movement and the monumentality of the peasant – by whom Tolnay and Vanbeselaere were rightly reminded of figures by Michelangelo – all these qualities contribute to making this one of Bruegel's most accomplished works.

145-146

THE MISANTHROPE

Naples, Museo Nazionale.

Canvas; $33\frac{7}{8} \times 33\frac{1}{2}$ in. (86×85 cm.). Signed and dated on the painted frame: BRVEGEL 1568. In the collection of Count G. B. Masi, Parma, by 1611, in which year the canvas was confiscated by the Farnese.

The inscription at the bottom reads in translation: 'Because the world is so faithless I am going into mourning'. There is not much to be added to this explanation. He who is too much concerned with worldly things, cannot escape the perfidy of the world. His mourning does not help him. He is being robbed by the wicked world, from which he wants to escape, a figure in a glass ball, the symbol of vanity (*cf.* the analogous figure in the *Proverbs*, Plate 13, in the foreground on the right; see also the notes on Plates 36–44) and is unaware of the man-traps which threaten him on his path. That this righteous man is not free from hypocrisy, as demonstrated by the purse he is hiding under his cowl, has been well observed by Tolnay, though I should call this man's sin covetousness rather than hypocrisy. A shepherd, in the background, faithfully guarding his sheep is contrasted with the faithless world.

147-151

THE PARABLE OF THE BLIND

Naples, Museo Nazionale.

Canvas; $33\frac{7}{8} \times 60\frac{5}{8}$ in. (86×154 cm.). Signed and dated: BRVEGEL.M.D.LX.VIII. Like the *Misanthrope* (Plate 146), in the collection of Count G. B. Masi, Parma, by 1611, in which year confiscated by the Farnese.

Bruegel here illustrates the words from the Gospel of St. Matthew, xv, 14: 'If the blind lead the blind, both shall fall into the ditch.' He was not the first artist to be attracted by the parable, but he has rendered it as no artist before or after him. Whereas among the artists who inspired Bruegel Bosch showed two blind men and Cornelis Massys four, their number is raised to six by Bruegel, which only protracts our tension and fearful expectation of the fall we know to be inevitable for all of them. The crescendo in the expression of the faces, reaching an almost unbearable climax in the man who has lost his balance and is about to fall (Plate 149), is matched by the expressiveness of the postures, by the gradual increase in unsteadiness. Although they are greatly differentiated, each man fully and unforgettably represents as it were the idea of blindness itself (Plates 148–151). For the great artist is a creator of types. His images become our images, and if we see old age with the eyes of Rembrandt, we owe our image of blindness to Bruegel. In the Naples picture Bruegel has given final expression to what had occupied him for many years. In 1559 he had included blind men in his picture of *Carnival and Lent* (Plates 9 and 10), in 1562 he made a drawing of three blind people (now in Berlin) and from several early inventory entries as well as from paintings and drawings by other artists (especially his elder son Pieter and Martin van Cleve), which appear to be inspired by Bruegel, we can

deduce the existence of further compositions of this kind. If there is pity and compassion for the physical affliction in the earlier works, its symbolic content endows the late painting with a new sense of tragedy and grandeur. The inner blindness, which is meant by the parable, is a greater defect than the blindness of the eyes. Those who are blind to true religion, who do not perceive its message which is symbolized in the background by the church, a strong and firm structure with its spire pointing to heaven and contrasted with the unsteady broken row of the wretched men – such people must lose their way and fall into the abyss. If in the *Conversion of St. Paul* Bruegel asked us to open our hearts to the divine message, in the *Parable of the Blind* he showed what fate befell those who did not follow God.

152

HEAD OF AN OLD PEASANT WOMAN

Munich, Alte Pinakothek.

$8\frac{5}{8} \times 7\frac{1}{8}$ in. (22 × 18 cm.). Neither signed nor dated.

In 1868 the picture was transferred to Schleissheim from Schloss Neuburg a.D. (Bavaria), where, according to Glück, it had been as early as 1804. I agree with Glück in placing this head, which as an isolated character study is unique in Bruegel's extant oeuvre, near the end of his career. It should be compared not only with the head of the blind man (Plate 151) but with the connoisseur in Bruegel's late drawing of the *Artist and the Connoisseur* in the Albertina, Vienna. From old inventories it is to be inferred that Bruegel painted a greater number of such heads. The concentration on few figures is a characteristic of Bruegel's late style.

153-154

THE MAGPIE ON THE GALLOWS

Darmstadt, Museum.

$18\frac{1}{8} \times 20$ in. (45.9 × 50.8 cm.). Signed and dated: BRVEGEL 1568.

Mentioned by van Mander as bequeathed by Bruegel to his wife. Van Mander suggests that 'by the magpie he meant the gossips whom he would deliver to the gallows'. This explanation is not quite satisfactory, because it does not account for a number of features.

According to D. Bax (in *Nederlands Kunsthistorisch Jaarboek*, XIII, 1962, pp. 5–9), Bruegel here expressed the idea that treacherous gossip is bound to bring people to the gallows and that in particular he may have had in mind the fate of Protestant victims. Bax has also suggested plausible interpretations for some individual features but, like in so many works of Bruegel, a great deal still remains unexplained. For instance, does the dance at the foot of the gallows express sin, as is usual with Bruegel or is it meant as a gesture of defiance as that of the man in the left bottom corner might be? And, perhaps most surprisingly, the radiant landscape, the air filled with light as in no other picture by the master, the rapturous rhythm of the dance in which even the gallows seem to join, give this painting an air of optimism which seems to belie the sombre meaning of the gallows. While in the works of Bruegel's last year large figures usually dominate the composition, here and in the *Storm at Sea* (Plate 155) Bruegel's interest is centred on the atmosphere, in the literal and in a metaphorical sense of the word. Is this a new departure, a new development cut short by Bruegel's premature death?

155

THE STORM AT SEA

Vienna, Kunsthistorisches Museum.

$27\frac{5}{8} \times 38\frac{1}{4}$ in. (70.3 × 97 cm.). Neither signed nor dated. Unfinished.

First publicly exhibited after 1880 when taken from the Belvedere depot of the Imperial Collection in Vienna. It was then ascribed to Bruegel; later the attribution was changed to Joos de Momper in the Museum catalogues, until it was again claimed for Bruegel by A. Romdahl (*Jahrbuch der Kunsthistorischen Sammlungen des Ah. Kaiserhauses*, XXV) in 1905. Recently Bruegel's authorship has again been questioned. It is true, there is a certain relationship to Momper to whom the picture has been re-attributed by Kjell Boström (in *Konsthistorisk Tidskrift*, XXIII, 1954, pp. 45 ff.), but as far as our present knowledge of the artist goes, the greatness of the invention seems to be beyond Momper's powers and, moreover, there is a theatrical element in Momper's landscapes which is lacking in our picture. For some time I was also slightly inclined to doubt Bruegel's authorship,

but the technique, particularly in the underpainting, visible in the unfinished parts (not completed because death intervened?) points to Bruegel, as well as the deeper symbolic significance of the composition. The subject has been explained by Ludwig Burchard on the basis of the following passage in Zedler's *Universal-Lexikon* (1732–50): 'If the whale plays with the barrel that has been thrown to him and gives the ship time to escape, then he represents the man who misses the true good for the sake of futile trifles.' The correctness of this explanation has been confirmed by further analogous passages, even nearer in time to Bruegel, which were later discovered by others and by Burchard himself. This interpretation was supplemented by the valuable observation of H. Schrade (in *Das Werk des Künstlers*, 1, 1939, p. 422 ff.) that the church visible beyond the waves is to be understood as the saving element in the dangers of life symbolized by the stormy sea. Similarly, it has been suggested by Stridbeck that the ship and the sea voyage are symbols of human life and of the dangers and temptations besetting it. In addition Stridbeck interprets the episode with the barrel thrown to the whale as the abandoning of material goods in order to achieve salvation. Auner sees in the ship also a symbol of the Church and assumes rather boldly that one of the tiny figures in the ship on the left is Christ, the Saviour.

INDEX OF COLLECTIONS

ALPHABETICAL INDEX OF TITLES